COLORADO 24/7

CONNECTICUT 24/7

DELAWARE 24/7

FLORIDA 24/7

GEORGIA 24

KANSAS 24/7

KENTUCKY 24/7

LOUISIANA 24/7

MAINE 24/7

MARYLAND 24/7

MONTANA 24/7

NEBRASKA 24/7

NEVADA 24/7

NEW JERSEY 24/7

NEW HAMPSHIRE 24/7

OKLAHOMA 24/7

OREGON 24/7

PENNSYLVANIA 24/7

RHODE ISLAND 24/7

SOUTH CAROLINA 24/7

VIRGINIA 24/7

WASHINGTON 24/7

WEST VIRGINIA 24/7

WISCONSIN 24/7

WYOMING 24/7

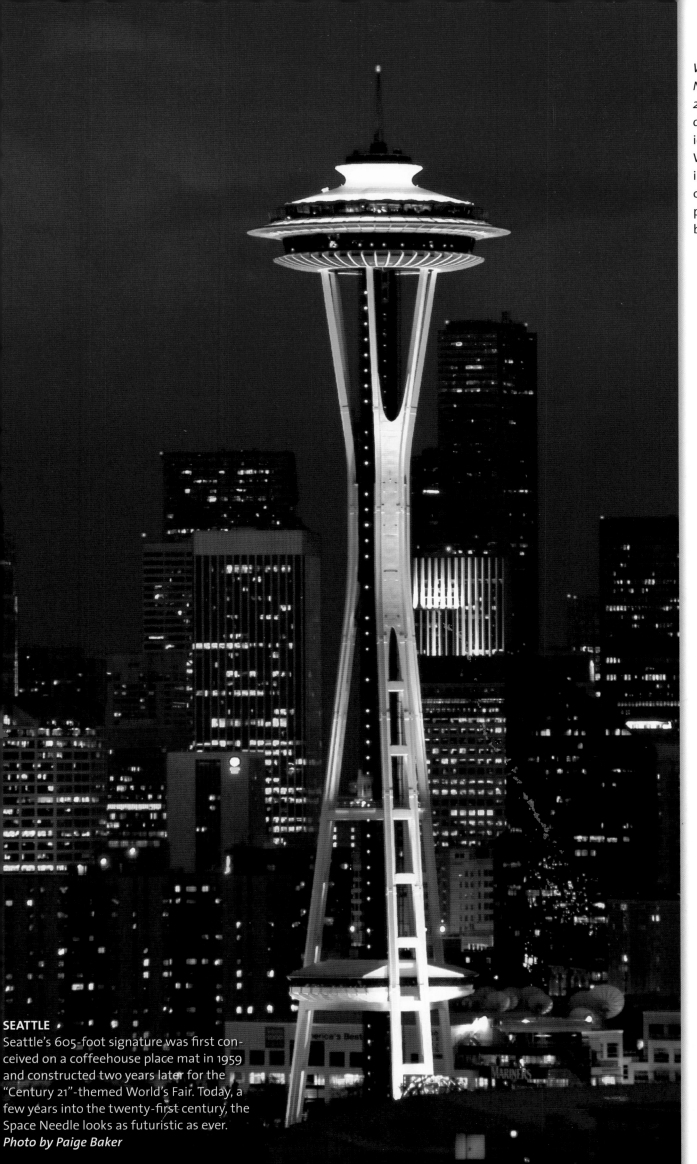

SEATTLE
Seattle's 605-foot signature was first conceived on a coffeehouse place mat in 1959 and constructed two years later for the "Century 21"-themed World's Fair. Today, a few years into the twenty-first century, the Space Needle looks as futuristic as ever.
Photo by Paige Baker

WITHDRAWN

Washington 24/7 is the sequel to *The New York Times* bestseller *America 24/7* shot by tens of thousands of digital photographers across America over the course of a single week. We would like to thank the following sponsors, the wonderful people of Washington, and the talented photojournalists who made this book possible.

Adobe

OLYMPUS

LEXAR *Media*

snapfish

jetBlue AIRWAYS

WEBWARE

Google

DIGITAL POND

ebaY

LONDON, NEW YORK, MUNICH, MELBOURNE, and DELHI

Created by Rick Smolan and David Elliot Cohen

24/7 Media, LLC
PO Box 1189
Sausalito, CA 94966-1189
www.america24-7.com

First Edition, 2004
04 05 06 07 08 10 9 8 7 6 5 4 3 2 1

Published in the United States by
DK Publishing, Inc.
375 Hudson Street
New York, NY 10014

DK Publishing, Inc. offers special discounts for bulk purchases for sales promo-
tions or premiums. Specific, large-quantity needs can be met with special
editions, personalized covers, excerpts of existing guides, and corporate
imprints. For more information, contact:

Special Markets Department
DK Publishing, Inc.
375 Hudson Street
New York, NY 10014
Fax: 212-689-5254

Cataloging-in-Publication data is available
from the Library of Congress
ISBN 0-7566-0088-x

Printed in the UK by Butler & Tanner Limited

First printing, October 2004

BREMERTON
Jammed together over eons by shifting
plates in the Pacific Ocean, the Olympic
Mountains rise nearly 8,000 feet above sea
level. In the foreground, the shipyard town
of Bremerton (pop. 37,259) nestles into the
Kitsap Peninsula.

WASHINGTON 24/7

24 Hours. 7 Days.
Extraordinary Images of
One Week in Washington.

Created by Rick Smolan and David Elliot Cohen

DK Publishing

About the America 24/7 Project

A hundred years hence, historians may pose questions such as: What was America like at the beginning of the third millennium? How did life change after 9/11 and the ensuing war on terrorism? How was America affected by its corporate scandals and the high-tech boom and bust? Could Americans still express themselves freely?

To address these questions, we created *America 24/7*, the largest collaborative photography event in history. We invited Americans to tell their stories with digital pictures. We asked them to shoot a visual memoir of their lives, families, and communities.

During one week in May 2003, more than 25,000 professionals and amateurs shot more than a million pictures. These images, sent to us via the Internet, compose a panoramic yet highly intimate view of Americans in celebration and sadness; in action and contemplation; at work, home, and school. The best of these photographs, more than 6,000, are collected in 51 volumes that make up the *America 24/7* series: the landmark national volume *America 24/7*, published to critical acclaim in 2003, and the 50 state books published in 2004.

Our decision to make *America 24/7* an all-digital project was prompted by the fact that in 2003 digital camera sales overtook film camera sales. This technological evolution allowed us to extend the project to a huge pool of photographers. We were thrilled by the response to our challenge and moved by the insight offered into American life. Sometimes, the amateurs outshot the pros—even the Pulitzer Prize winners.

The exuberant democracy of images visible throughout these books is a revelation. The message that emerges is that now, more than ever, America is a supersized idea. A dreamspace, where individuals and families from around the world are free to govern themselves, worship, read, and speak as they wish. Within its wide margins, the polyglot American nation manages to encompass an inexplicably complex yet workable whole. The pictures in this book are dedicated to that idea.

—*Rick Smolan and David Elliot Cohen*

American nightlight: More than a quarter of a billion people trace a nation with incandescence in this composite satellite photograph. *Photo by Craig Mayhew & Robert Simmon, NASA Goddard Flight Center/Visions of Tomorrow*

Evergreen

by Joel Connelly

In Washington State, we dream big dreams. It goes with a larger-than-life setting, sculpted by glacial ice and prehistoric floods, and with the boldness of its settlers. We've harnessed rivers: Grand Coulee Dam was touted as "The Biggest Thing on Earth" when cement was poured in the 1930s. The signature project of the New Deal, the dam would make 500,000 acres of desert bloom and power the manufacture of plutonium for nuclear weapons at Hanford. It also inundated one of the premier Native American fishing and gathering spots in North America.

We introduced Americans to the passenger jet: The moment was driven into the memory of a 6-year-old boy, this writer, whose parents had taken him to watch hydroplane races on Lake Washington in 1954. Out of nowhere, a Boeing 707 prototype thundered over the lake at low elevation. As 150,000 Seattleites raised their eyes, test pilot Tex Johnston dipped a wing...and suddenly barrel rolled the huge jet. The future had arrived.

In the late 1970s, childhood friends Bill Gates and Paul Allen moved their embryonic company Microsoft back to their native Puget Sound and brought computing to the masses. The future had arrived again.

Washington has status in the global economy, but we've also shown the will and foresight to hold on to what remains of our world-class natural environment.

A radical tradition lives here: Seattle was shut down in 1919 by a general labor strike. In the 1930s, FDR's political strategist James A. Farley, exasperated by the utopian socialism swelling among voters allied with the Washington Commonwealth Federation, spoke of an America consisting of "47 states and the Soviet Republic of Washington."

LEAVENWORTH
A spring storm shellacs Douglas firs in Stevens Pass along Highway 2. The scenic byway traverses the Cascade Mountains, following the Skykomish and Wenatchee rivers.
Photo by Blake Woken

Sixty years later, a World Trade Organization meeting brought thousands of peaceful protestors and a few hundred violent anarchists to downtown Seattle. Tear gas wafted through city streets. In future venues, globalization protesters gained the unwanted nickname "Seattle people."

Yet, the nation's consumer-protection laws would not exist without our longtime (1944 to 1980) Senator Warren Magnuson. He served side by side for 28 years with Senator Henry "Scoop" Jackson, twice a presidential candidate and author of the Clean Water Act and National Environmental Policy Act. Washington produced gentlemanly House Speaker Tom Foley and, in Governor Dan Evans, perhaps the Republican Party's greatest champion of preserving wilderness since Teddy Roosevelt.

We will always be a place where people begin life anew. Our population has doubled to 6 million since 1954. A million more folks are expected to settle in the Puget Sound basin by 2020. The state faces the challenge to keep diversifying while holding on to our quality of life. It's what makes the state a magnet.

Recently, three buddies and myself—all Washington natives—hauled backpacks to the remote McAllister Pass in the North Cascades. At sunset we scrambled to the summit of a nearby butte.

Ice-draped peaks of the "American Alps" surrounded us. No human creation was visible. Ah, wilderness!

A bottle of Walla Walla Valley cabernet appeared and was poured into Sierra Club cups, and metallic clinks marked our toast to the disappearing sun. One of us spoke for the group when he said, "I feel very much at home here."

Joel Connelly, *a Bellingham native, writes the "In the Northwest" column in the* Seattle Post-Intelligencer.

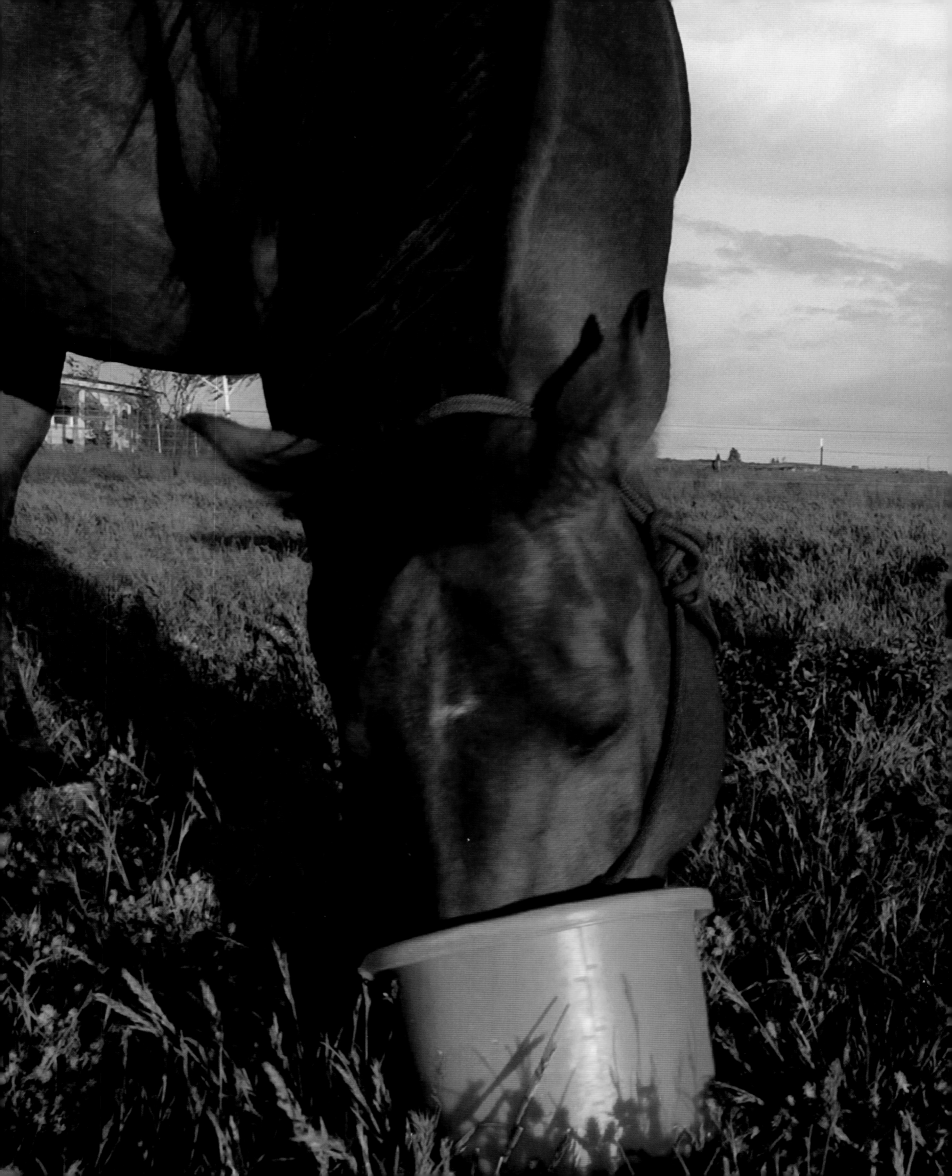

CRESTON
Dusty Roller gently handles a skittish 3-day-old foal while its mother Brownie snacks on some sweet grain. Roller's 640-acre ranch, 50 miles west of Spokane, consists mainly of scab rock. While it's not good for growing crops, it's perfect for cattle and horses.
Photo by Torsten Kjellstrand

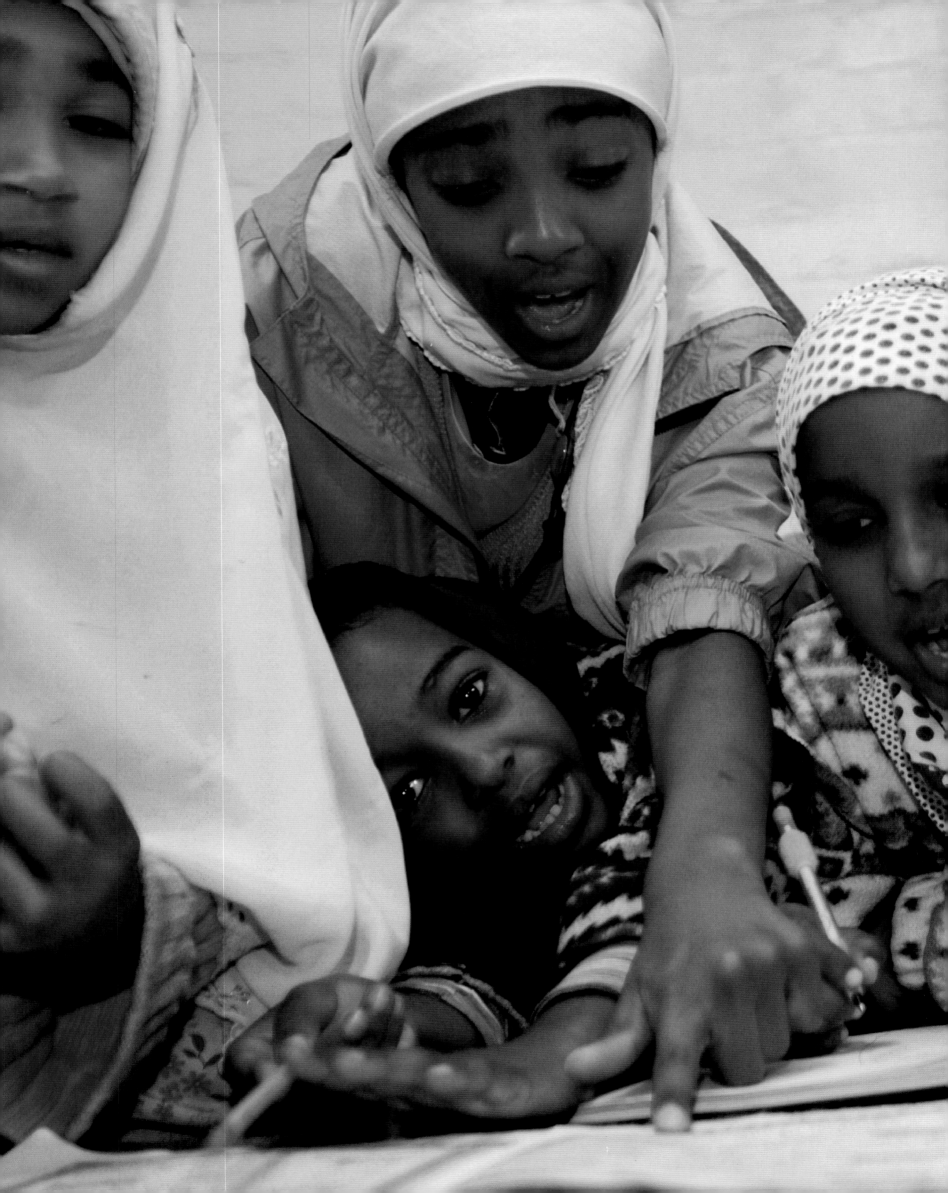

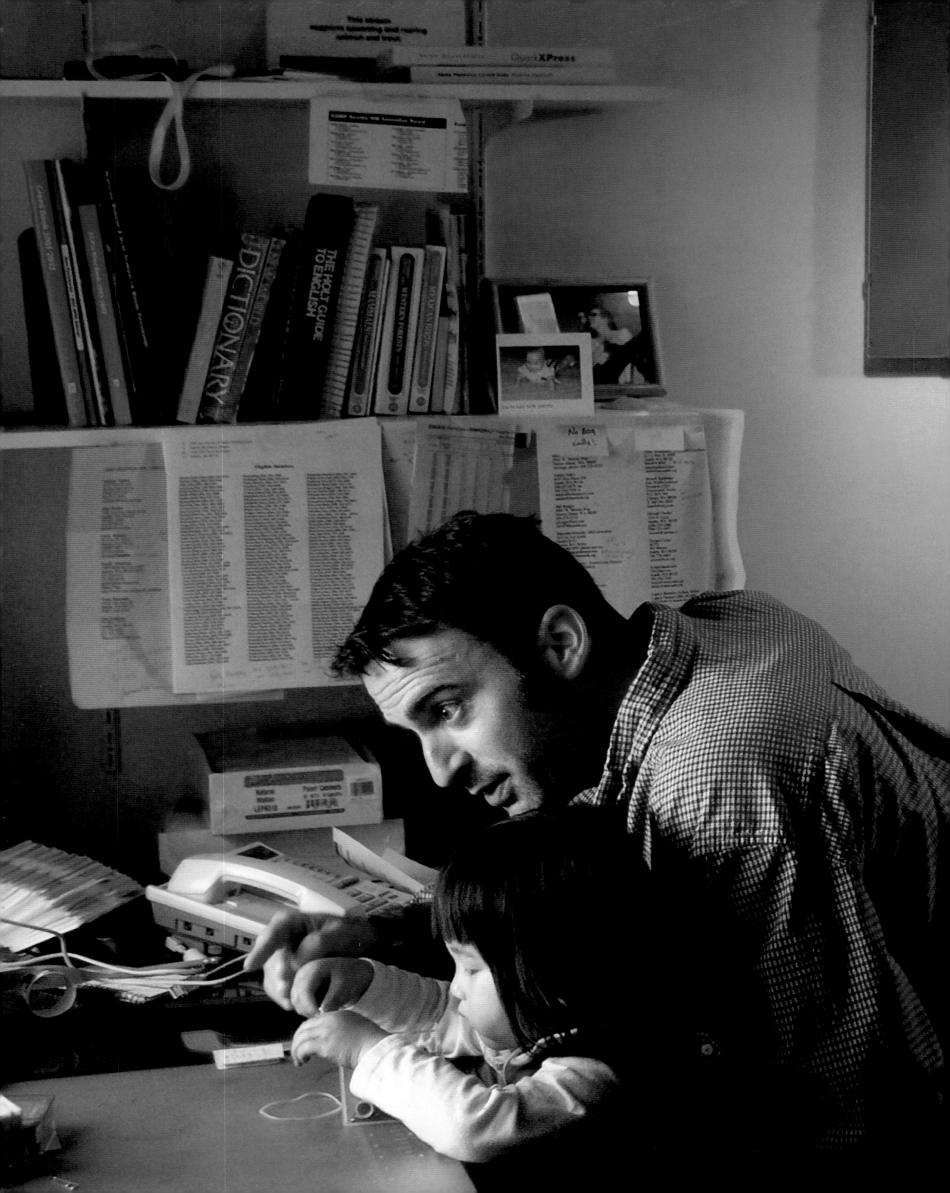

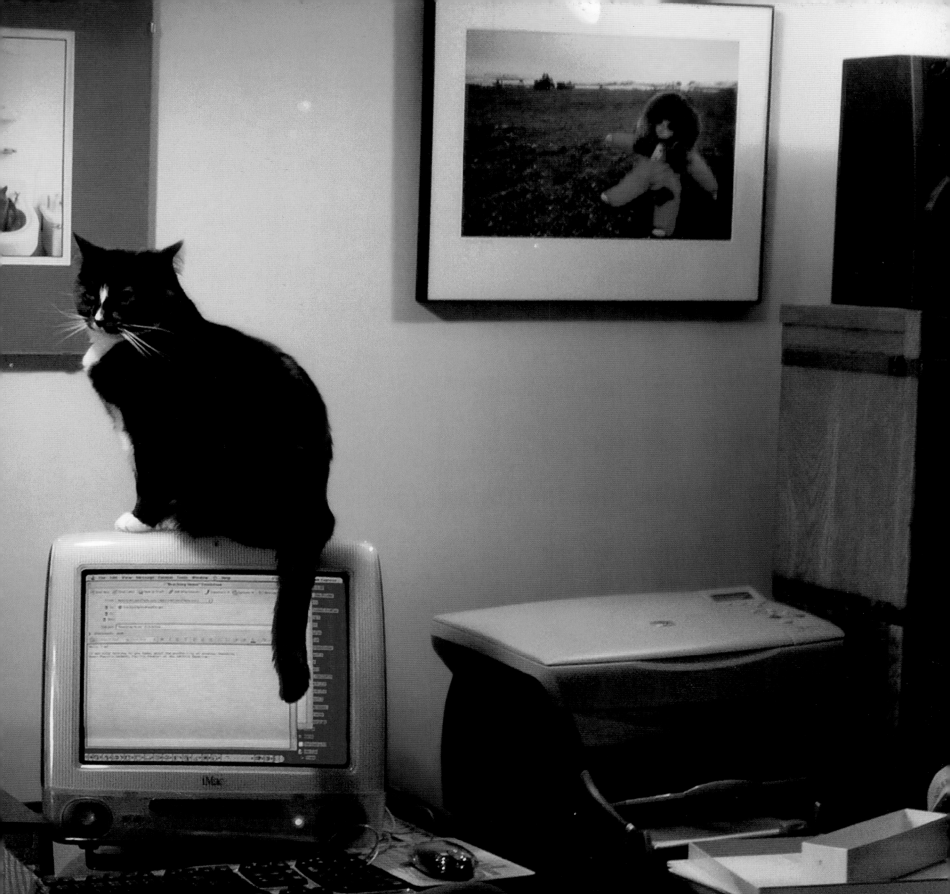

SEATTLE
Mike Hipple is more than an office manager for photographer Natalie Fobes. He's like a member of the family. Just ask her daughter Ginny Sunde, who often diverts him in her mom's home office. "Their friendship is wonderful, but I am paying him to work," says Fobes, half in jest.
Photo by Natalie Fobes

MEDINA
There are wealthy suburbs and then there is
Medina, whose residents include Bill Gates.
During late afternoons, Lake Washington
shimmers, while the narrow landmass of
Seattle fills most of the horizon.
Photo by Nathan P. Myhrvold

LUMMI INDIAN RESERVATION
Sisters Treena and LeAnne Humphreys
romp on the grassy shore near Gooseberry
Point. Fairhaven College photography stu-
dent Anya Traisman says her friends look at
this image whenever they need a lift.
Photo by Anya M. Traisman

Hearth & Home

EDMONDS

Kitchen rhythm: Karin Nes boogies with her mom Kristen. Edmonds, which bills itself as the "friendliest town on Puget Sound," is 18 miles north of Seattle.

Photo by Rika Manabe

CLINTON
Chamois has her monthly bath at A Special Touch
Grooming on Whidbey Island. In addition to dogs,
owner Debra Shirey pampers cats and rabbits.
Her strangest request so far? "I once shaved a
guinea pig," she says.
Photo by Rachel Olsson Photography

SEATTLE
After squirming and screaming her way through
a bath, Ginny Sunde finds cottony comfort in a
towel. "Bathing her once a week is our goal," says
mom Natalie. "Some weeks we even achieve it."
Photo by Natalie Fobes

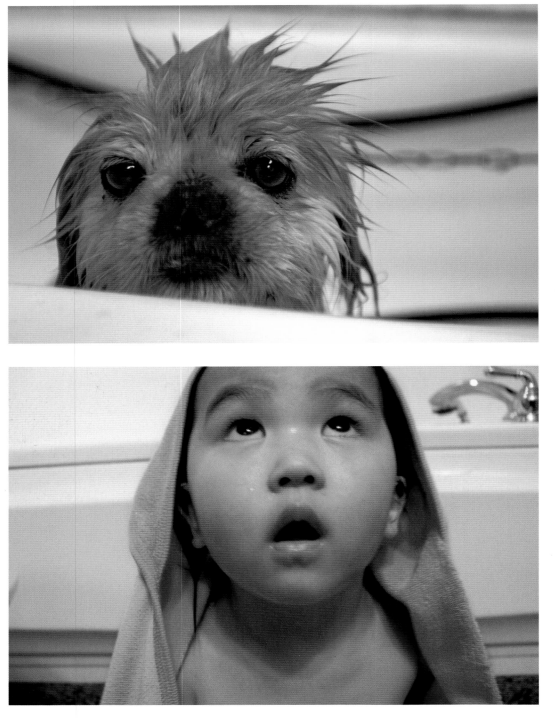

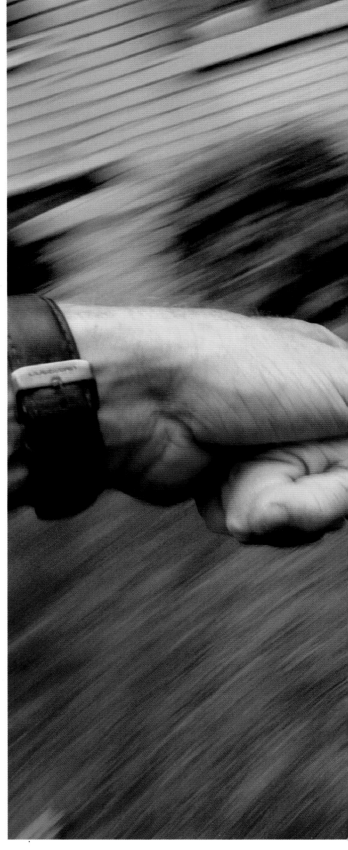

SPOKANE
Sam Dunlap gets a spin around the world from dad Brian while neighbor and photographer Colin Mulvany snaps the shot over Brian's shoulder.
Photo by Colin Mulvany

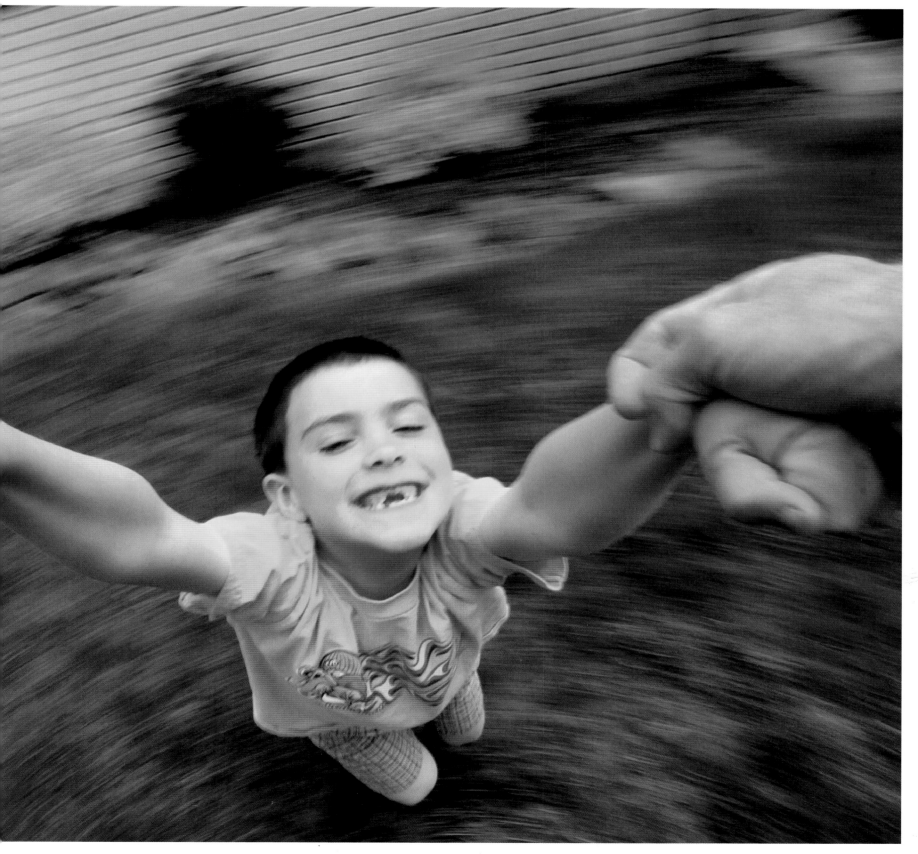

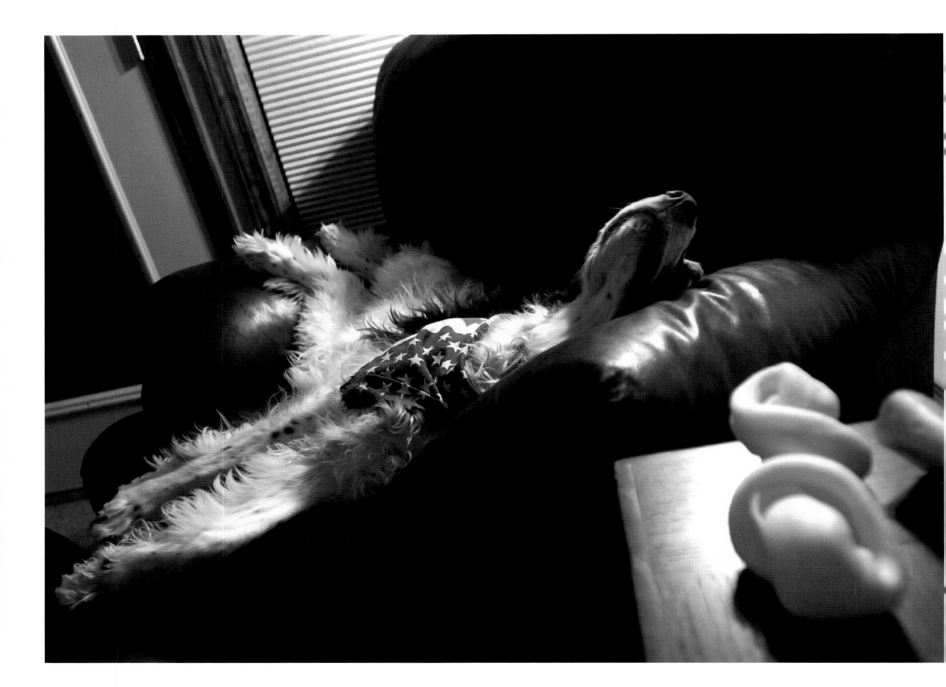

SPOKANE
Eleven-year-old Ping, an English springer spaniel, still wears the flea-repellent bandana that protected her during a long day chasing birds out on the Palouse. Photographer Christoper Anderson adopted Ping from the Spokane Humane Society.
Photo by Christopher Anderson,
The Spokesman-Review

SEATTLE

Breathing deeply, squatting deeply, eight months pregnant Rebecca Stoller practices yoga at the Seattle Holistic Center. The dancer turned psychologist says yoga helped a lot during pregnancy, but, apart from breathing exercises, was not much help in labor. After 10 hours, she had a cesarean section. Julian was born June 11, his mother's birthday.

Photo by Betty Udesen

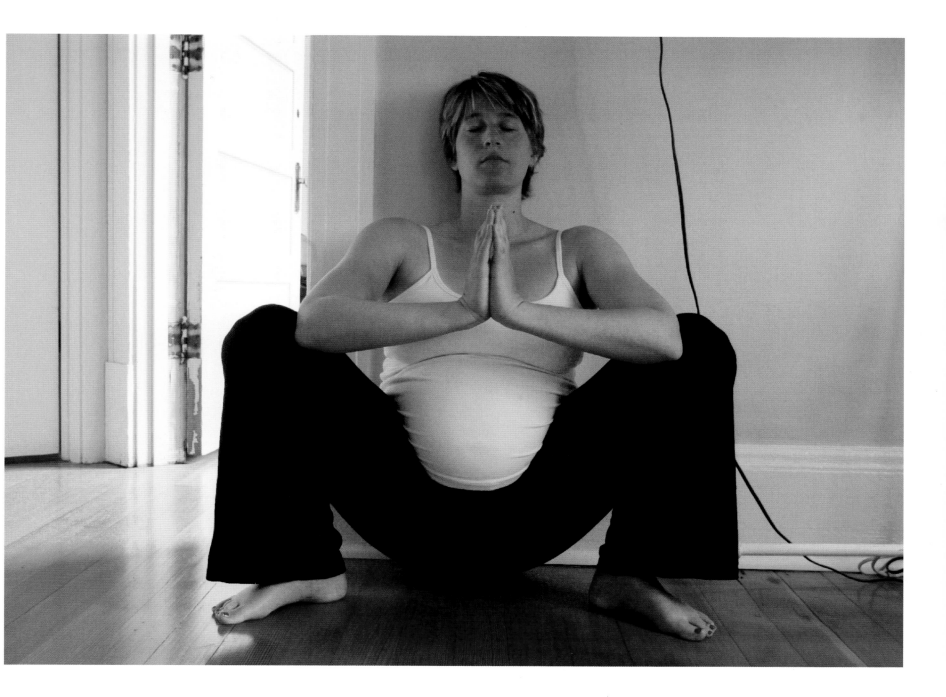

WENATCHEE
Strings attached: Alex Sweet got a kite for his fourth birthday but ran into a little trouble on a test flight at Walla Walla Point Park.
Photo by Don Seabrook

BREMERTON
After being stationed in Spain for three months to treat U.S. soldiers wounded in Iraq, 150 personnel from Naval Hospital Bremerton return home. Hospital Corpsman 3rd Class Ophael Myrtil gets a relieved welcome-home embrace from his girlfriend, Navy Hospitalman Christal Hernandez.
Photo by Carolyn J. Yaschur, The Sun

ORCAS ISLAND
Jimi Mudd and daughter Pearl pose for a picture in his front yard. The old boat was an eyesore, so Mudd and his brother painted it to honor Memorial Day in 2001.
Photo by Paul Kitagaki, Jr.

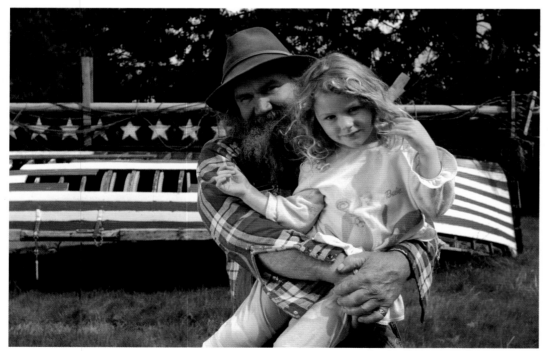

CLINTON

Some children invent imaginary friends. Sommer Harris and Athena Michaelides are real friends who created an imaginary home on Whidbey Island. Using found objects, the girls cook dinner, set the table, and even wash clothes in their faux abode under a cedar tree in Athena's backyard.
Photo by Rachel Olsson Photography

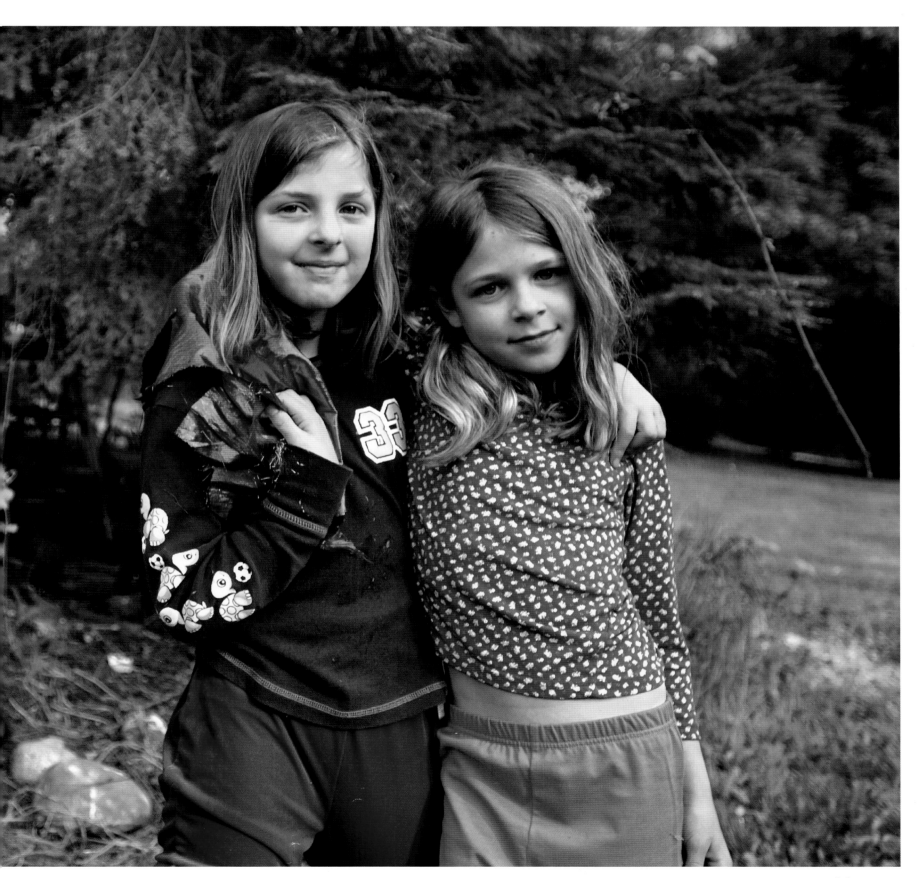

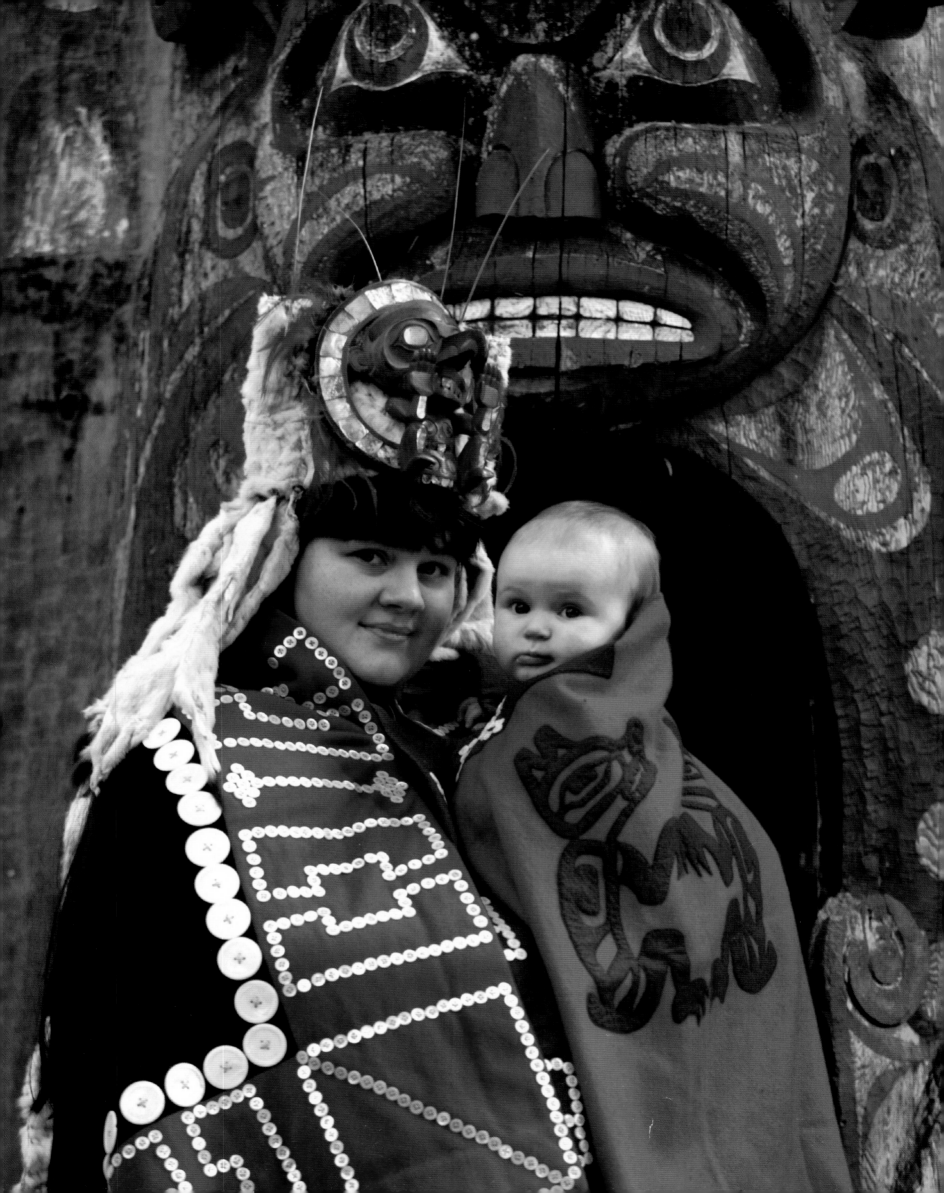

ARIEL

Mariah Stoll-Smith Reese and daughter Mara, both in Kwakwaka'wakw dress, pose before a tribal ceremonial house. Mostly Cherokee in blood lineage, the two are members of the Lelooska clan, which was adopted into the Kwakwaka'wakw tribe of the Pacific Northwest. The carved figure represents *sisiutl*, a lightning serpent in the tribe's tradition.

Photo by Brian Lanker,
Photo courtesy of Lelooska Foundation

WALLA WALLA

End of the trail. During the fall, winter, and spring, Dana Owens, 14, takes care of 18-year-old quarter horse Walker at a stable near her house. Walker spends summers working as a camp horse in Idaho.

Photo by Kirk Hirota

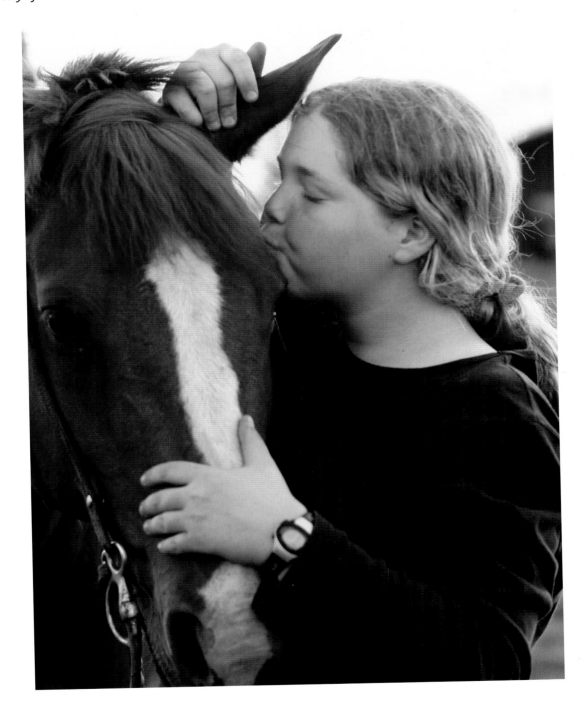

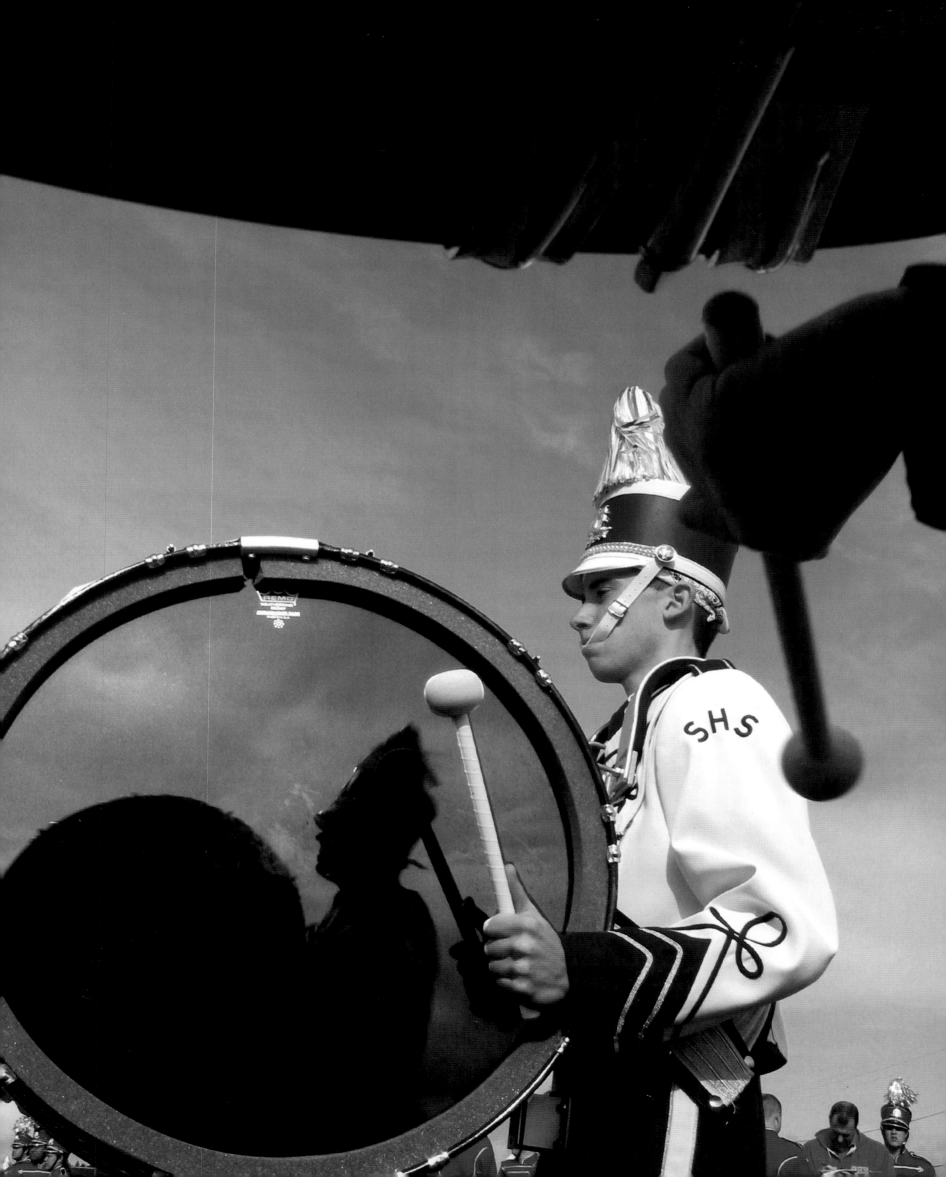

BREMERTON

Getting into the rhythm, Sultan High School drummer Hans Kleinman warms up with his band mates. The Sultans are about to march for 5 miles through the heart of Bremerton in the Armed Forces Day Parade. Twenty bands are competing for the top prize.

Photo by Larry Steagall, The Sun

BREMERTON

Oh, the price of beauty. Britney Eaton of Central Kitsap High School's color guard braves chilly glitter hair spray before her turn on the parade route.

Photo by Larry Steagall, The Sun

BREMERTON

The biggest Armed Forces Day parade in the country takes place in the home-town of Naval Station Bremerton, the Naval Hospital Bremerton, and the Puget Sound Naval Shipyard. Today marks Bremerton's 55th Armed Forces Day parade.

Photo by Carolyn J. Yaschur, The Sun

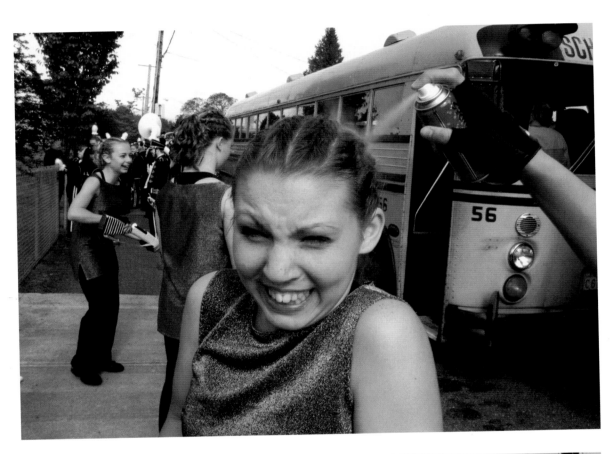

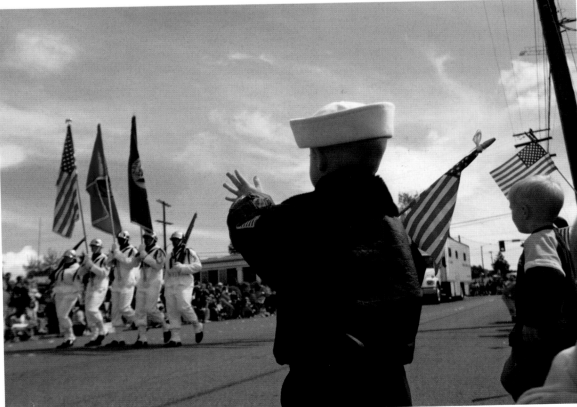

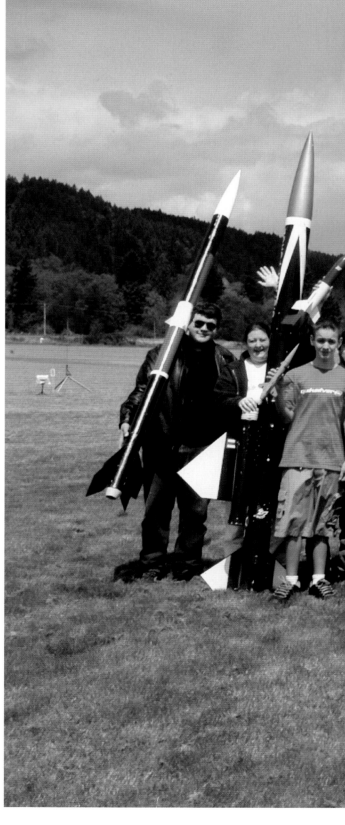

SEATTLE
After playing outside, the kids ride the elevator in the Providence Mount St. Vincent building up to the Intergenerational Learning Center. The child care program shares two floors with The Mount, a long-term care and assisted-living facility. The proximity encourages interaction between the kids and seniors, making The Mount more of a home than a nursing home.
Photo by Natalie Fobes

ORTING

High-powered rockets might be an endangered species. Their fuel has been restricted by the Department of Homeland Security, and launch sites are being scrutinized by the FAA. These members of the Washington Aerospace hobby rocketry club are working with Governor Gary Locke to find suitable launch locations.
Photo by Roger Ressmeyer, Visions of Tomorrow

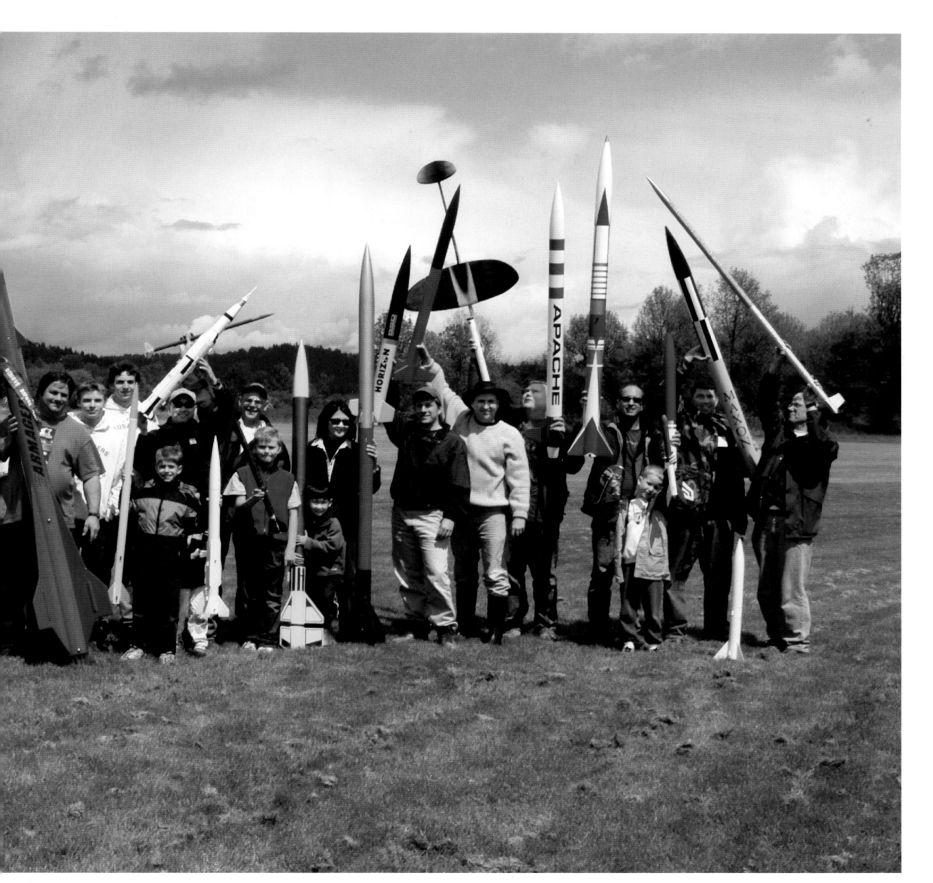

PORT ANGELES
The first annual Native American Day at Dry Creek Elementary School was a show-and-tell of salmon and storytellers, canoes and dancers. The K-5 school has about 20 percent Native children, most from the Lower Elwha Klallam tribe. Melaine Wheeler (Klallam and Nez Perce tribes) and Chuck Fryberg (Tulalip tribe) take a break from their demonstration of Plains dancing.
Photo by Joanna B. Pinneo, Aurora

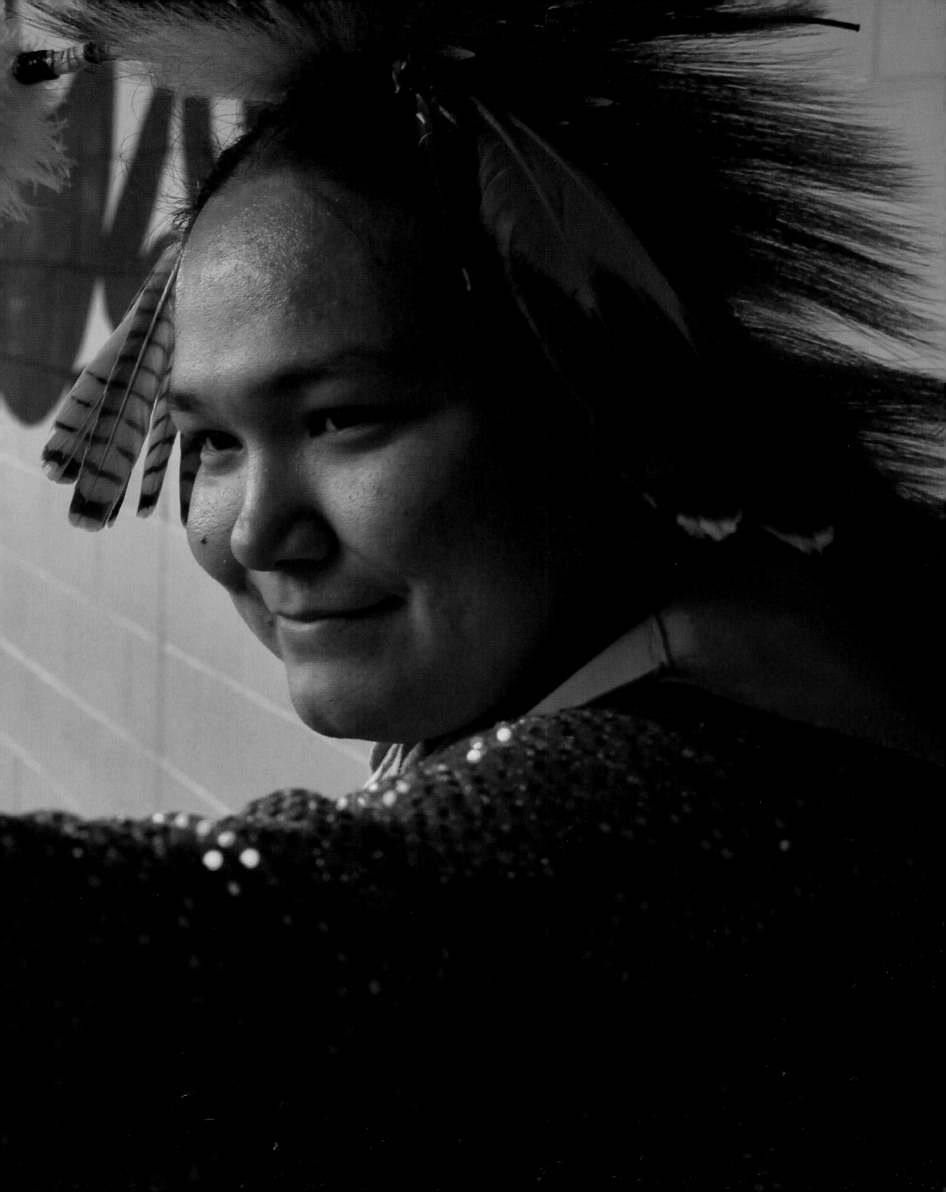

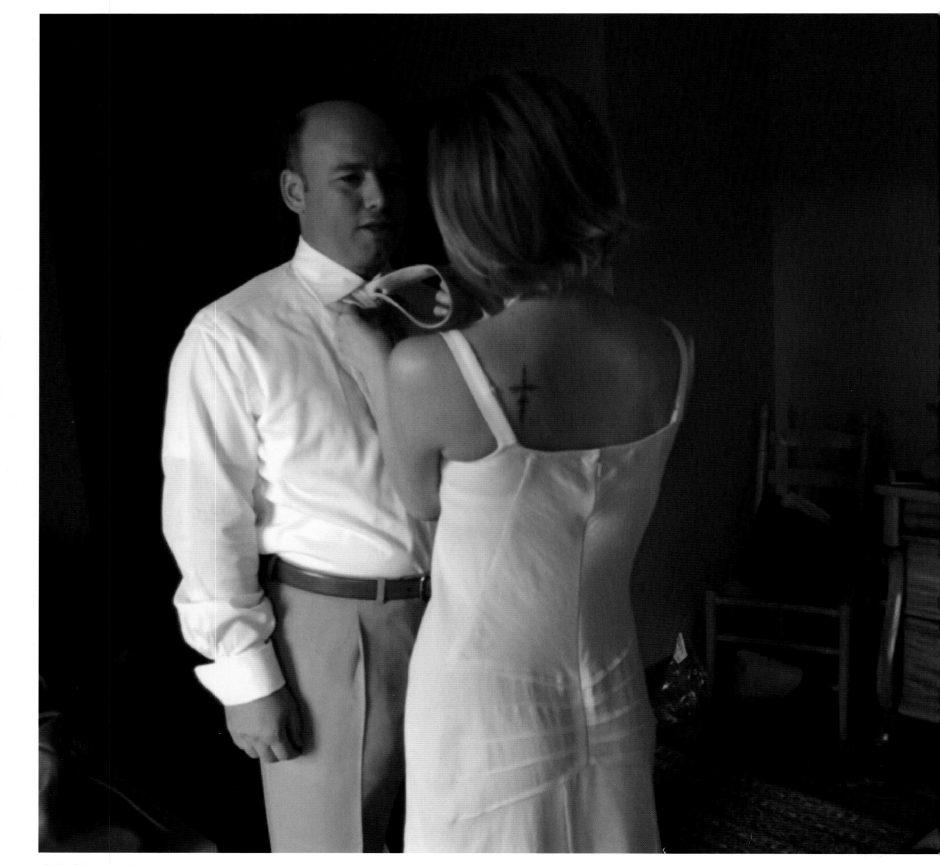

ORCAS ISLAND

Susheela Hoefer ties Michael Teather's necktie in their room at the Turtleback Inn just before their wedding. "She doesn't like the way I do it," says Teather, whose brother Ted reflects on the effort. The small ceremony was officiated by Hoefer's father, a Lutheran minister.
Photo by Paul Kitagaki, Jr.

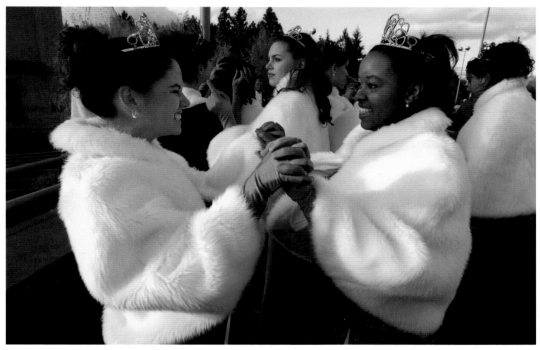

SPOKANE

High school seniors Ali Clark and Ciera Beard of the Lilac Festival's Royalty Court prepare for the annual Armed Forces Torchlight Parade. The Spokane Lilac Society (Spokane calls itself "Lilac City") and Fairchild Air Force Base cosponsor the festival.
Photo by Colin Mulvany

SEATTLE

At Zerene Salon, Adrienne Thompson checks out her wedding-day hairstyle with friend Leslie Boyd and salon co-owner Valerie Zook. Why come in a month before the big day? "There's too much pressure," says Zook. "That's why we require a wedding practice."
Photo by Natalie Fobes

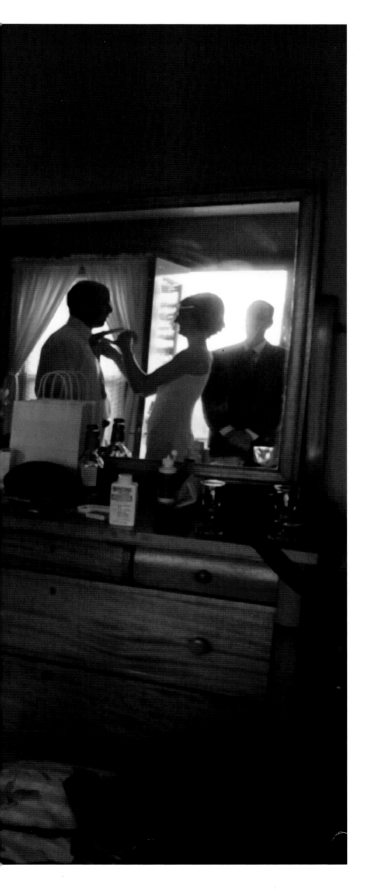

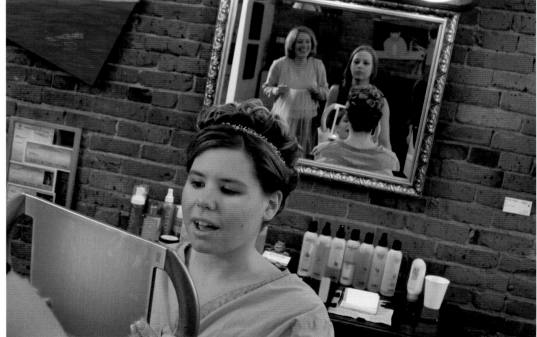

PORT ANGELES

It was the first time stylist Teia Stitzel of Hair Connections Salon had worked on a transgendered person, and the first time Robin had been made up and coiffed as a woman. "It made her feel so good," Stitzel said. Robin was attending the Esprit Convention, which welcomes people in varying stages of gender transition.

Photos by Joanna B. Pinneo, Aurora

PORT ANGELES

Among the attendees at the convention, Tracy Ann Whalen of Oregon (center) is a postoperative transsexual and a woman 24/7, as she puts it. Her grown children and the steel company for which she negotiates freight rates have accepted her transformation.

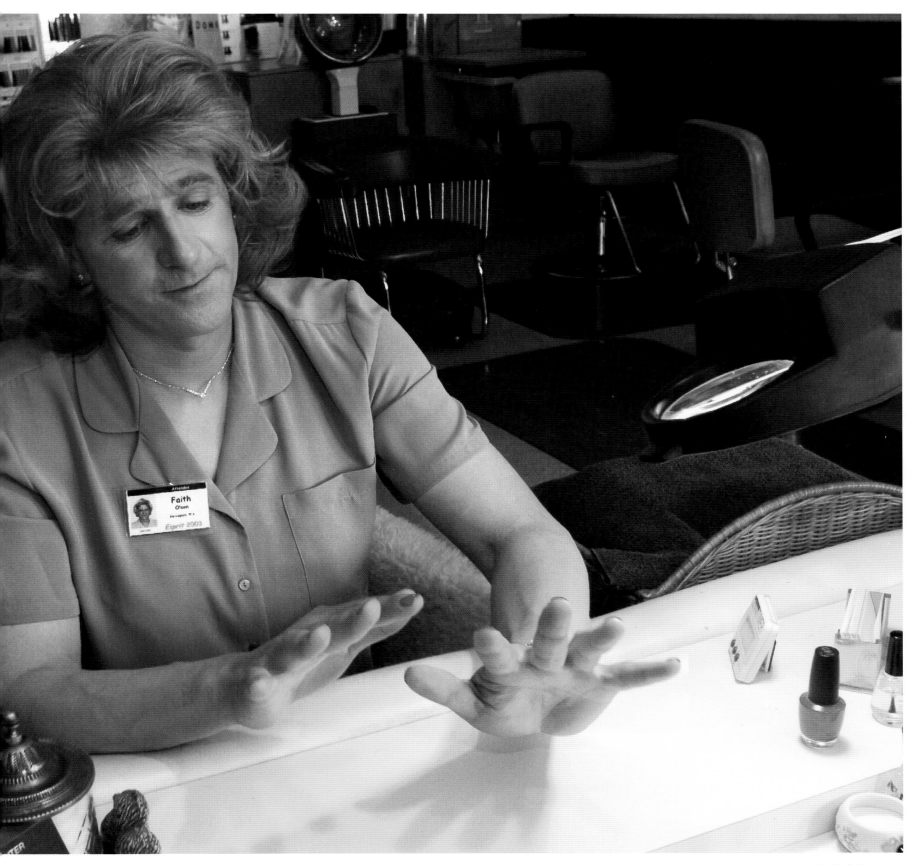

PORT ANGELES

"It was an epiphany," says Faith Olson about the Esprit Convention. At age 46, Faith (whose wife accompanied her to the convention) has begun her exploration of life as a woman, including taking female hormones. She still works at Inland Power and Light but no longer as a heavy equipment operator. "Gosh, no! Too hard on my nails!"

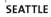

SEATTLE

At the studio of the internationally known glass artist Dale Chihuly, hotshop gaffer Joey DeCamp decides which pieces to use for a chandelier project. As hotshop gaffer, DeCamp is the studio's master craftsman, in charge of its team of hot glass workers.
Photos by Nathan P. Myhrvold

SEATTLE

Chihuly converted a building on Lake Union into his studio and home. A reception area, called the Indian Room, displays his Native American art collections, including a wall of trade blankets and a 1914 Indian brand motorcycle.

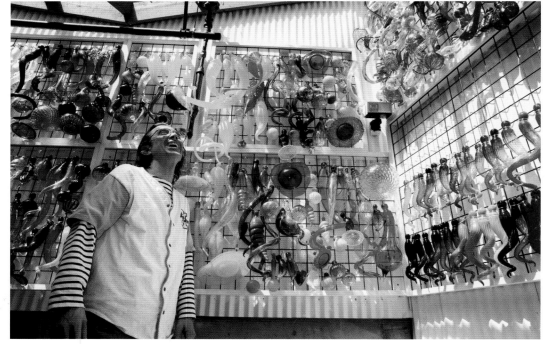

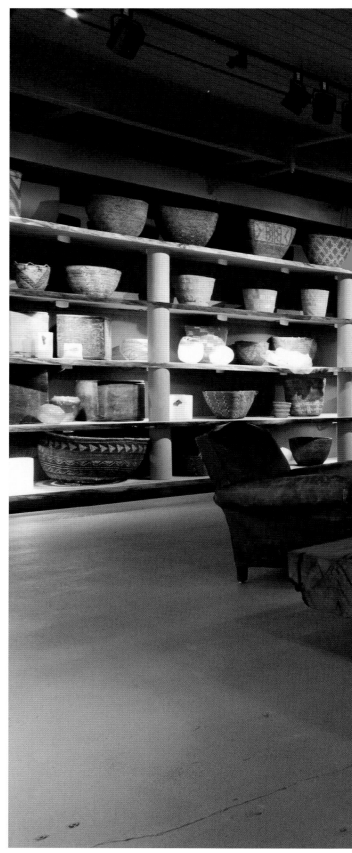

SEATTLE

This table in the Indian Room is a 1,100-year-old slice of Douglas fir. Shelves to the left display Chihuly's collection of Northwest Coast baskets; the wall to the right lines up photogravures of Native Americans by famed photographer Edward S. Curtis.

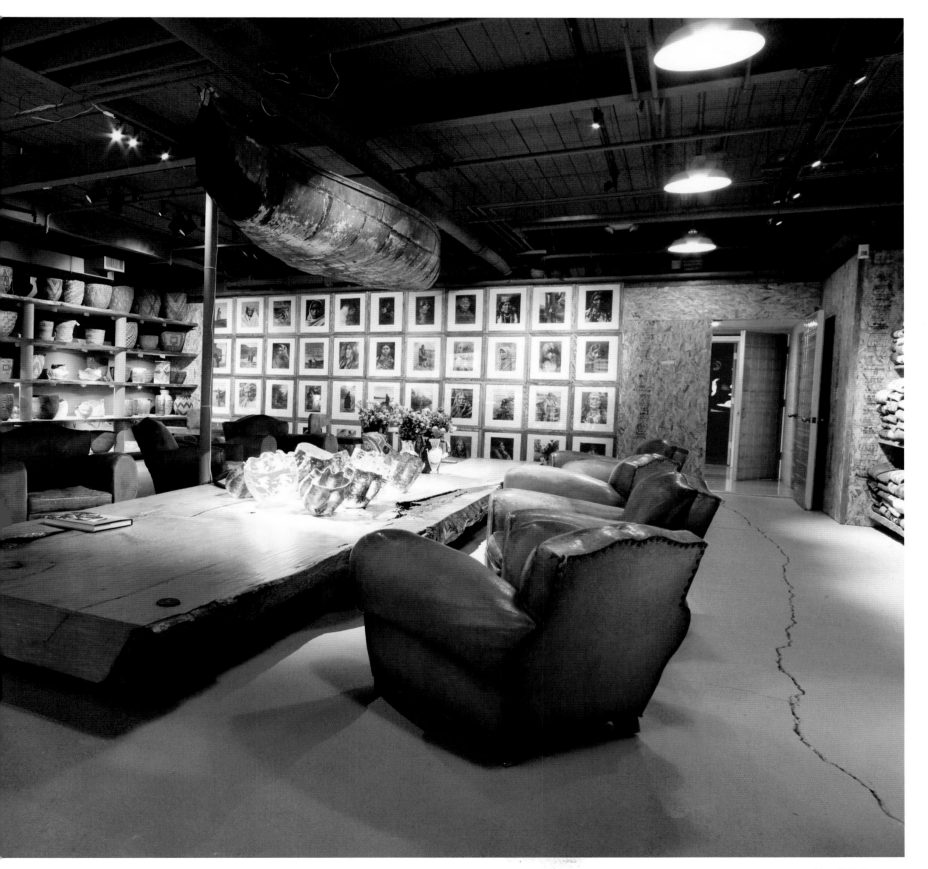

The year 2003 marked a turning point in the history of photography: It was the first year that digital cameras outsold film cameras. To celebrate this unprecedented sea change, the *America 24/7* project invited amateur photographers—along with students and professionals—to shoot and, via the Internet, submit digital images. Think of it as audience participation. Their visions of community are interspersed with the professional frames throughout this book. On the following four pages, however, we present a gallery produced exclusively by amateur photographers.

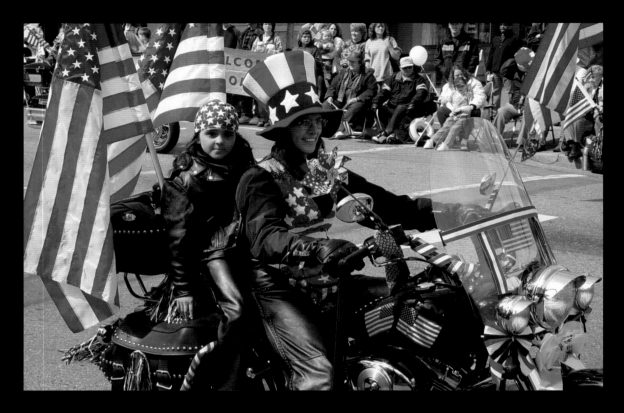

BREMERTON The Armed Forces Day parade in Bremerton brings out a mother-daughter team in stars, stripes, and leather. *Photo by Pat Newsome*

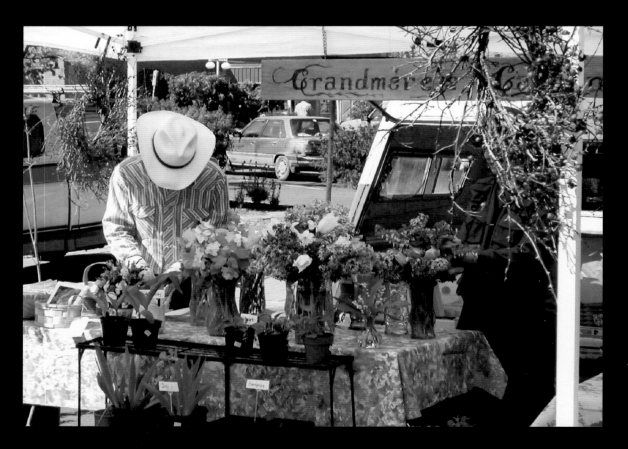

YAKIMA With sunny weather and volcanic soil, the area around Yakima yields a rich variety of flowers and produce, on display at the weekly farmers' market. *Photo by Joan Wildman*

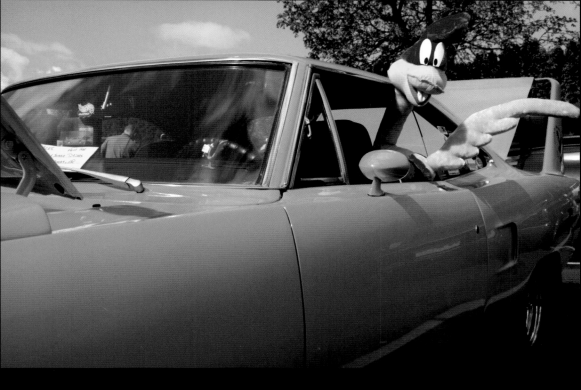

CAMAS Beep beep! This souped-up 1970 Plymouth Super Bird preens at a Sunday hot-rod gathering in a dealer's lot just across the Columbia River from Portland, Oregon. *Photo by Mike Hanson*

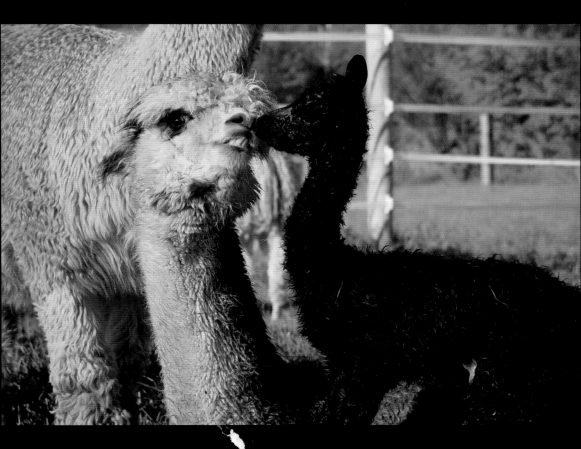

NACHES Born just minutes before, Ebony Star greets his mother, Peppermint Patty. The birth occurred at the DiamondStar Alpacas ranch in the eastern foothills of the Cascade Mountains. *Photo by Kathryn Riebe*

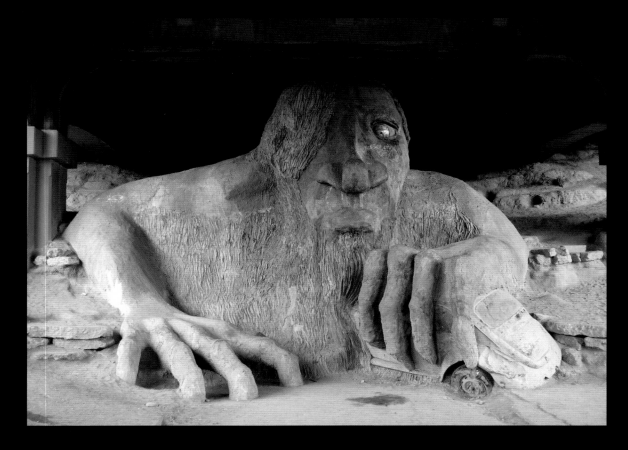

SEATTLE Like the Man from Mars, the Fremont Troll—commissioned by the Fremont Arts Council and carved in 1990 by local artists Steve Badanes, Will Martin, Donna Walter, and Ross Whitehead—has a penchant for eating cars. *Photo by Doug Rowan*

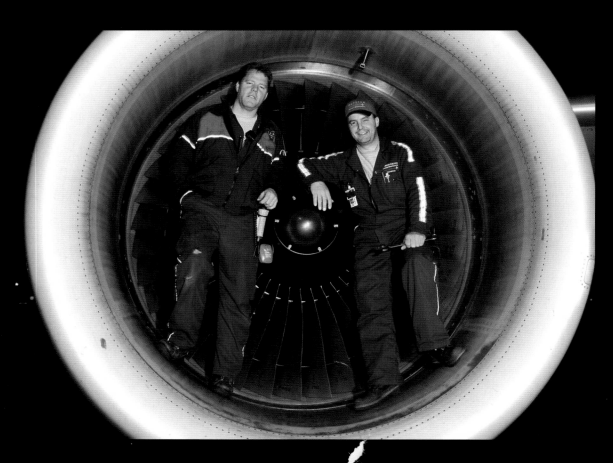

SEATAC At Sea-Tac International, veteran maintenance techs Cary Gaffney and Donald Eddy strike a pose inside a 757's engine cowling. *Photo by Rocky Ross*

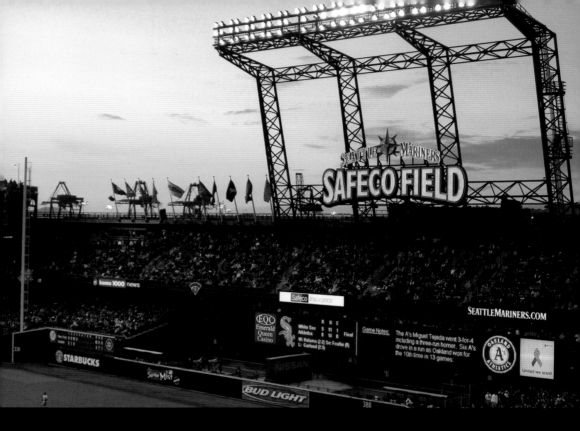

SEATTLE The Seattle skyline and sunsets over Puget Sound: In 2002, fans got views of both from four-year-old Safeco Field, along with a third straight season of 90-plus wins. *Photo by eLisa Teague*

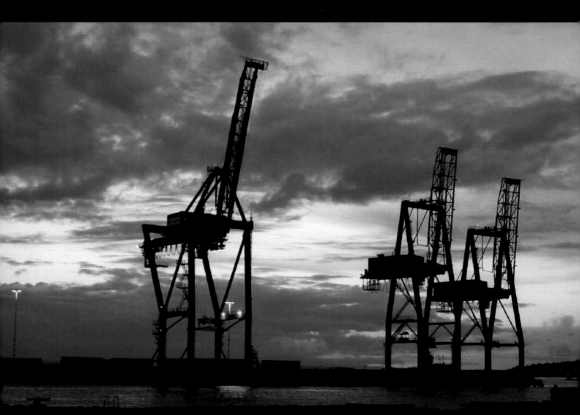

PORT OF SEATTLE Giraffe-like cranes load and offload 1.5 million shipping containers annually at Seattle's port. These three, up to 200 feet tall, are among the port's shorter cranes. *Photo by Amy Hsieh*

REDMOND
Peter Devery, Microsoft's public relations manager for the United Kingdom, test drives an experimental computer monitor at the company's Center for Information Work. The center displays product prototypes that might be available to the public in three to five years.
Photo by Stuart W. Conway

Hard At Work

SEATTLE

In the late 1960s, Pike Place Market, the funky old (circa 1907) waterfront warren of shops occupied by fishmongers, grocers, and butchers, was slated for demolition. Developers wanted to replace it with a hotel and apartment complex. Seattleites reacted quickly, passing a law to protect the entire market district.

Photo by Rick Wong

SEATTLE

She's got legs: She's also got berry jam, tea cookies, and salmon paté. Marcia Prunty of Biringer's Farm Fresh at Pike Place Market readies the shop for the throngs. The farm is located in Everett, where it produces summertime fruits—strawberries, raspberries, and tayberries—and autumn pumpkins.

Photo by Alan Berner

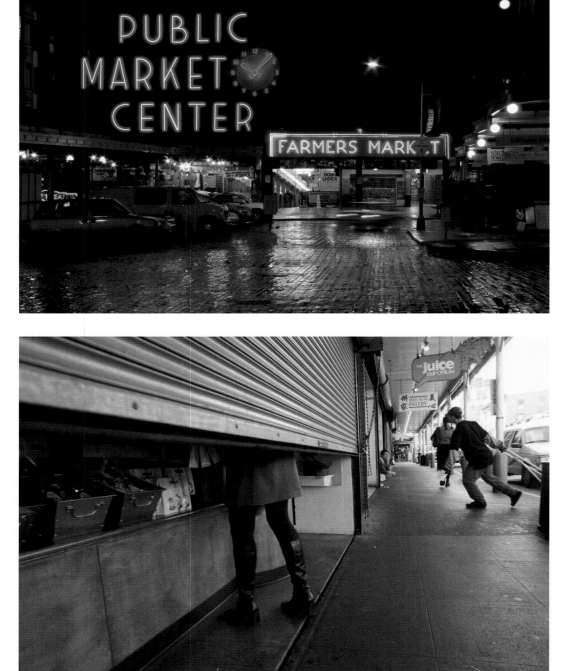

SEATTLE

Aspiring wide receiver Jaison Scott, 30, entertains tourists at the Pike Place Fish Company. When he was 9, his mother got a job at the fish market and put him to work shoveling ice. Substitute footballs include salmon, crab, monkfish, and lobster. "It's fun to throw fish," he says. "It's a big shop so tossing them is more e*fish*ent."

Photo by Alan Berner

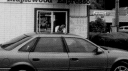

RENTON

Jessica Waltman at Maplewood Espresso makes sure her customers are fueled up for their morning commutes on 405. The most popular drink order? The 16-ounce vanilla latte.
Photo by Randy S. Corbin

MERCER ISLAND

Friends since second grade, baristas Breanna Murphy and Avery Menzies keep commuters caffeinated. Located on posh, suburban Mercer Island, the drive-through coffee stop is one of the state's busiest Starbucks.
Photo by Roger Ressmeyer, Visions of Tomorrow

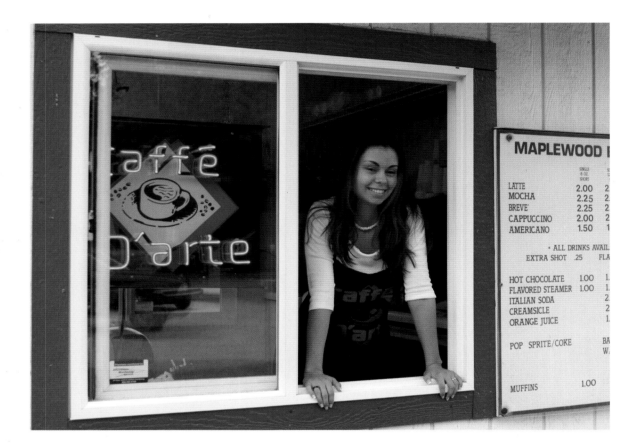

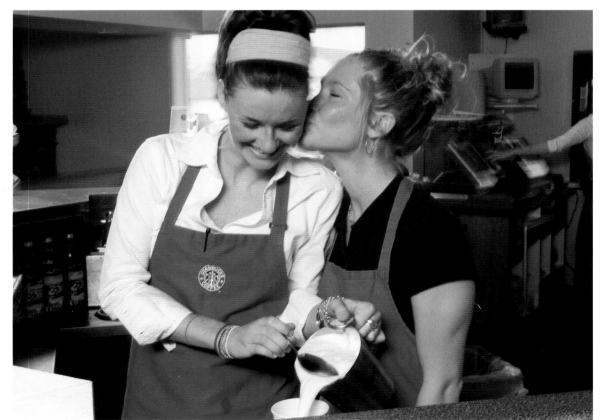

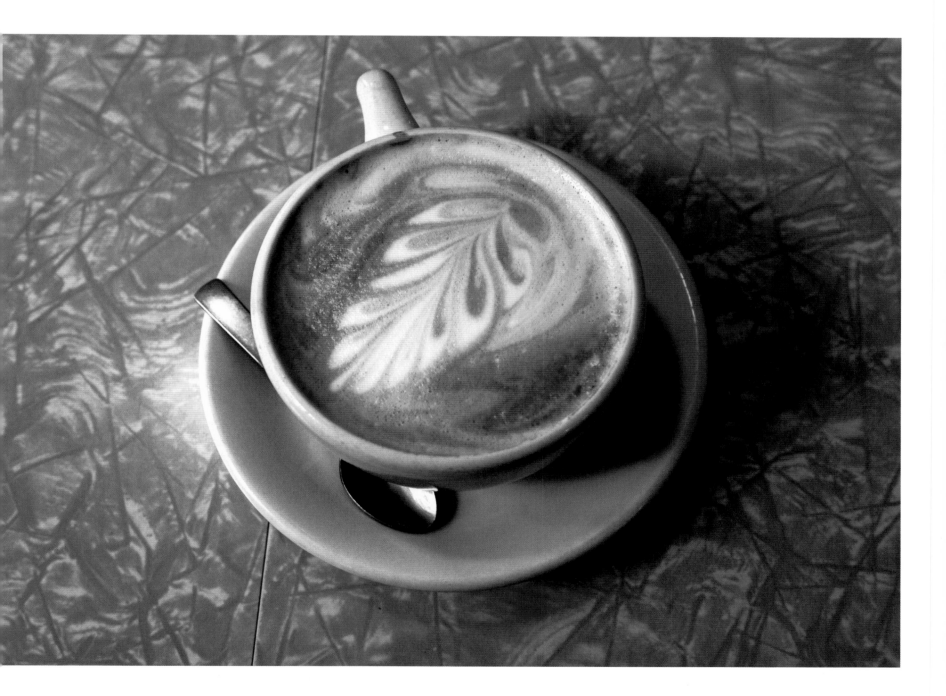

SEATTLE

Espresso Vivace Roasteria, located in the Capitol Hill area, sells a $2.50 work of art: a cappuccino featuring Vivace's trademark rosetta. Explaining precisely how to pour the foam pattern—puncturing the big bubbles, tilting the cup, shaking a wrist, zigzagging the pitcher—takes far longer than the actual pouring.

Photo by Nathan P. Myhrvold

SEATTLE
Dogs love trucks. Clients of Fetch, a pet store and doggie day care, wait patiently in the company's Ford pickup. Co-owners Marie Emery and Shellie Sarff round up the rest of their 20 charges after an hour at Blue Dog Pond. As long as the humans are around, the pooches get along. "They know we're the alpha dogs," says Sarff.
Photo by Alan Berner

DUSTY

Chad Lindgren and daughter Hally pull in at Flying Five Big Bend Rodeo Company to pick up a load of horses. Lindgren, his wife Sally, and Hally travel 5,000 miles every summer, transporting bucking broncos to rodeos throughout the West.
Photos by Colin Mulvany

DUSTY

Born to buck: Rodeo contractor Sonny Riley sorts bucking horses headed to their first rodeo. Good bucking stock has draft-horse blood in its lineage —bigger bodies and feet give the horses better balance for kicking up their heels.

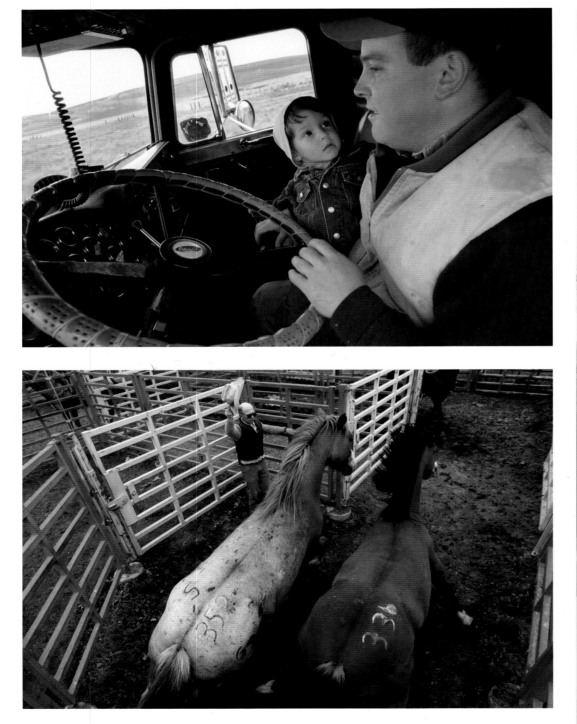

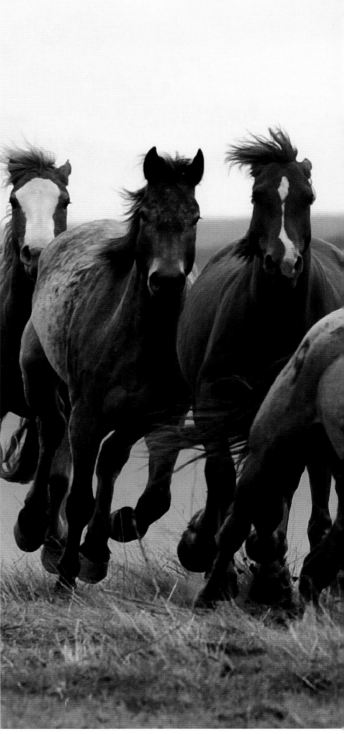

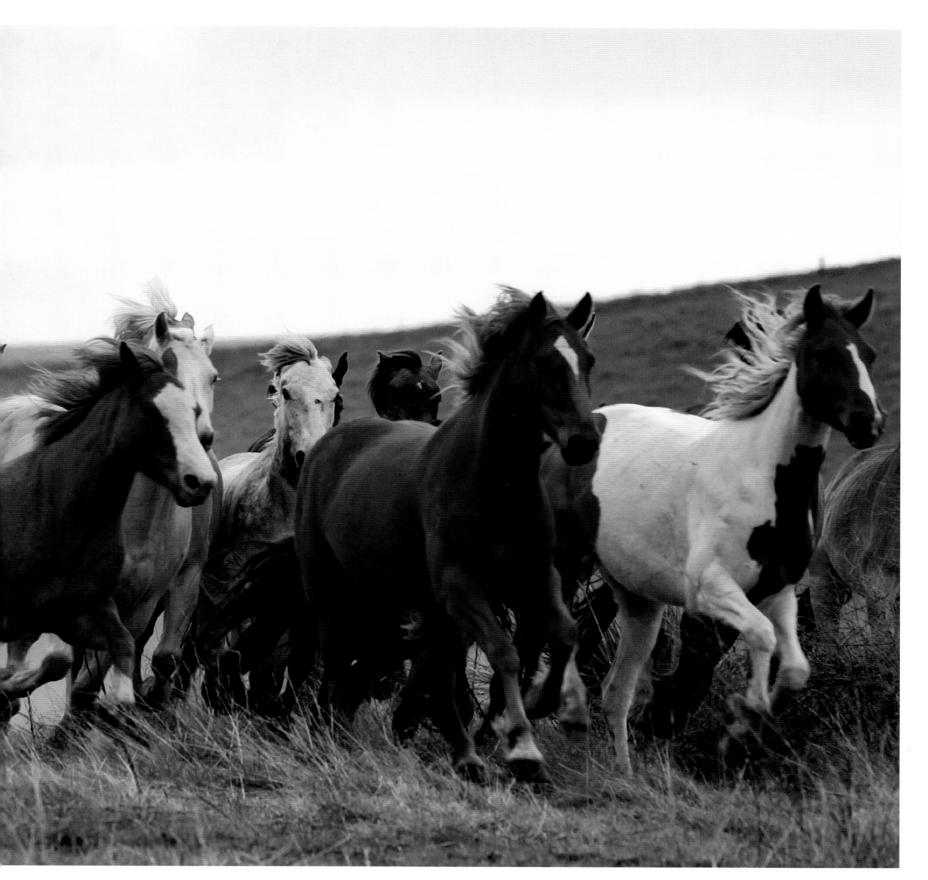

DUSTY

If a horse qualifies to be a bronco, it will spend the summers trailering from rodeo to rodeo and bucking off pesky humans. The rest of the year is spent on the range kicking back.

CRESTON

Dusty Roller, 25, grew up in the sagebrush drylands of Lincoln County. In 1999, he and his wife began raising beef cattle and quarter horses (like brood mare Blue) on their own ranch. To bolster their income, Roller also shoes and trains horses, teaches riding, works cattle roundups for other ranchers, and lends muscle at livestock auctions.
Photo by Torsten Kjellstrand

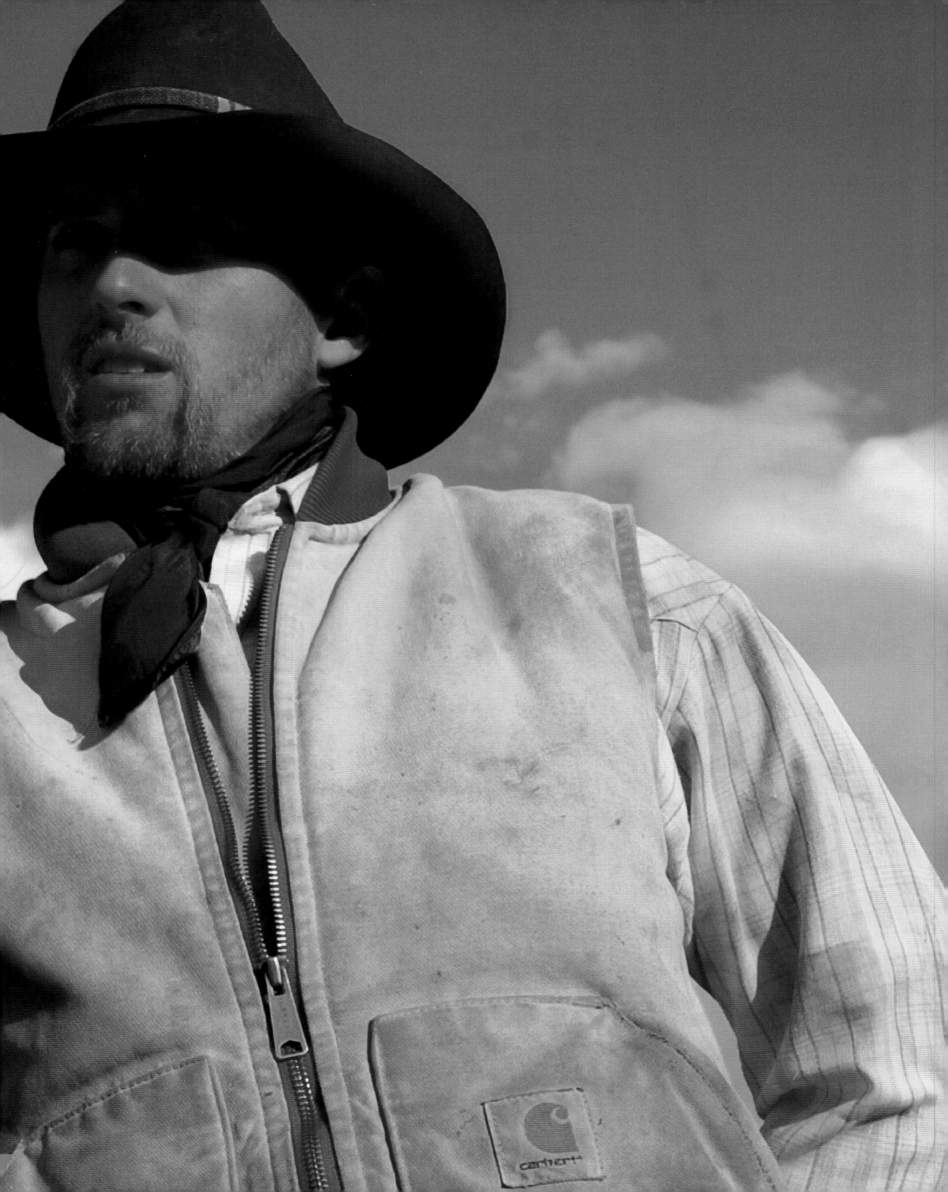

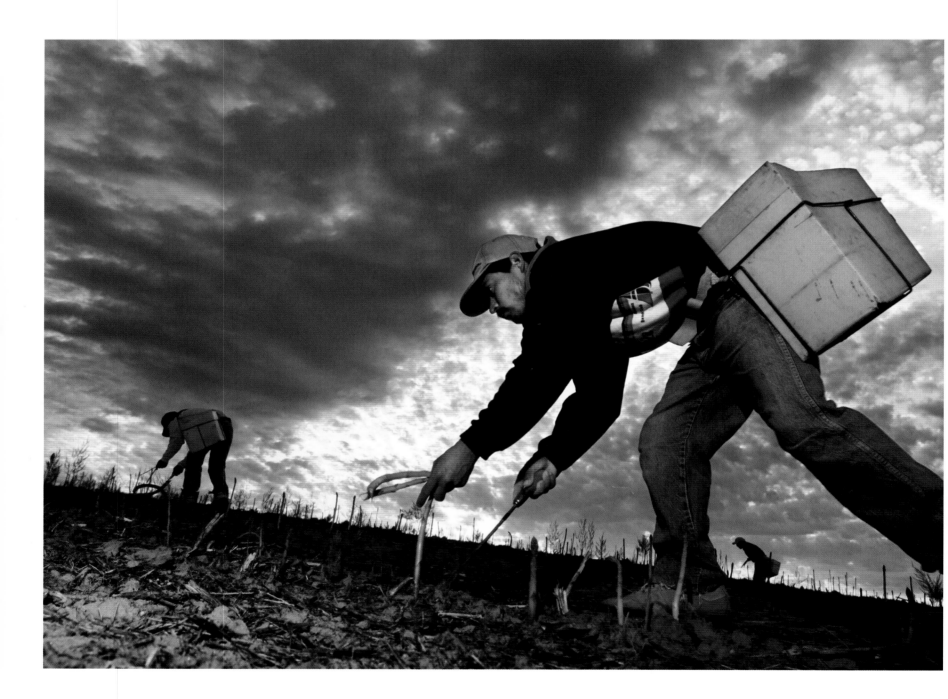

WALLA WALLA

In the asparagus fields of eastern Washington, an economic cycle turns within an agricultural one. Immigrant laborers, like Leonero Lopez, bend to the harvest, while growers worry about a flood of cheap asparagus from Peru—a result of U.S. incentives to Peruvian farmers to produce vegetables instead of opium and coca.
Photo by Kirk Hirota

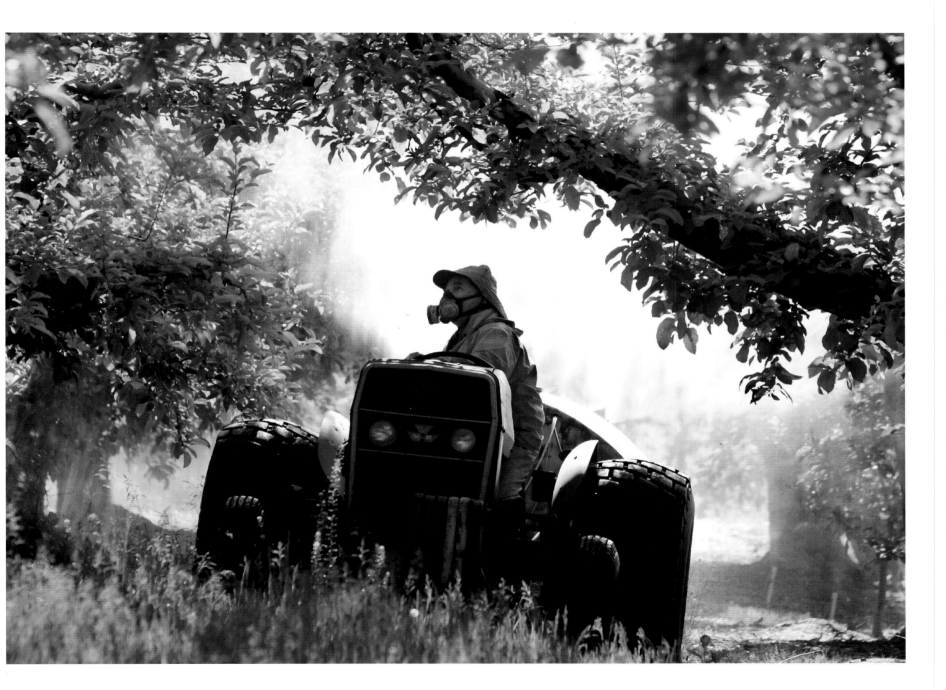

ROCK ISLAND

Bigger is better: Charlie Lewis sprays his Golden Delicious apple trees with insecticides to thin out the crop, allowing the remaining fruit to flourish. Lewis has been growing apples in the Wenatchee Valley, the self-proclaimed apple capital of the world, for 30 years.

Photo by Don Seabrook

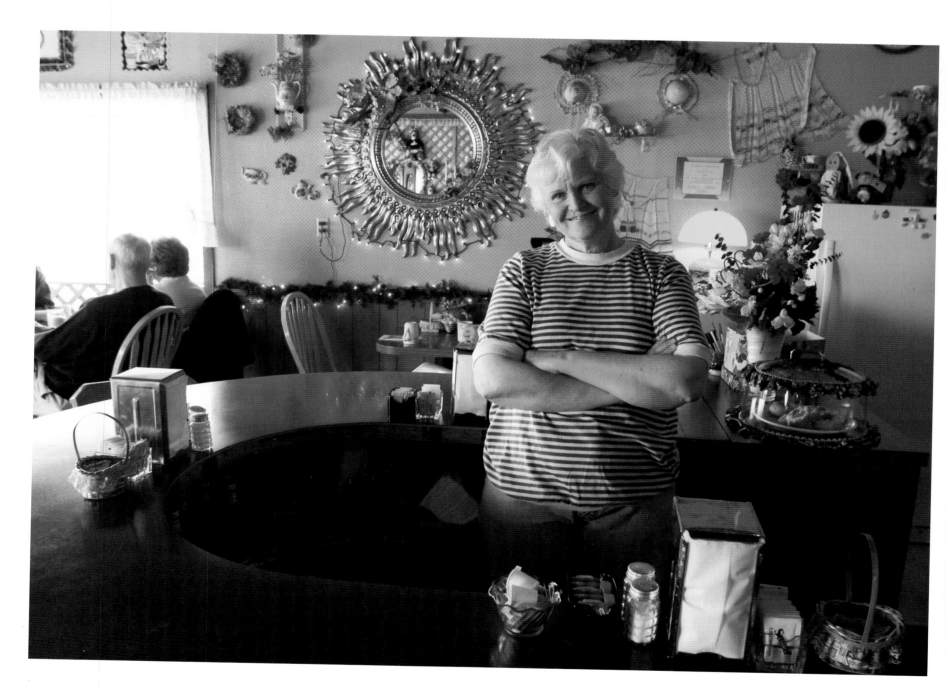

PORT ANGELES

"It makes us a living," says Gloria Coburn of Coburn's Cafe, which she owns with daughter Darla and grandson Ryan. The walls display her grandmother's aprons as well as decorations from other restaurants she's owned. Word of mouth fills the neighborhood cafe's 32 seats— that and Coburn's omelets and homemade pies.
Photo by Joanna B. Pinneo, Aurora

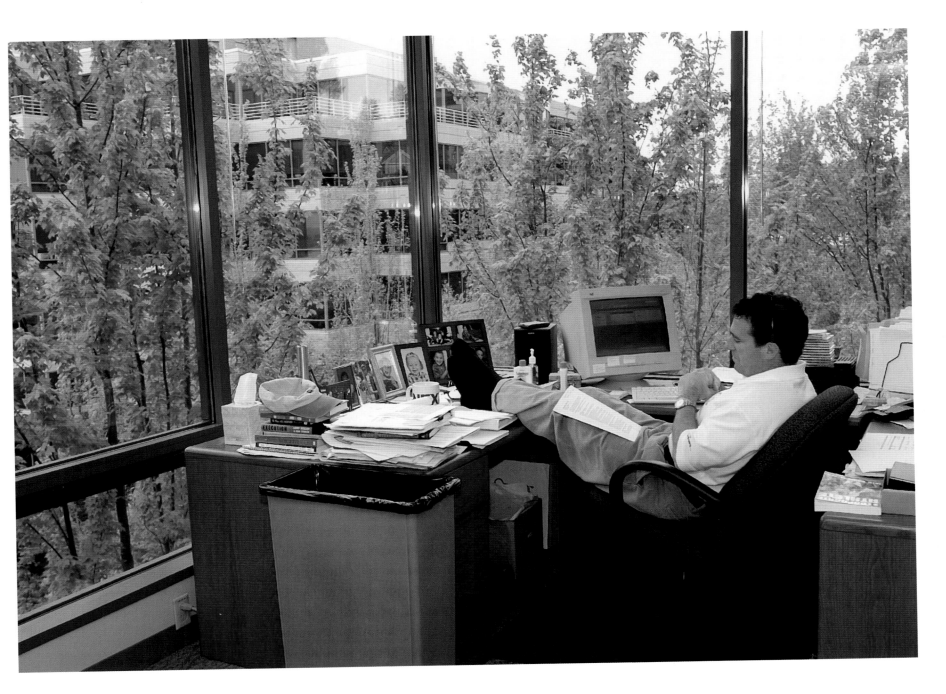

KIRKLAND

"We see ourselves as 'partners,'" explains Perry Satterlee, the laid-back chief operating officer of Nextel Partners. His title, he says, is strictly for outside investors who want titles. Satterlee, a former Nextel employee, cofounded Nextel Partners to serve smaller wireless communications markets than its parent company.

Photo by Warren Mell

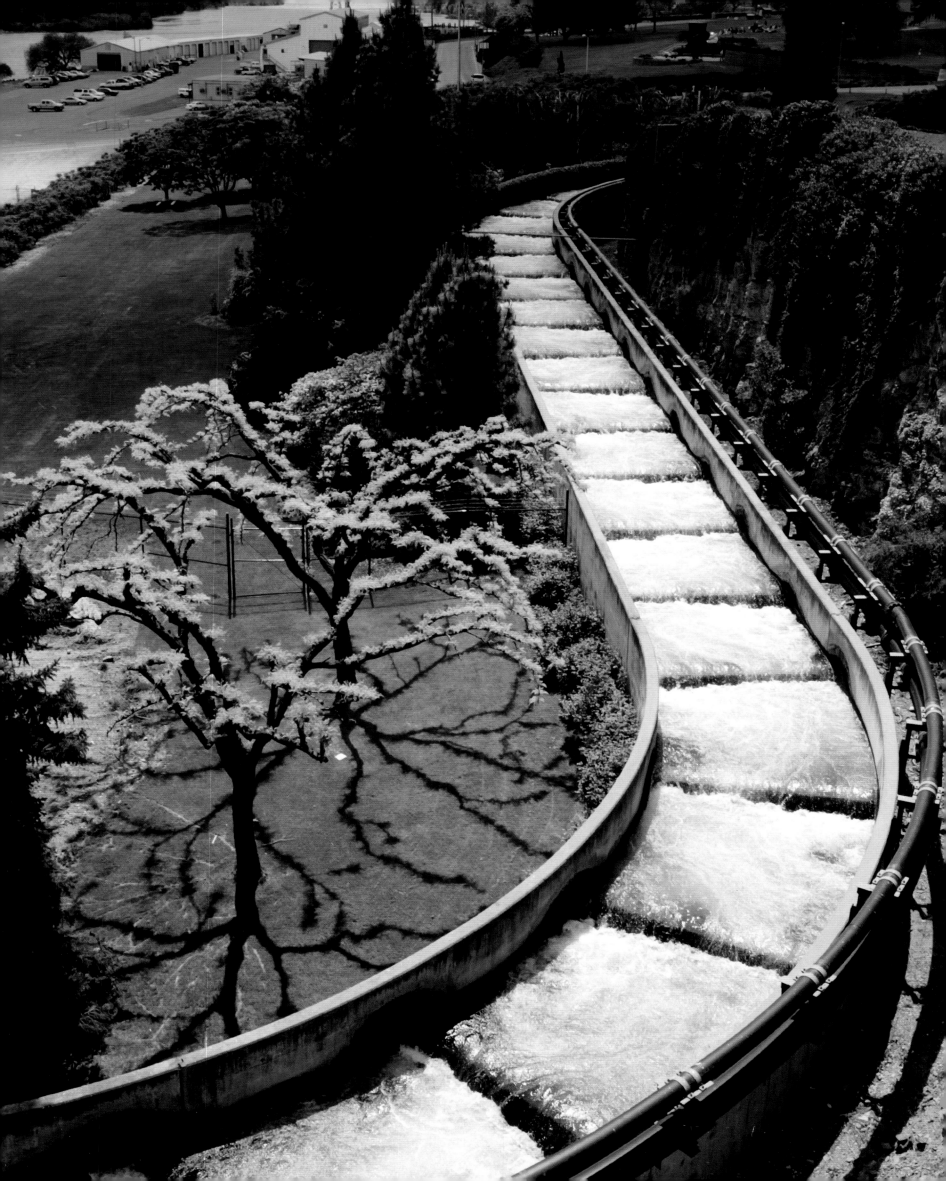

WENATCHEE

Spring Chinook salmon use the fish ladder at Rocky Reach Dam. Then they continue up the Columbia River as far as the Grand Coulee Dam to spawn.

Photos by Don Seabrook

WENATCHEE

Rocky Reach Dam electrical engineer Paul Resler ascends the dam's anchor block as water rushes through the spill gates. All the dams along the Columbia River flush juvenile fish downstream, away from power generating turbines that could kill them.

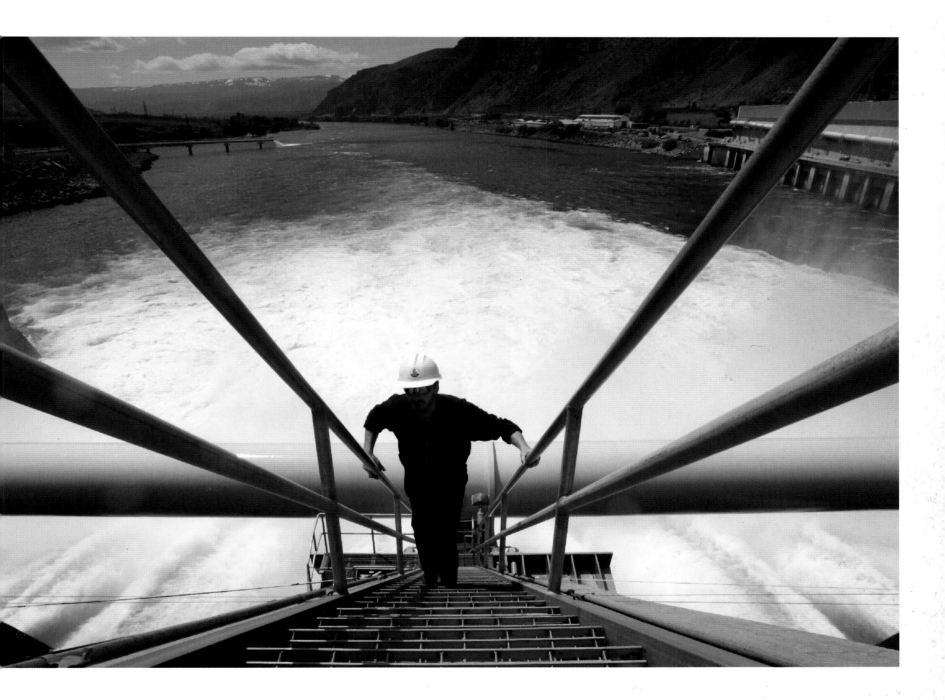

SEATTLE

At the CASA Latina Day Workers' Center morning job lottery, Jimmy Ventura hopes manager Ricardo Segura will call his number. Since opening in 1999, CASA Latina has dispatched 2,000 migrant laborers to 17,782 temporary jobs. The center also offers English classes and employee-rights workshops.

Photos by Laurence Chen, LChenphoto.com

SEATTLE

With an ID issued by CASA Latina Day Workers' Center, Isidro Serrano no longer has to stand on the street, worrying that whoever offers him a job will take advantage of him. Employers now know that Serrano is registered with a reputable agency. The Belltown neighborhood is also safer now. Fewer fights break out between workers scrambling for jobs.

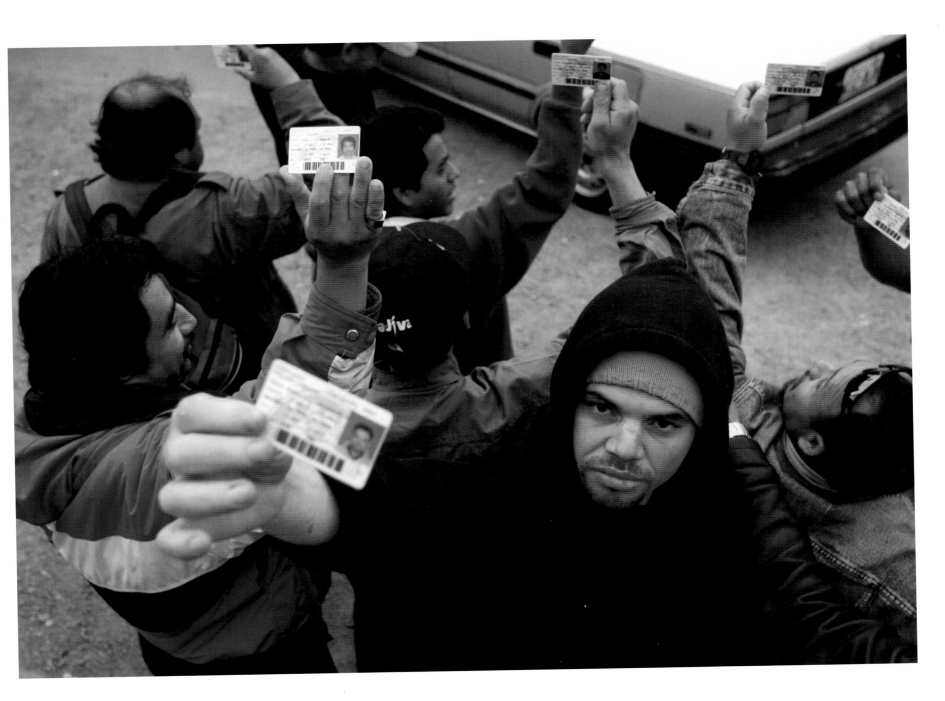

EVERETT
Assemblers work on the 444th Boeing 777 twin-engine commercial passenger jet—this one bound for Emirates Airlines. The Everett complex, with its 472-million cubic feet of space, is the largest building in the world.
Photo by Stuart W. Conway

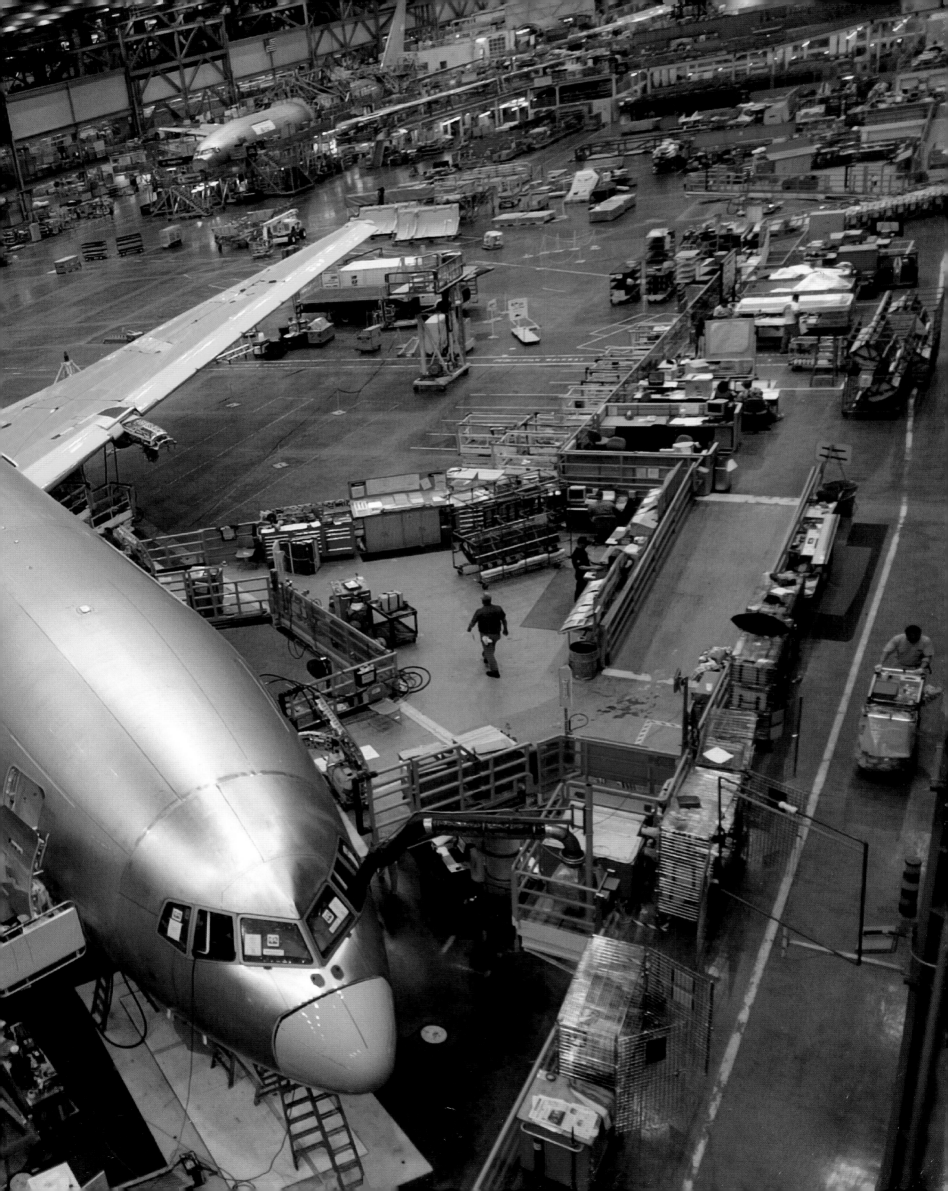

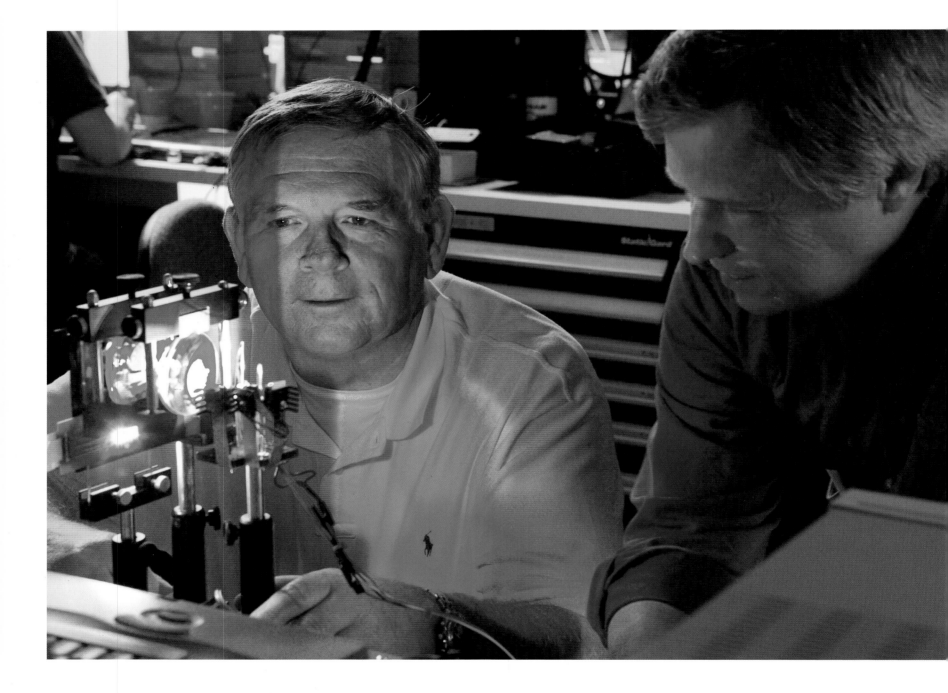

REDMOND

At Microsoft Research Hardware Lab, Gary Stark-weather and Mike Sinclair refine Sinclair's MEMS (micro-electromechanical systems) device, a mirror about the size of a human hair that deflects a laser beam fast enough to draw a video image...or something like that. As to Starkweather's credentials? He once worked at Xerox, where he invented the laser printer.

Photo by Nathan P. Myhrvold

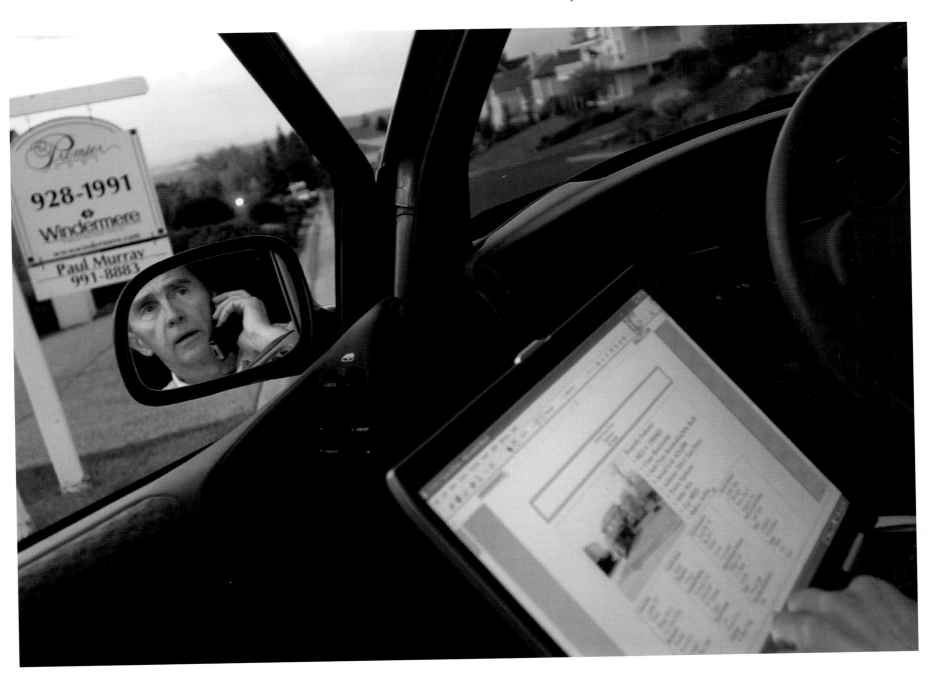

SPOKANE

Having been laid off from marketing jobs in an ad agency and a technology company, Douglas Hurd decided to go out on his own. He's now a real estate agent with a tech edge—he takes digital photos of properties, downloads them into his laptop, and sends them to clients. "It's rewarding financially, psychically, and spiritually," says Hurd of his newfound career.

Photo by Christopher Anderson,
The Spokesman-Review

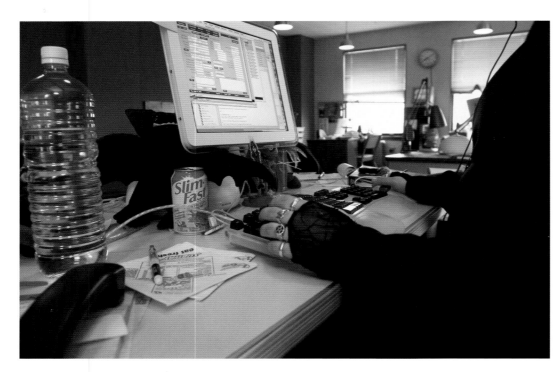

SEATTLE

During the day, Doug Carter provides technical support at Drizzle Internet Northwest in downtown Seattle. His alter ego, DJ Eternal Darkness, emerges on Wednesday and Sunday evenings when he works as a Goth/Industrial DJ at The Vogue, a dance club on Capitol Hill.
Photo by Douglas P. Dobbins

SEATTLE

Kilted Daniel Mahon works in the fraud detection department at Amazon.com. In his free time, he plays Scottish Highland Games, such as flipping telephone poles in the air. The 6-foot, 5 inch, 270-pound Mahon, who is half Irish and half Polish, bought his kilt for the games, but sometimes wears it to work to show off his nice knees.
Photo by Nathan P. Myhrvold

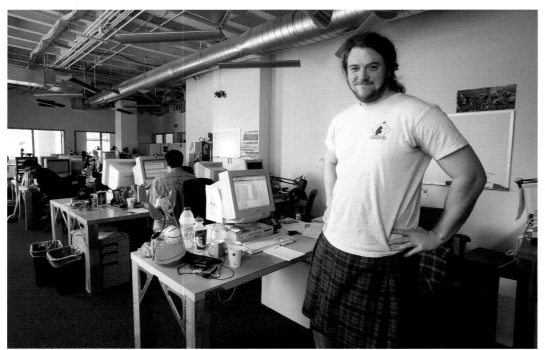

"My stuff is kind of experimental," says 28-year-old Khaela Maricich, working here at Dub Narcotic studio with fellow musician and tour buddy Anna Oxygen. Maricich's one-woman band, The Blow, has recorded five CDs. The latest is "Concussive Caress," which was released by the independent label K Records. She sells copies through their online site, in small stores, and at concerts.
Photo by Mike Salsbury, The Olympian

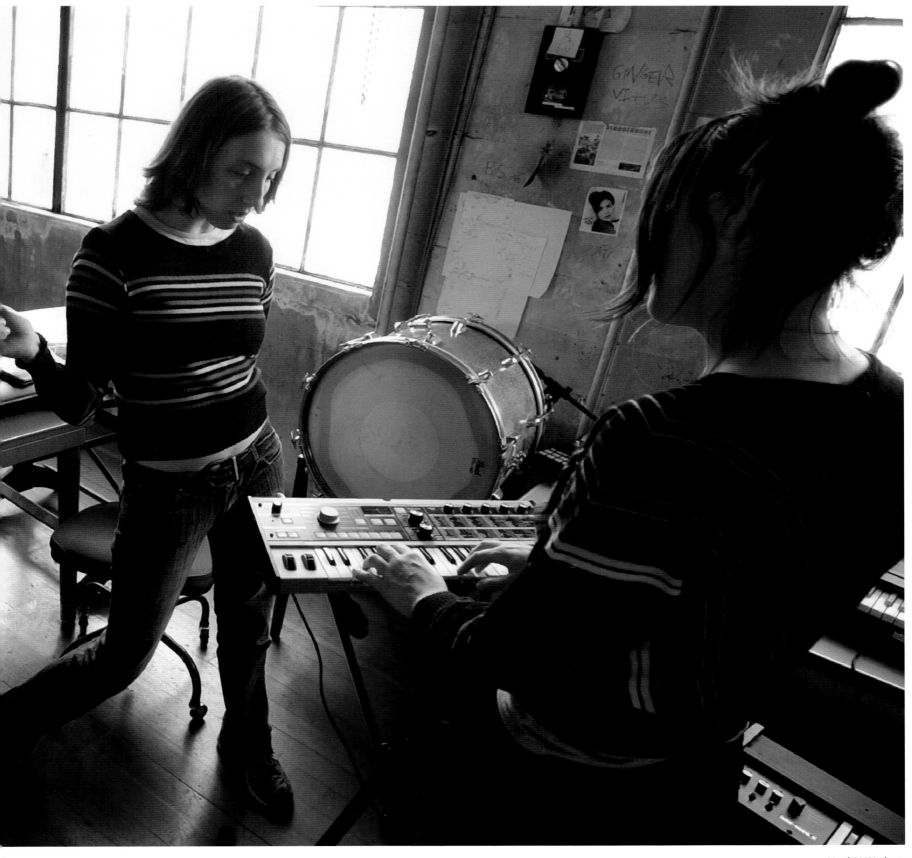

SEATTLE
At Memorial Stadium, soccer players Nathan
Leitner and Craig Bradley of Nathan Hale
High School celebrate their teammate Ed
Abrahms's goal.
Photo by Laurence Chen, LChenphoto.com

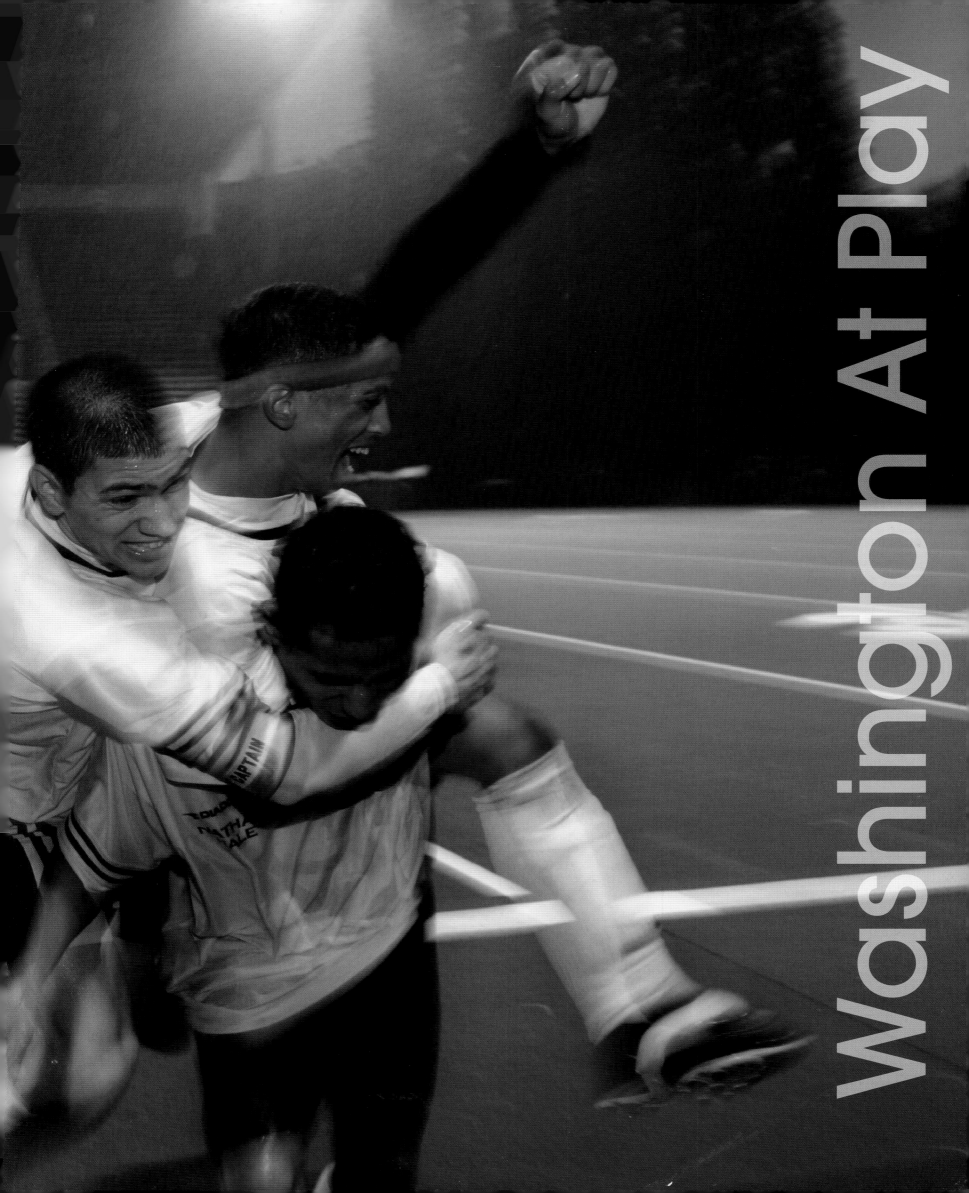

Washington At Play

WENATCHEE
Windexed in Wenatchee: A dirty windshield won't do for 8-year-old Daniel Brutskiy who's very excited to be at the Vue Dale Drive-In Theatre. Daniel and his family came to see *Shanghai Knights* starring Jackie Chan and Owen Wilson.
Photo by Don Seabrook

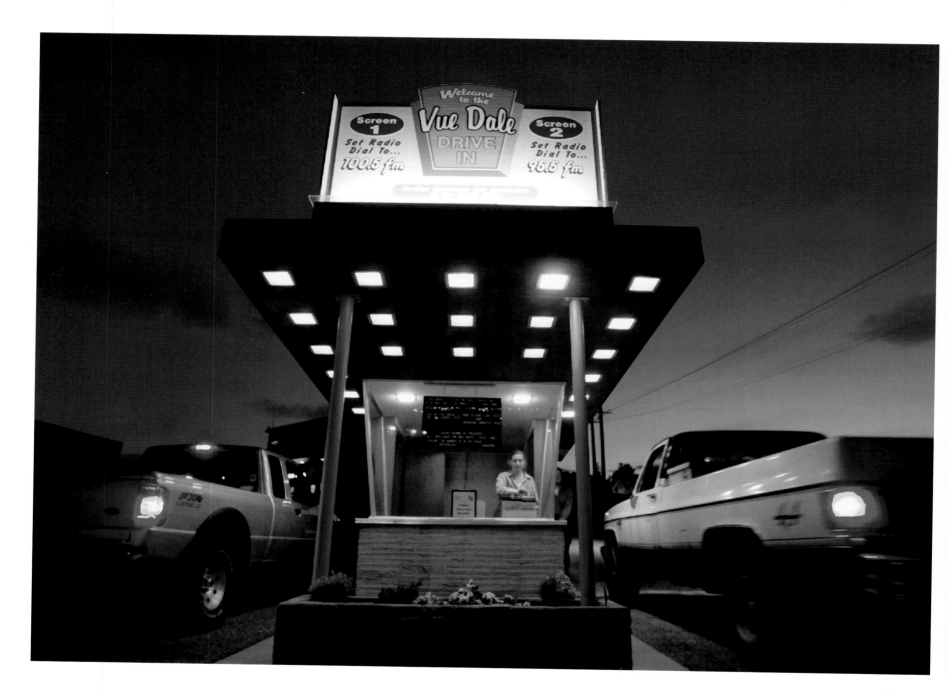

WENATCHEE

For the past three summers, eighteen-year-old Sabrina Hisey has worked the box office and concession stand at the Vue Dale Drive-In, the last remaining drive-in theatre in North Central Washington. The half-century-old Vue Dale charges $7 for a single passenger and $12 a carload.
Photos by Don Seabrook

WENATCHEE

Twin brothers Michael and James Morse have been dating their respective girlfriends, Stephanie Baldwin and Nicole Jackson, for four months. This was their first double date—it was a double feature, naturally.

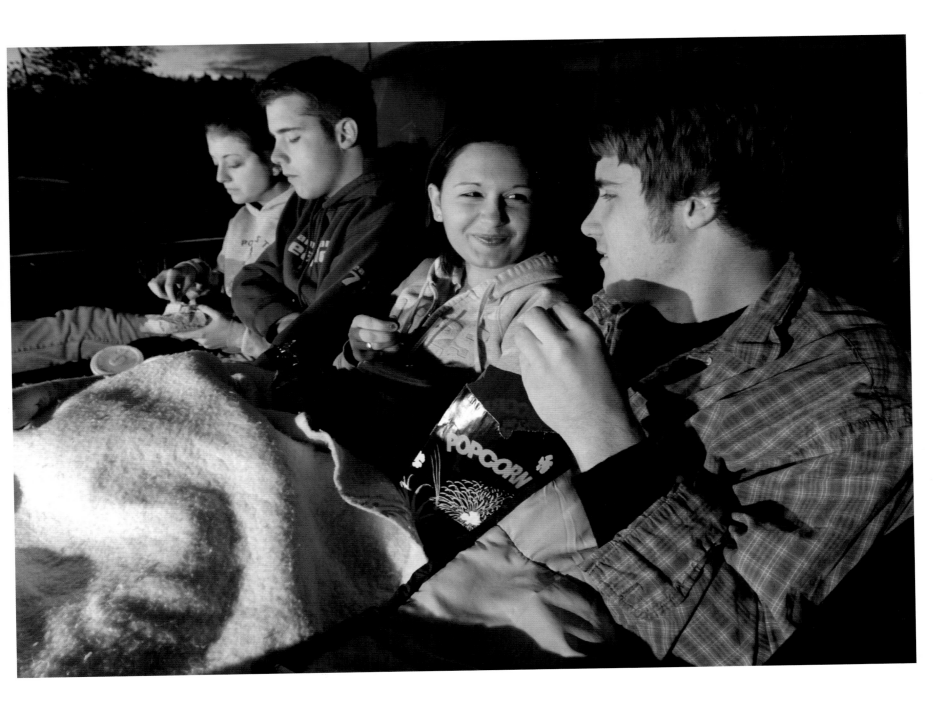

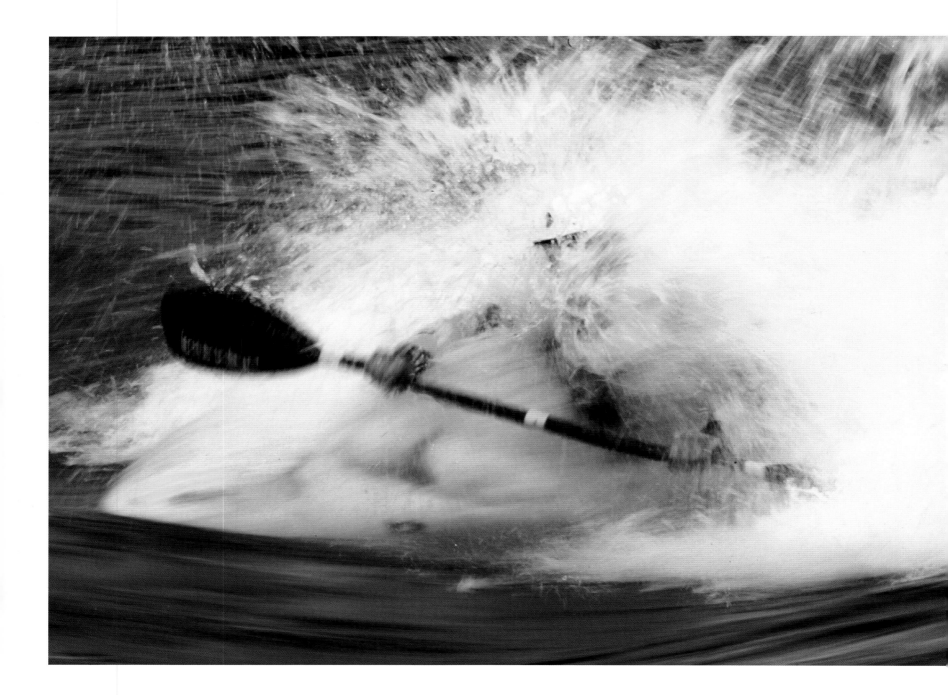

CASHMERE

Hit me with your best shot: Ron Turner of Burbank takes on Granny's rapid on the Wenatchee River. The Class III rapid is popular with whitewater paddlers seeking to perfect their technique.

Photo by Don Seabrook

TACOMA

Upon arriving at Point Defiance Zoo & Aquarium in 1982, he was 3 months old, weighed a mere 155 pounds, and resembled a well-known Hollywood movie extra terrestrial. Today, as one of fewer than 20 Pacific walruses in North American zoos, E.T. is 11 feet long and weighs 3,390 pounds. He's a favorite attraction for kids like Kamryn Jones, 4, and Lily Harris, 5.
Photo by Teri Harris, Ladybug Photography

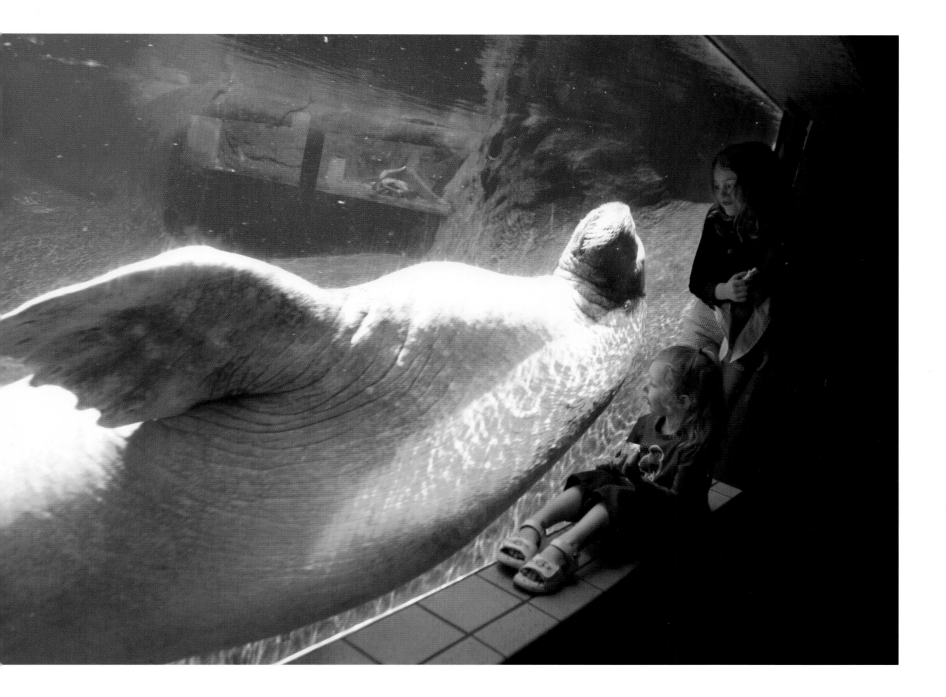

BELLINGHAM BAY

Along with his crew, Bob Diehl (seated far right) races *The Diehler*, a 52-foot Santa Cruz, every Wednesday evening during spring and summer. Bordered by the Cascade Mountains, Bellingham Bay has consistent winds and limited commercial traffic. "It's one of the best sailing bays on the West Coast," Diehl says.

Photo by Phil Schofield

ROCHE HARBOR

Naturalist Dealy Etter leads summer sea-kayaking tours around the San Juan Islands. Over the past 30 years, the islands have become desirable get-away destinations for artists, retirees, outdoor enthusiasts, and computer magnates. No noisy jet skis, though, in these waters—San Juan County banned them in 1996.

Photo by Tony Overman, The Olympian

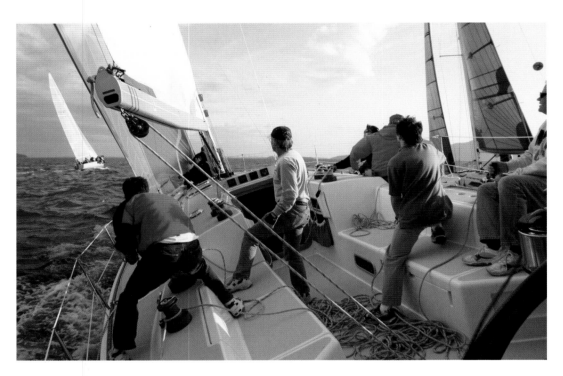

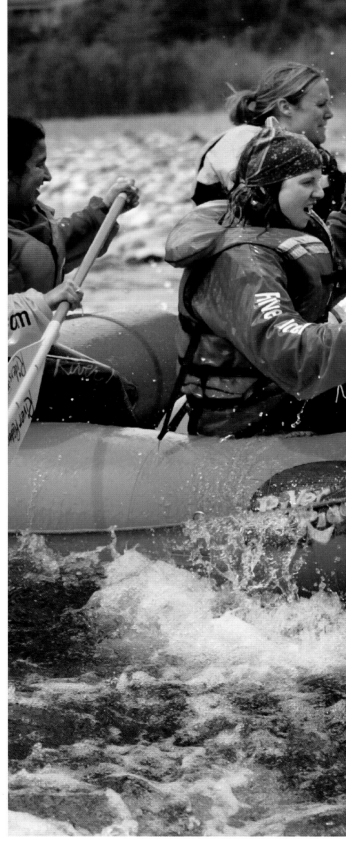

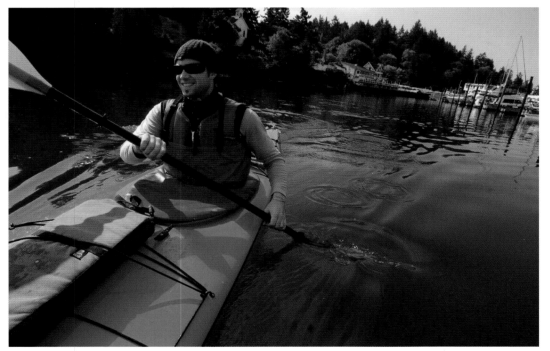

CASHMERE

The Wenatchee River is a whitewater rafter's dream—nearly 20 miles of Class III rapids with names like Hobo Gulch, Rock 'n' Roll, Boulder Bend, and Drunkards Drop.

Photo by Don Seabrook

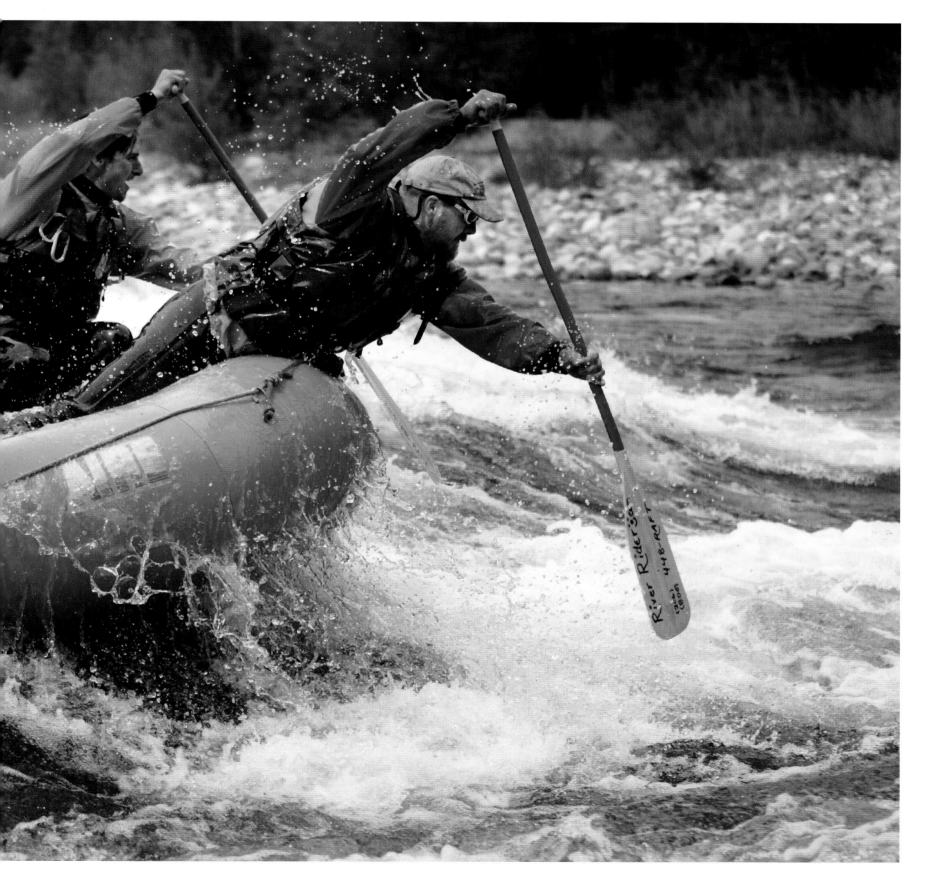

WALLULA GAP

Only 309 miles to go! To raise awareness of the environmental abuses of the Columbia River, Christopher Swain is swimming its entire 1,243-mile length. Back in June 2002, he plunged into Columbia Lake in Canal Flats, British Columbia. A year later, he strokes around the river's big bend where it becomes the Washington-Oregon border and heads west to the Pacific.

Photo by Kirk Hirota

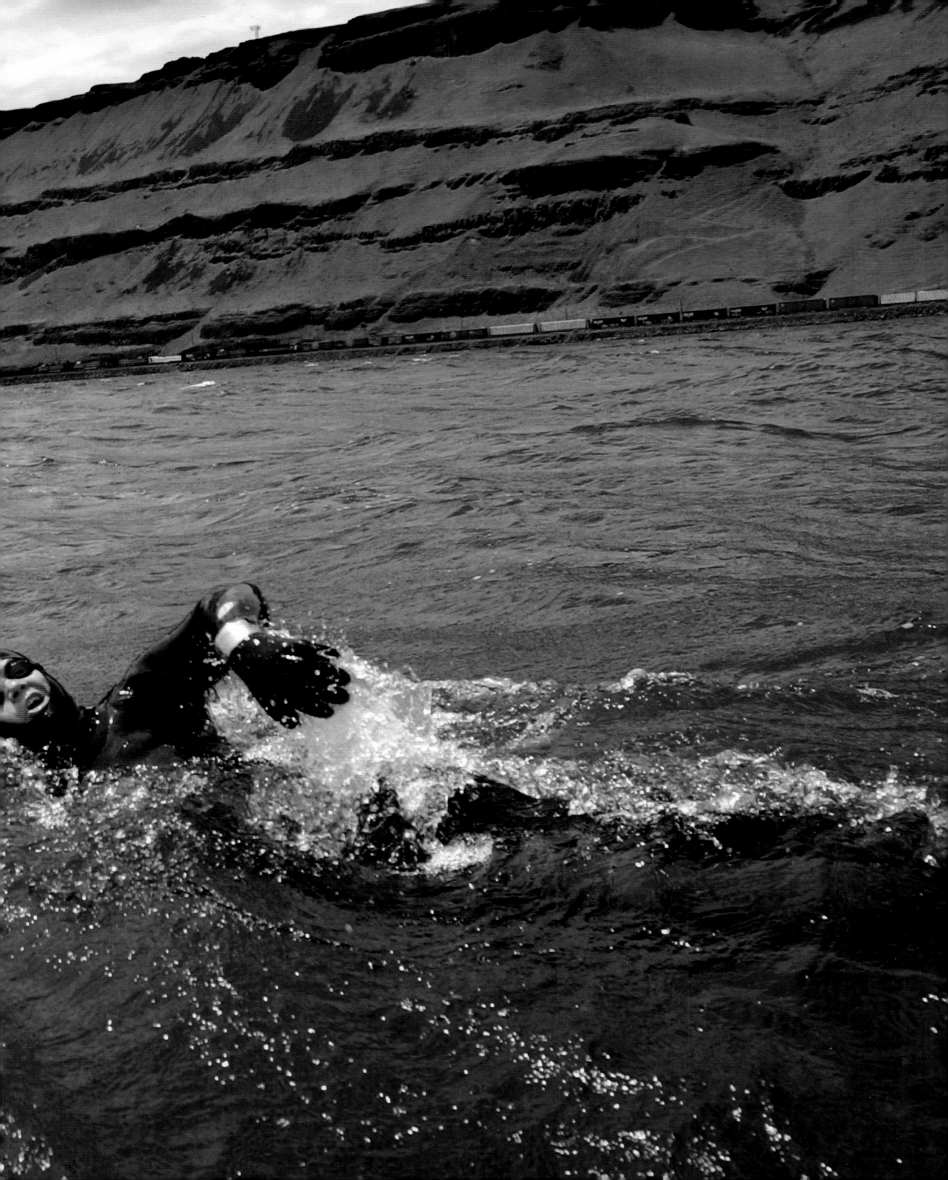

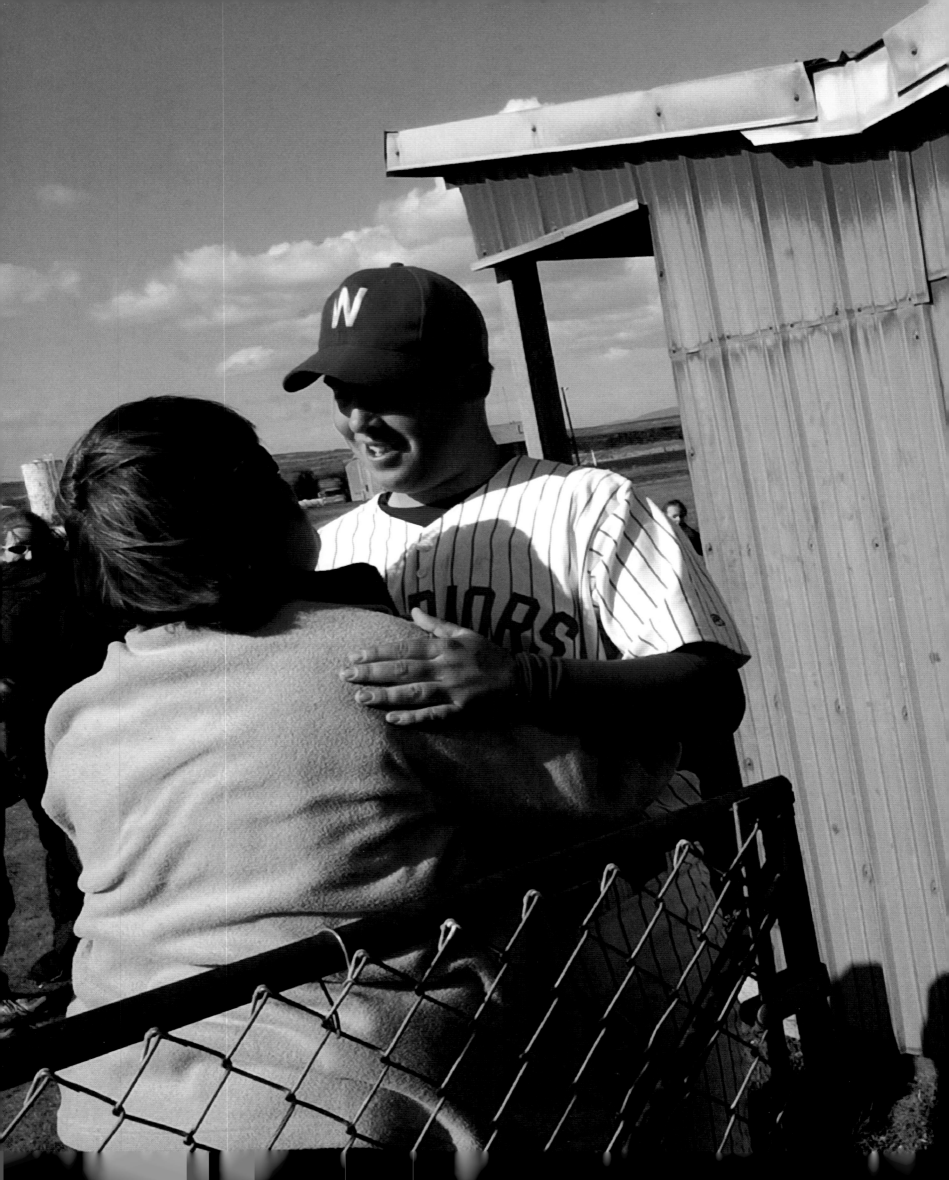

WILBUR

The 90-minute drive was worth it to Andrew Czapla of Spokane's St. Michael's Academy Warriors. His team just won a game during a district tournament in Wilbur (pop. 914). School principal Sister Mary Philomena Fuire says, "I never know what to pray for in baseball. So I just pray for them to do well."

Photo by Torsten Kjellstrand

LACEY

Go Rams! Students from North Thurston High School organized a barbecue-and-soda tailgate party and cheering section for the boys' soccer game. The team spirit worked: The Rams beat the undefeated Camas High School Papermakers.
Photo by Mike Salsbury, The Olympian

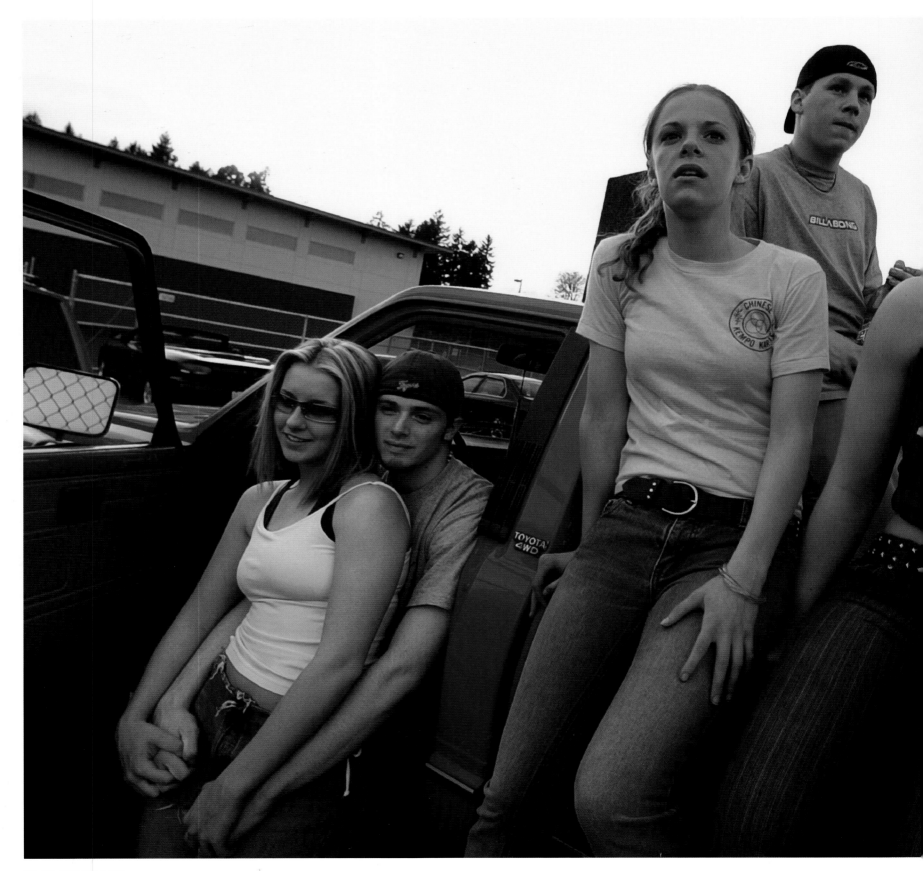

SEATTLE

During an overcast late afternoon at Memorial Stadium, Nathan Hale High's soccer team takes on Lakeside for the Seattle Metro League title.
Photo by Laurence Chen, LChenphoto.com

SEATTLE

Having won the championship with a 1–0 shut-out over Lakeside, Nathan Hale High teammates Craig Bradley (red socks) and Ben Callahan quickly change into tuxes to attend their senior prom. "For our team, it was as much a celebration as a dance," says Ben.
Photo by Laurence Chen, LChenphoto.com

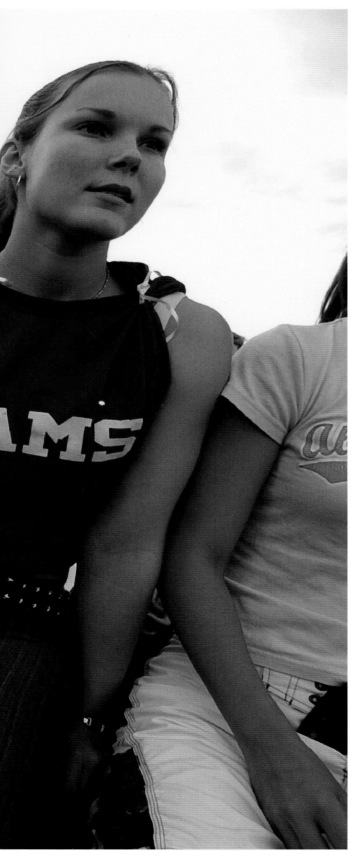

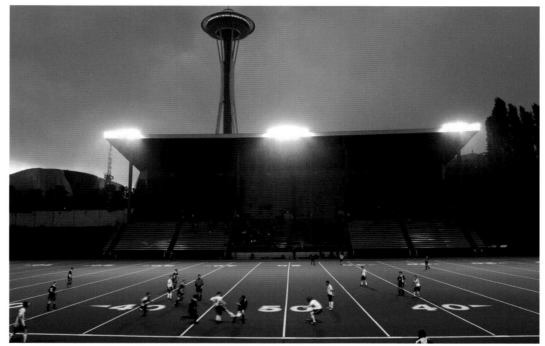

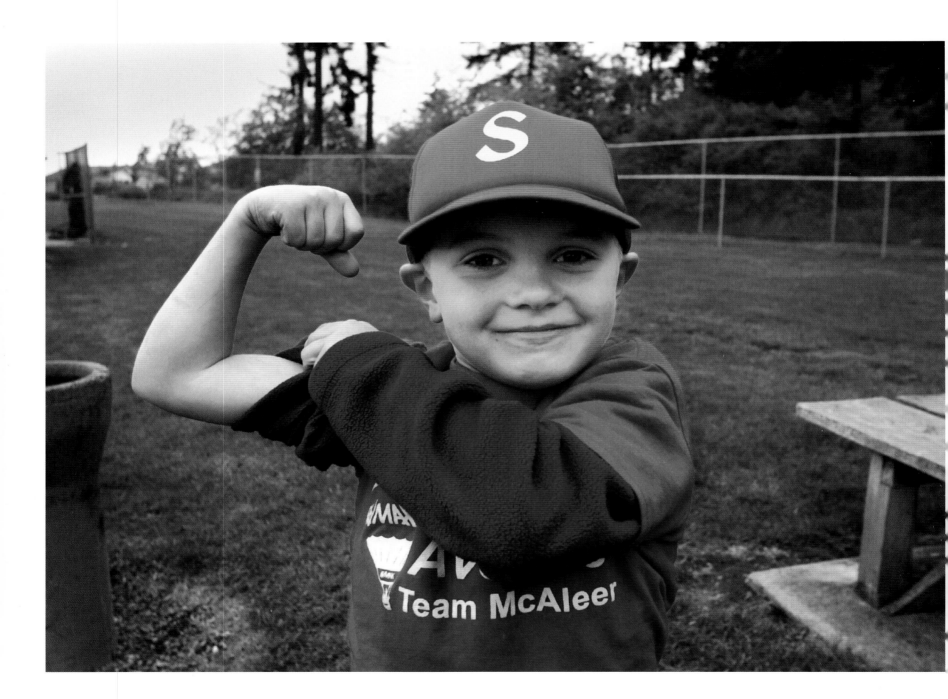

SEQUIM

Mr. T-ball: Erik Smith is proud of his strength and plans to put it to good use in his upcoming game. "My muscles are almost as big as my dad's," boasts the 6-year-old.

Photo by Kevin German

OLYMPIA

Governor Gary Locke helps son Dylan field the ball during a T-ball game. A Democrat, Locke became the nation's first Chinese-American governor in 1996. He was reelected to a second term with a platform stressing education, job creation, and health care.

Photo by Laurence Chen, LChenphoto.com

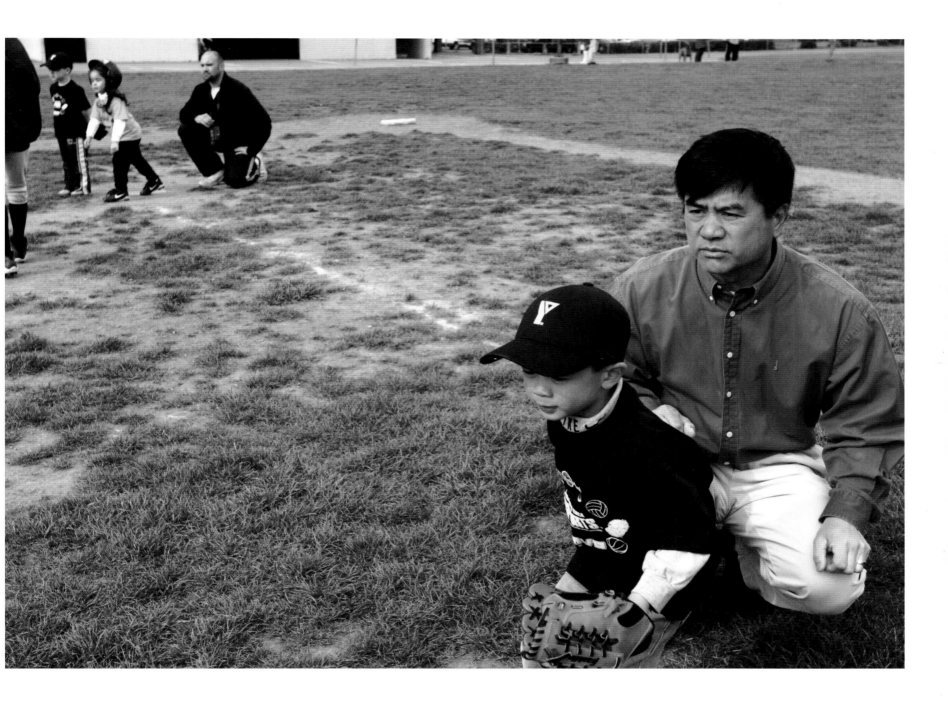

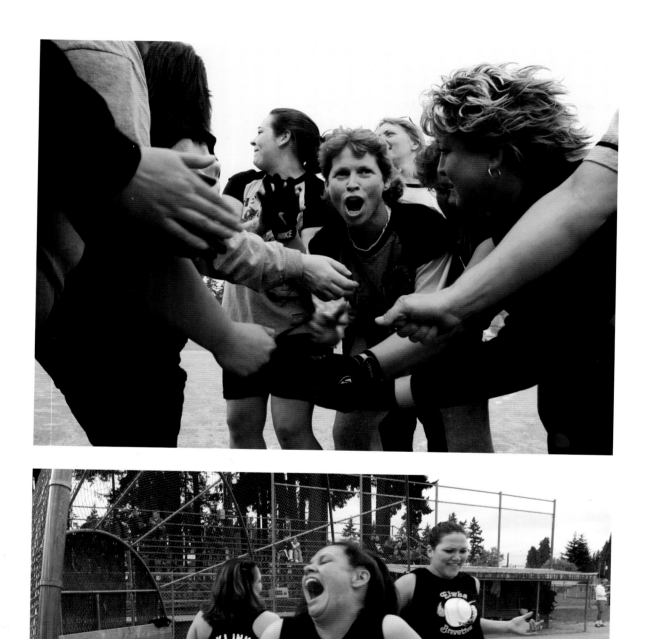

PORT ANGELES
Members of the Wreck Tavern women's softball team—that's pitcher Colette Wilson in the center—have good reason to shout. They came from far behind to defeat Caregivers Home Health, 19–10.
Photo by Joanna B. Pinneo, Aurora

PORT ANGELES
More joy in mudville: Women from the Lower Elwha Klallam Indian tribe—that is, the mighty Elwha Bravettes—faced a formidable foe: the undefeated Franklin Mortgage/Portac. That team's winning streak ended when the Bravettes retired Franklin 13–3.
Photo by Joanna B. Pinneo, Aurora

BELLEVUE
After two years of sparring, Peg Rahm and Shelby Barnes have become friends. Boxing, says Barnes, who also runs marathons, "is the most fun and exhilarating and hardest thing I've ever done." Some people, like her coach at RingSports United, call boxing "pugilistic chess."
Photo by Nathan P. Myhrvold

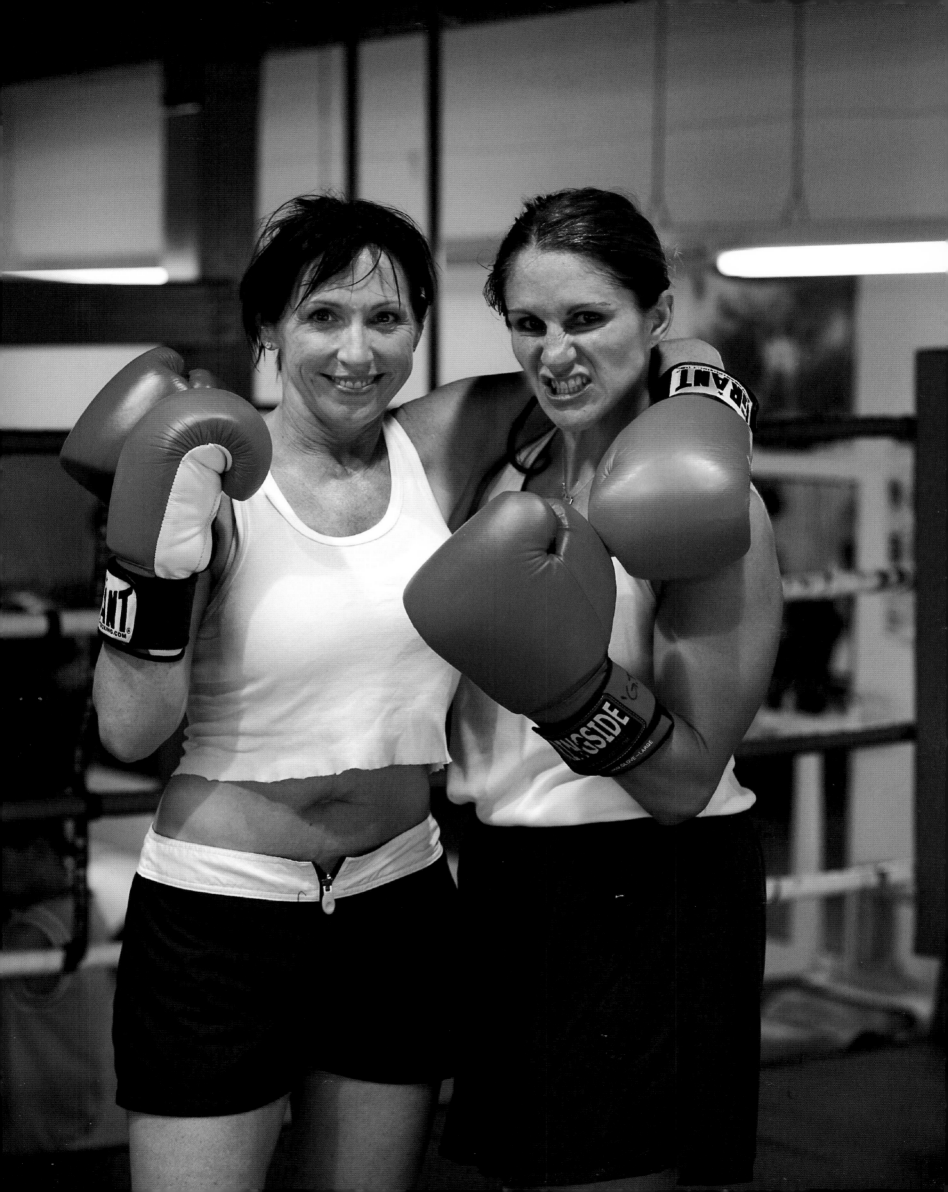

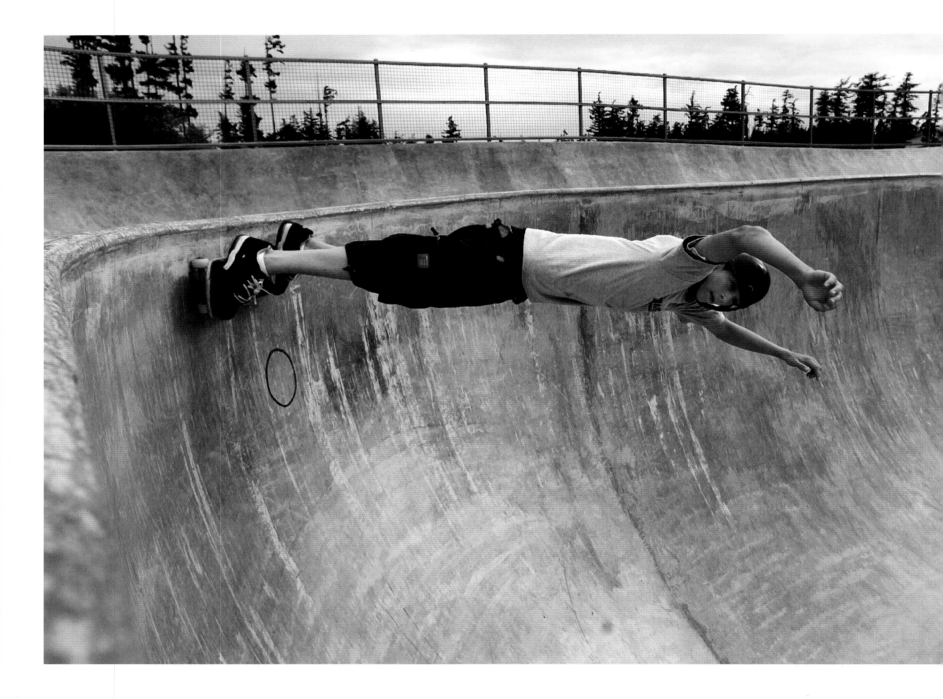

EASTSOUND

Glen Smith defies gravity—if only for a second—at the Eastsound Orcas Island Skate Park. Built in Buck Park in 2002, the 15,000-square-foot facility was paid for with private donations of both labor and money. Skaters, not architects, designed it. If the "table tops" and 12-foot bowl they devised do not present enough of a challenge, the "snake run" will.

Photo by Tony Overman, The Olympian

SEATTLE

Bubbleman, aka Garry Golightly, plies his trade for this cystic fibrosis fundraiser at the Seattle Center. Golightly's bubble machines include the one he is using today—10 tennis racquets tied to a ski pole. Golightly performs at birthdays, weddings, and flea markets. He's even done a divorce party. His motto is simple: "I'm availabubble."

Photo by Monte H. Gerlach

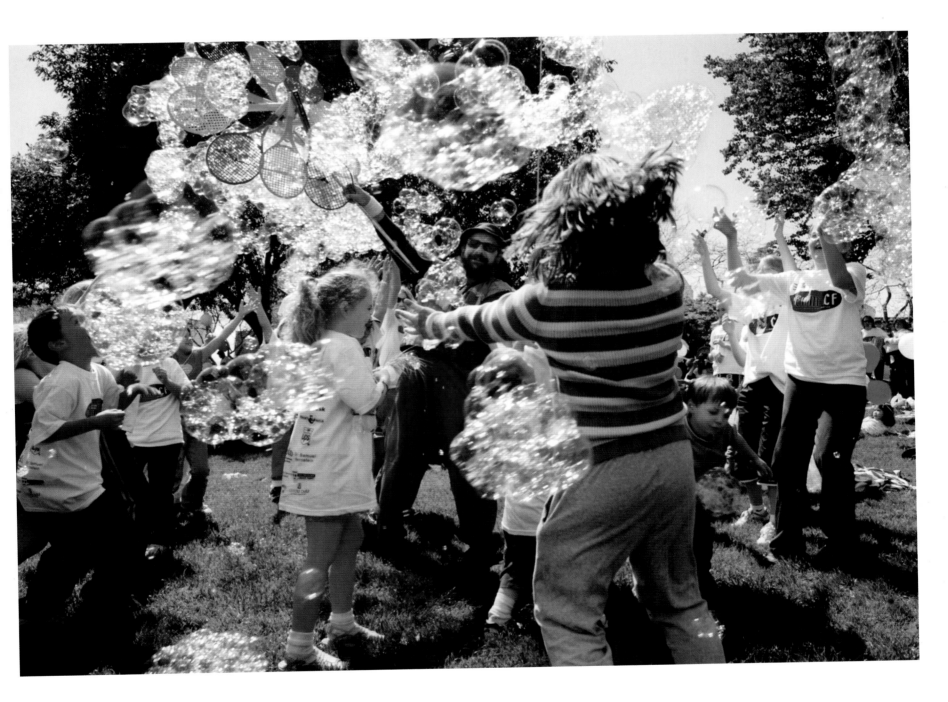

SEATTLE
Rana San and Amanda Leving swirl their silk shawls during their flamenco class at the American Dance Institute. The shawls, which were brought to Spain in the 16th century from the Philippines, are raised to represent wings at the moment that a dancer's skirt begins to rise.
Photo by Laurence Chen, LChenphoto.com

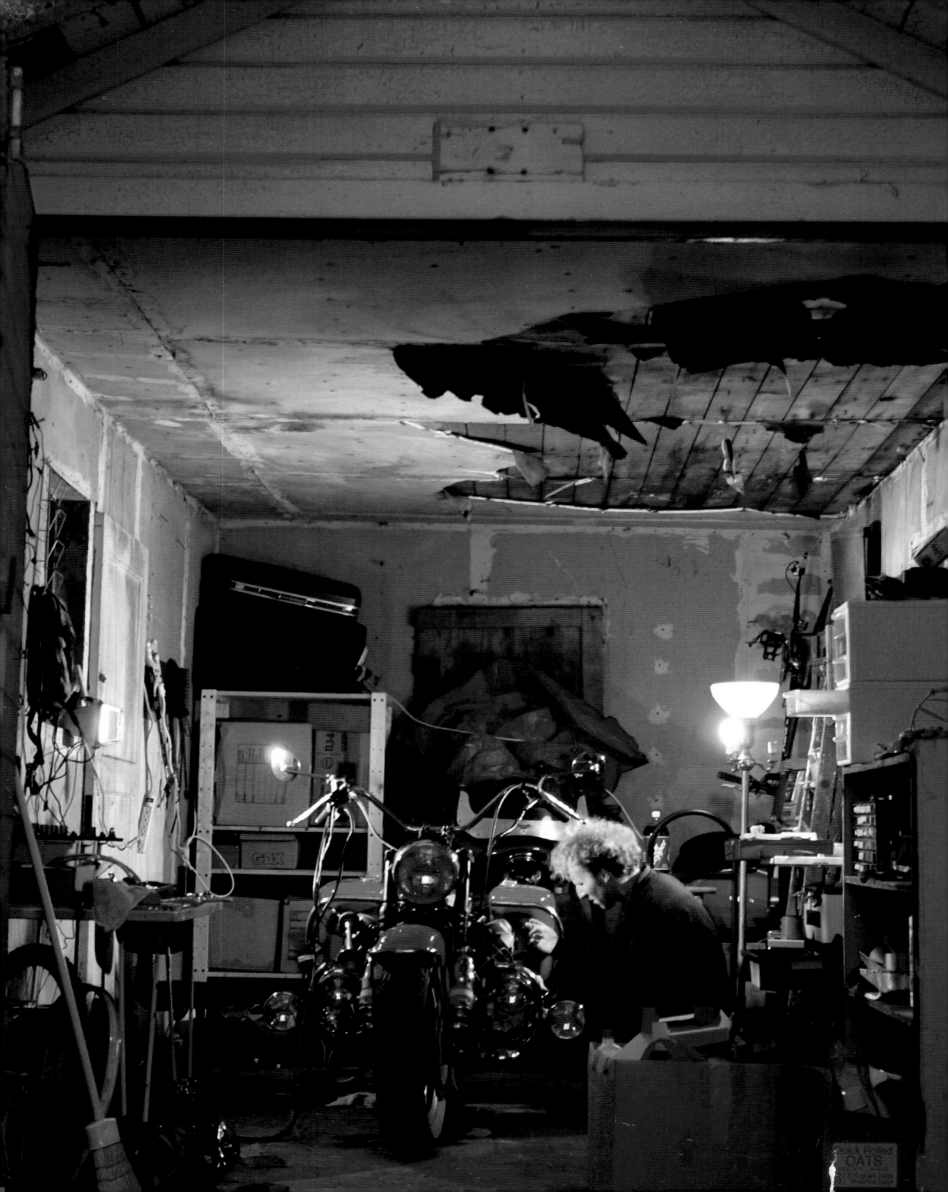

SEATTLE

J. White tinkers with a friend's Moto Guzzi in his Capitol Hill garage. When he's not in the garage, White works at the Belltown Bistro downtown and hangs out at the Seattle Glassblowing Studio.

Photo by Casey Kelbaugh

LOPEZ ISLAND

Shortly after sunset on the last day of a three-day cycling tour, British Columbia bikers Beverly and John Coles and Yvonne Leusen dismount to start setting up camp at Odlin County Park. Affiliated with the Chilliwack Outdoor Club, the bikers pedalled about 40 miles a day, making their way across three of the biggest San Juan Islands: Orcas, San Juan, and Lopez.

Photo by Tony Overman, The Olympian

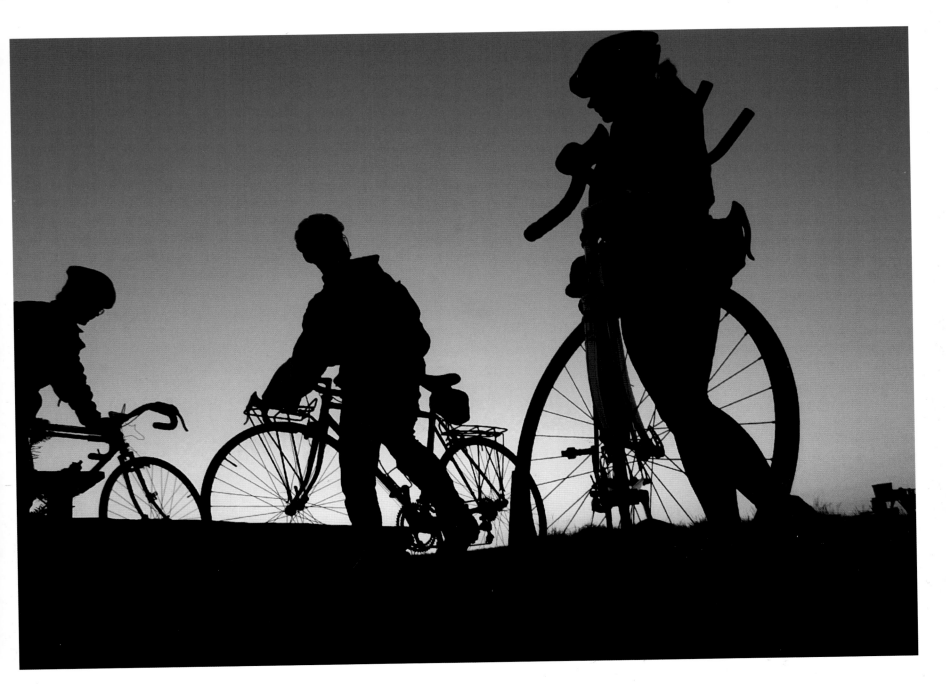

EAST WENATCHEE

Spin city: Car 69 is directionally challenged at Wenatchee Valley's Super Oval, a NASCAR short track. The yellow flag is waved, forcing all the cars in the entry-level Hornet Class to slow down so the driver can turn around. The 4-cylinder stock cars can't be modified, except to add safety features like a roll cage.
Photos by Don Seabrook

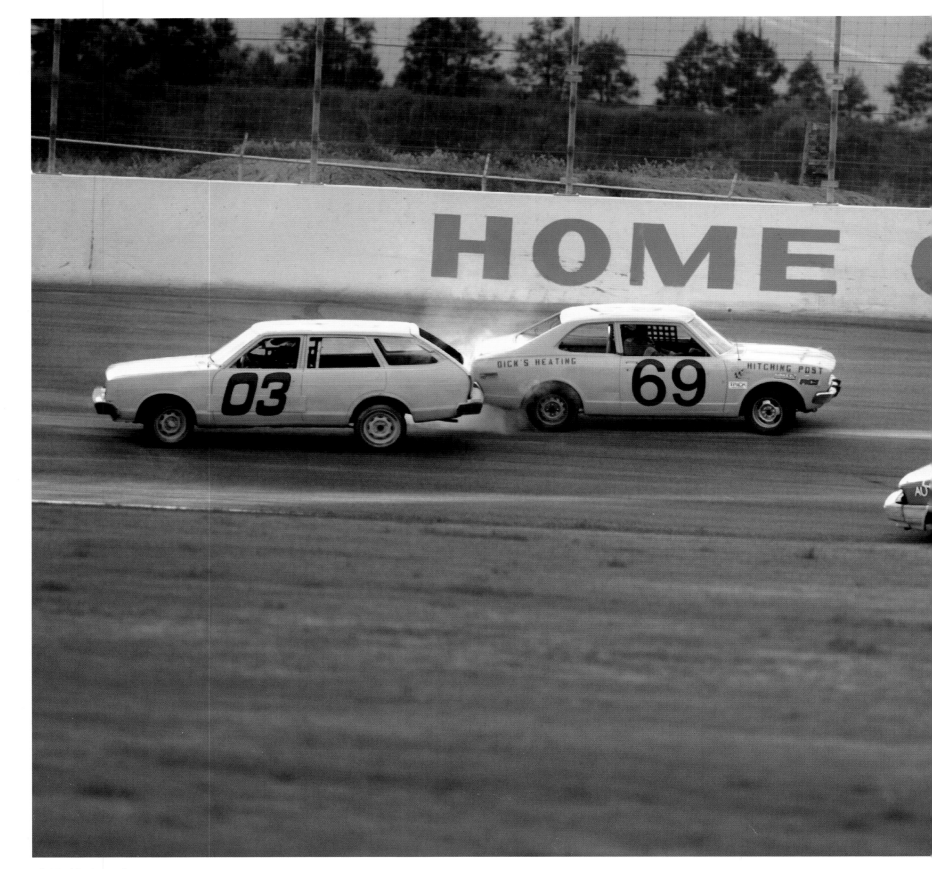

EAST WENATCHEE

On any given Saturday night between April and September, up to 5,000 spectators can see everything from stock car to open wheel racing at Wenatchee Valley's Super Oval. They also get a nice view of the Cascades.

EAST WENATCHEE

Don Meza stands at attention for the National Anthem before revving up his '83 Honda Accord stock car for the Hornet Class race. His 6-year-old son says all he wants from his dad is a "stinkin' trophy." Meza didn't win one that night but did a month later—his very first—and personally delivered it to his son in the stands.

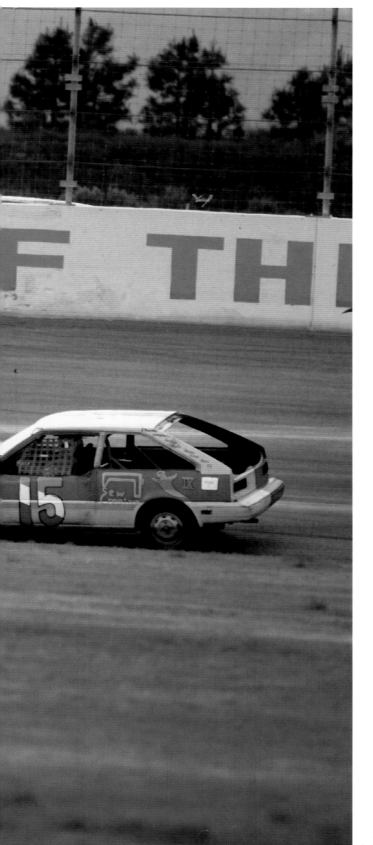

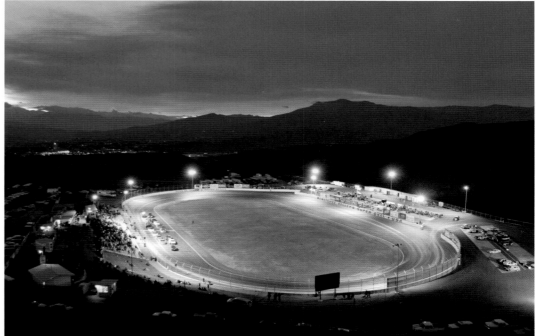

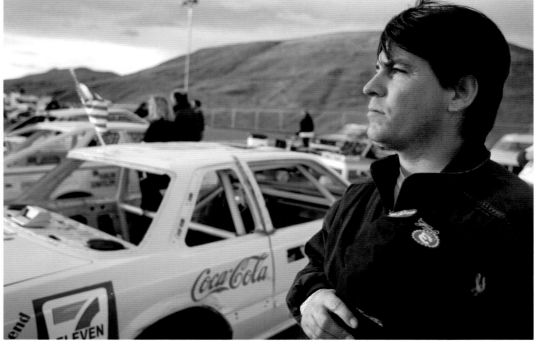

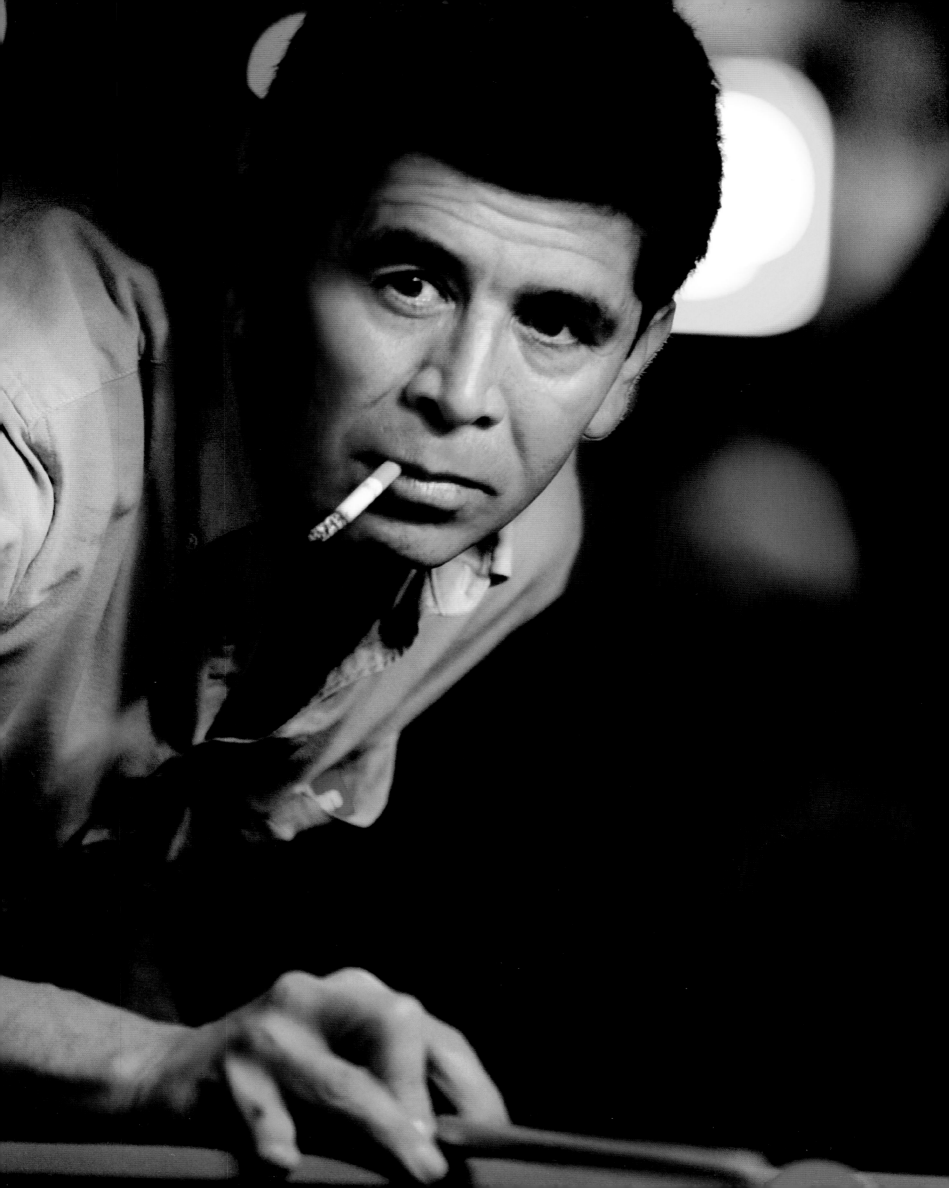

WENATCHEE

Minn's Club team captain Manuel Miranda follows his shot during an eight-ball league play-off game against shooters from Clearwater Steakhouse and Saloon. The teams were vying for third place in the final tournament of the season at Phat Tuesday's Tavern.

Photo by Don Seabrook

LANGLEY

Gordon Rowe, foreground, waits his turn to shoot skeet at Holmes Harbor Rod & Gun Club. Before retiring in 1982, Rowe spent four decades testing wings and other airplane parts in Boeing's wind tunnel. "I used to hunt, but not anymore," says the octogenarian. "I just shoot for fun now."

Photo by Rachel Olsson Photography

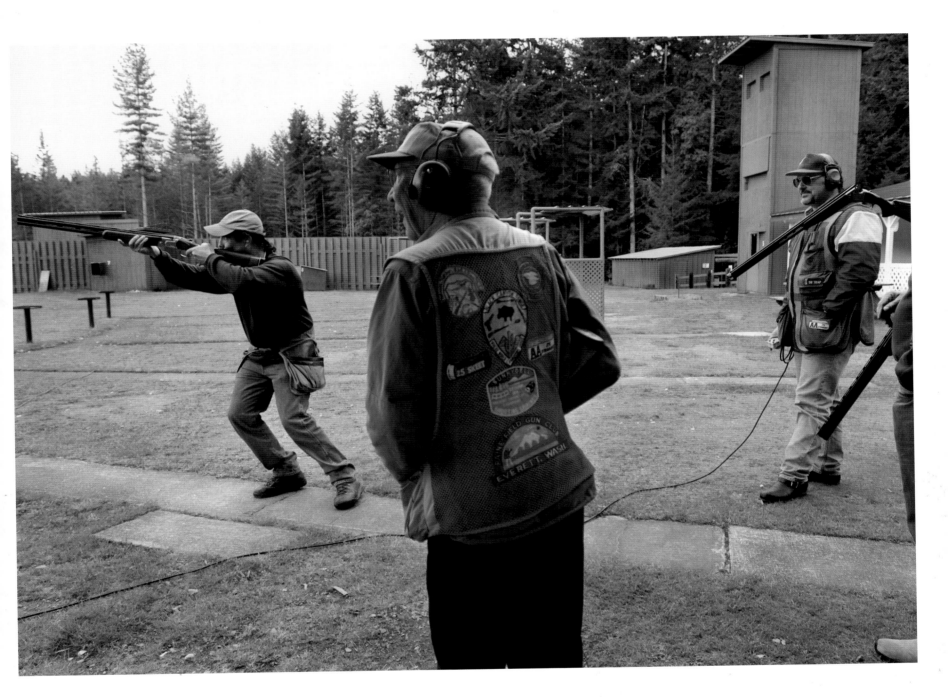

SAN JUAN CHANNEL

Whale watchers review a map of the San Juan Islands on the deck of the *Sea Hawk*, a Friday Harbor boat. The group is heading out to open waters in search of an orca pod. Three pods swim around the islands from mid-April to the end of September, hunting, playing, and romancing.
Photo by Tony Overman, The Olympian

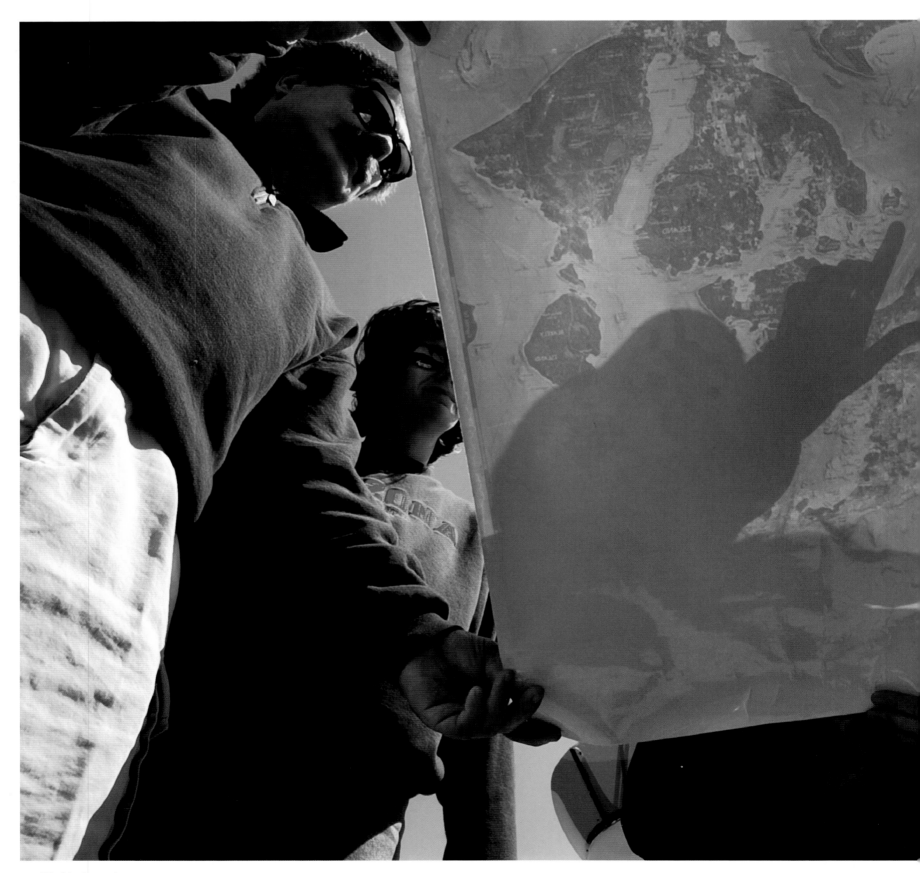

LEAVENWORTH

Single dad Grant Kroontje makes sure two of his four children, Sarah and Steven, don't scare away the fish. Trout Unlimited, a national organization promoting conservation, sponsored the one-day fishing derby. Nearly 75 kids attended and all got prizes for catching lots of trout in a man-made pond on the east slopes of the Cascades.

Photo by Don Seabrook

SHELTON

Sunday morning, May 18: On the dock at Spencer Lake Resort, Tony Picardo, Frank Barcelona, and Nick Picardo pray for trout.

Photo by Steve Zugschwerdt, The Sun

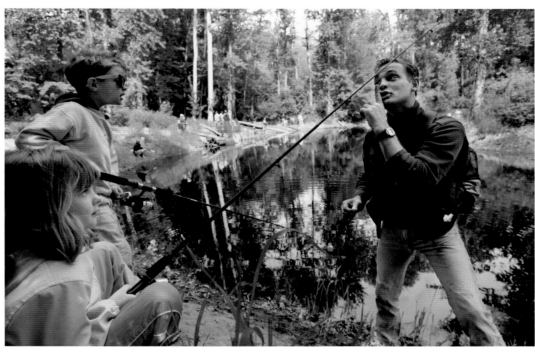

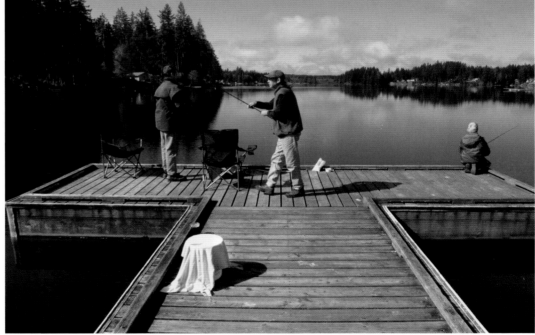

SEATTLE
After immigrating from Cambodia in 1984, Savun Neang received an engineering degree from Griffin College and started his own computer store. Neang regularly invites and hosts politicians from his homeland to come see his new life in Seattle.
Photo by Laurence Chen, LChenphoto.com

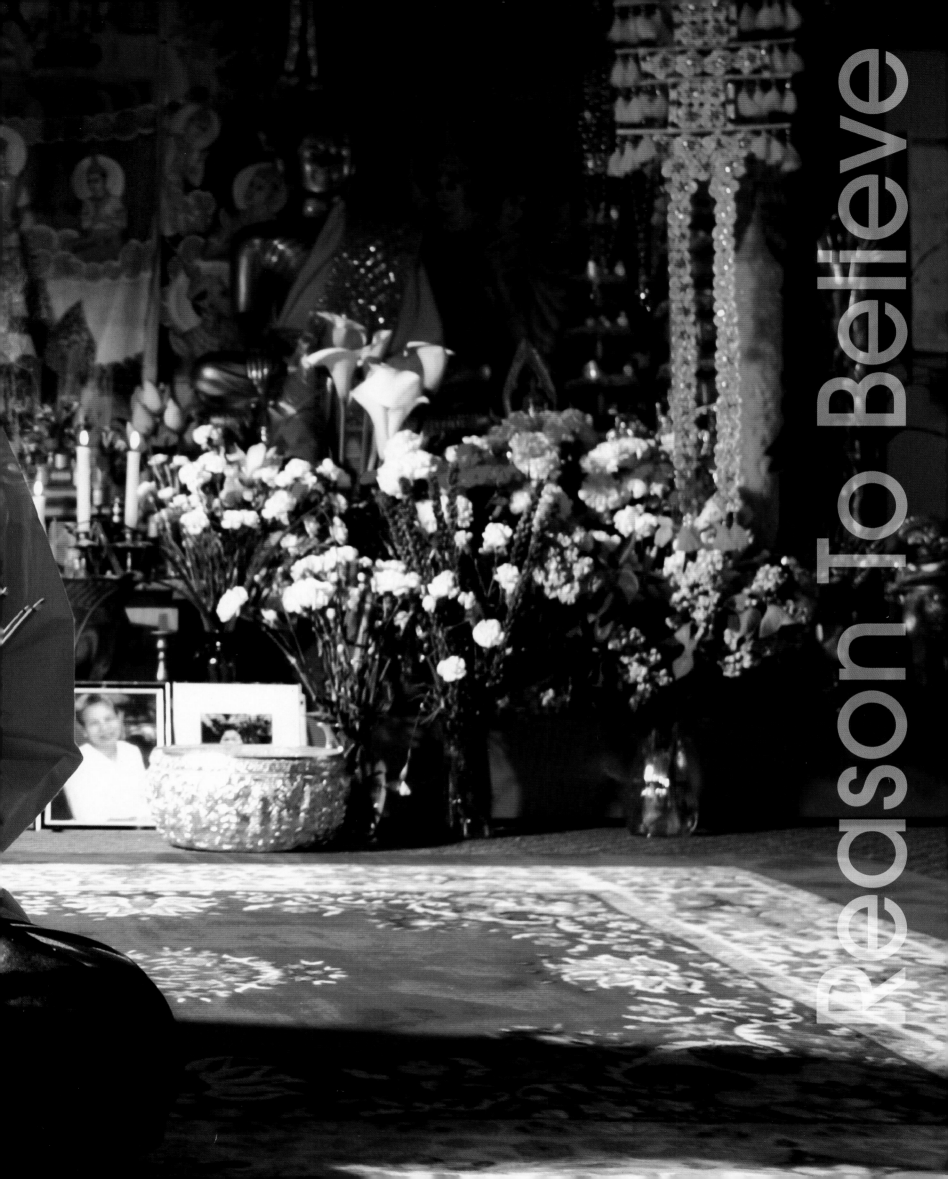

Reason To Believe

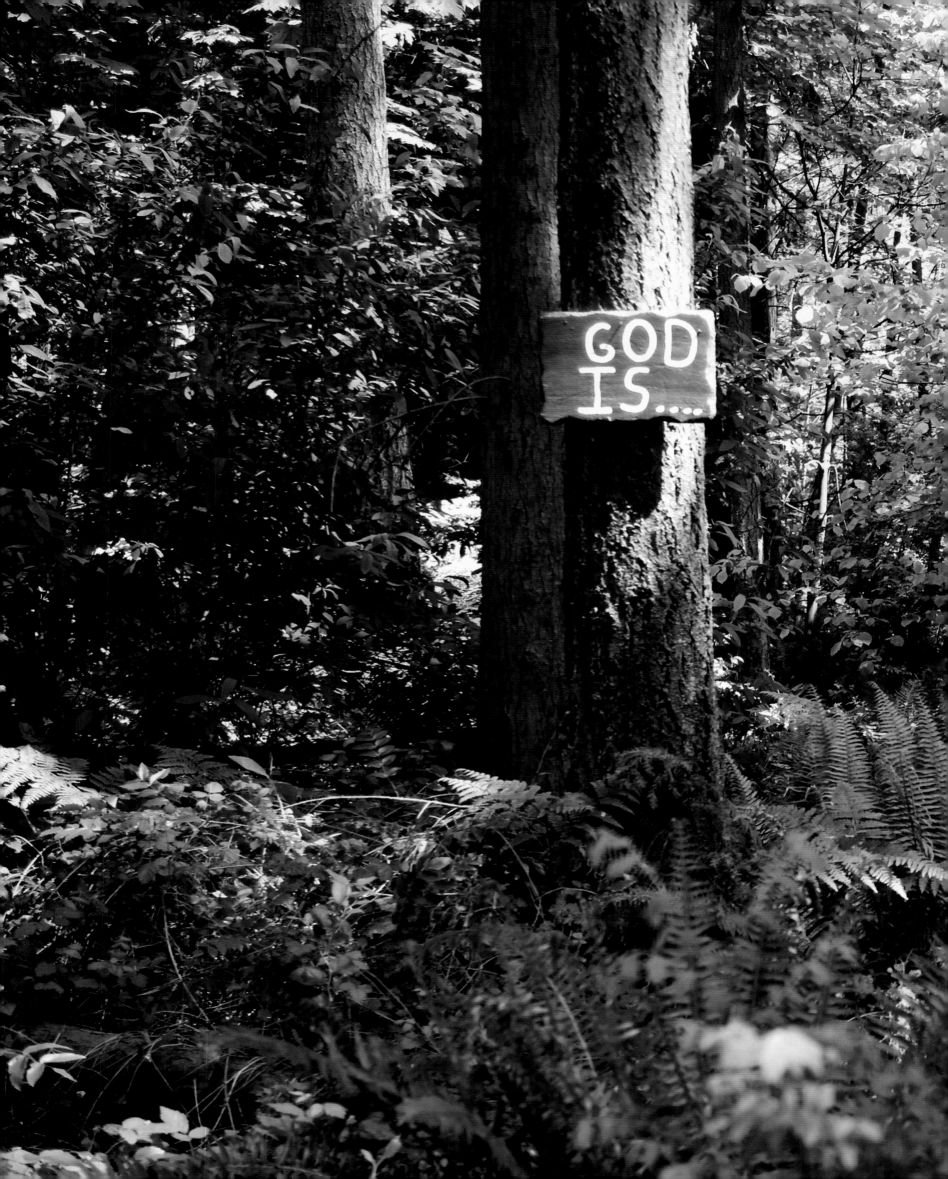

REDMOND
At the edge of the Snoqualmie-Mount Baker National Forest, a cryptically signed cedar shares turf with big leaf maples, birches, blackberries, and plenty of ferns.
Photo by Jon Canfield

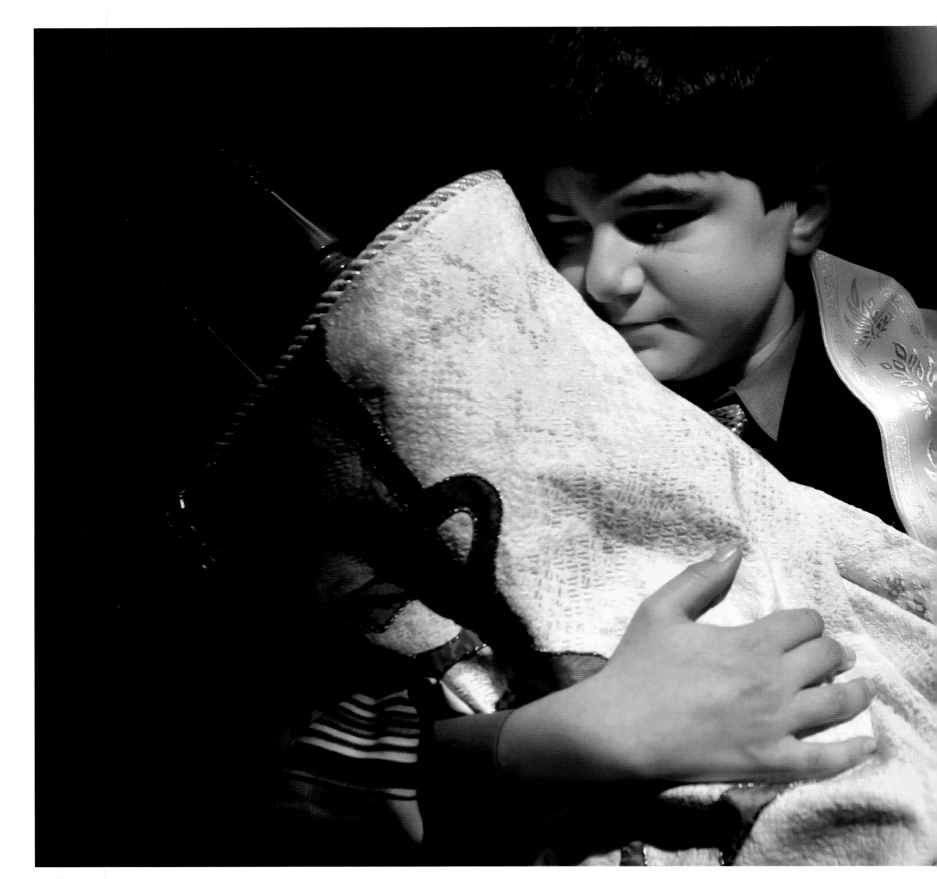

SEATTLE
Practicing for his Bar Mitzvah, Zachary Purcell
embraces the Torah scrolls at Temple Beth Am.
During his service, to be held the next day, the
scrolls will be passed from Zachary's grand-
mother to his mother to him.
Photos by Laurence Chen, LChenphoto.com

SEATTLE

Zachary rehearses his Torah portion, Leviticus verses 35–38, a passage giving instructions on how to treat those in need. For the past six years, Zachary has been studying Hebrew in preparation for his two-hour Bar Mitzvah.

SEATTLE

While her daughter Julia looks on, Peggy Crastnopol/Purcell straightens her son's *tallit*, or prayer shawl.

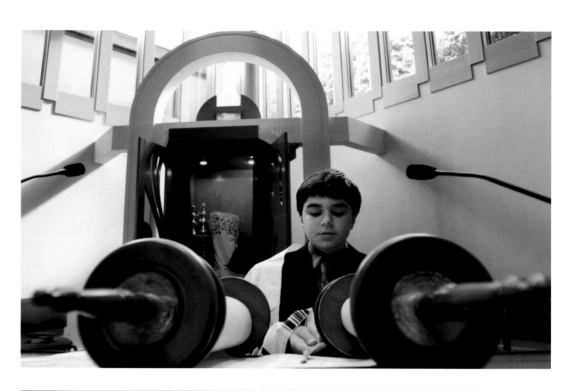

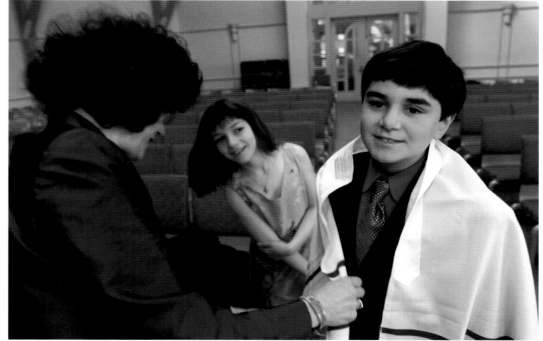

SEATTLE

St. Gebriel Church of Ethiopians holds services every Sunday and Wednesday. In the mid-1970s, fleeing civil war and famine, Ethiopian refugees began immigrating to the United States. Today, there are more than 3,000 Ethiopians living in the Seattle area.

Photos by Casey Kelbaugh

SEATTLE

Women sit in pews on one side and men on the other at St. Gebriel's. Services are held in Amharic, the official language in Ethiopia.

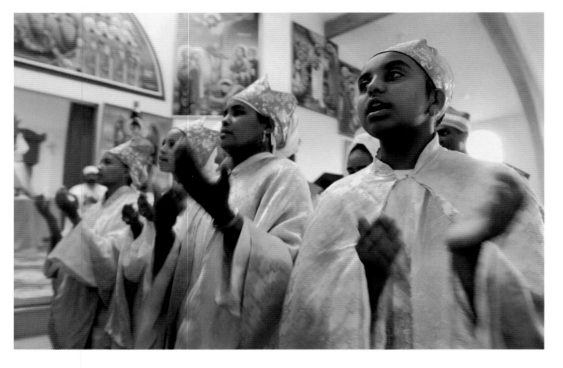

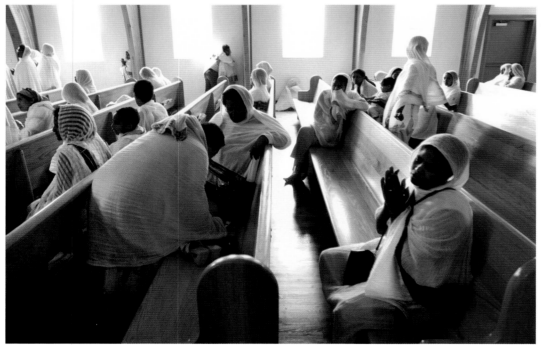

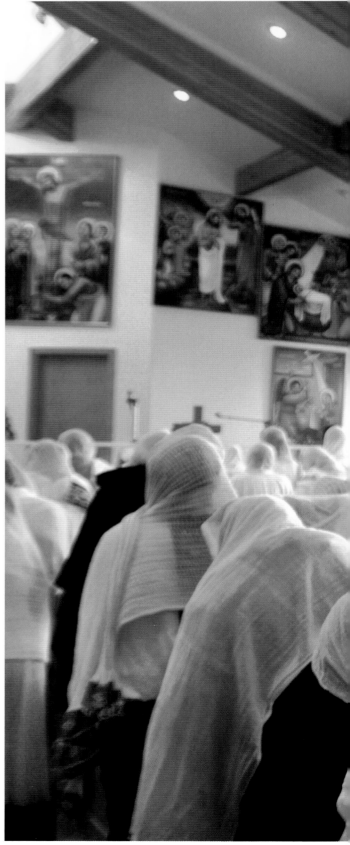

SEATTLE

The church, designed by Ethiopian engineers and architects, was completed in 2000. The $1.5 million building was funded without any loans. St Gebriel parishioners raised the money themselves through weekly collections over a four-year period.

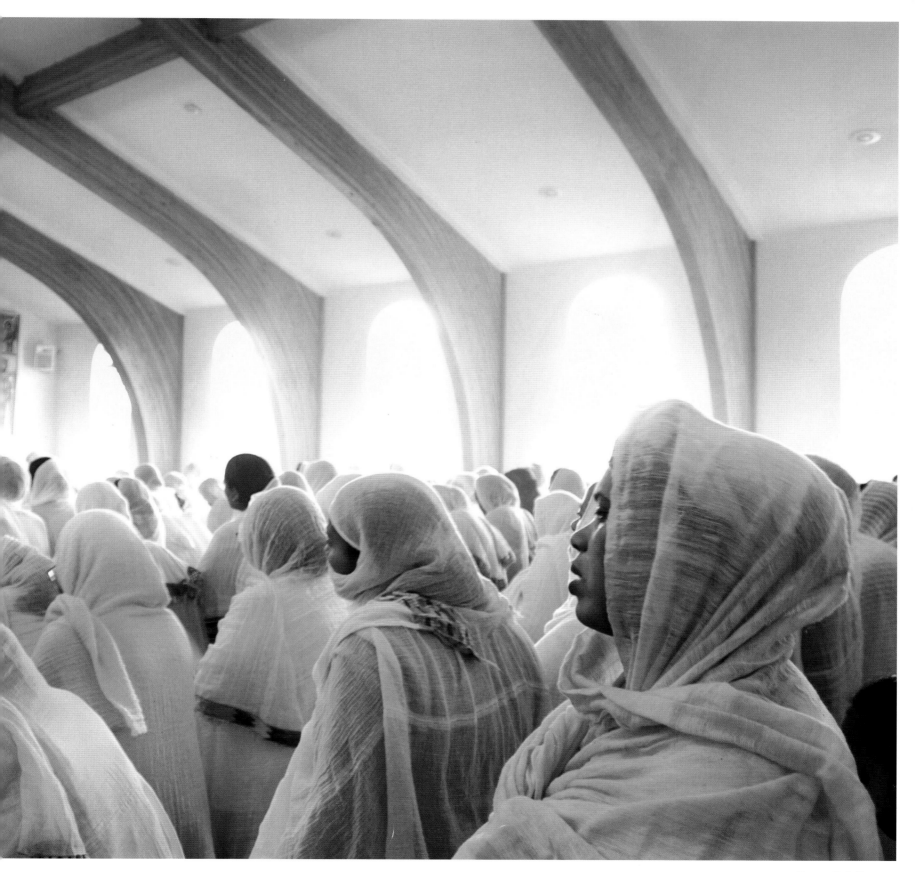

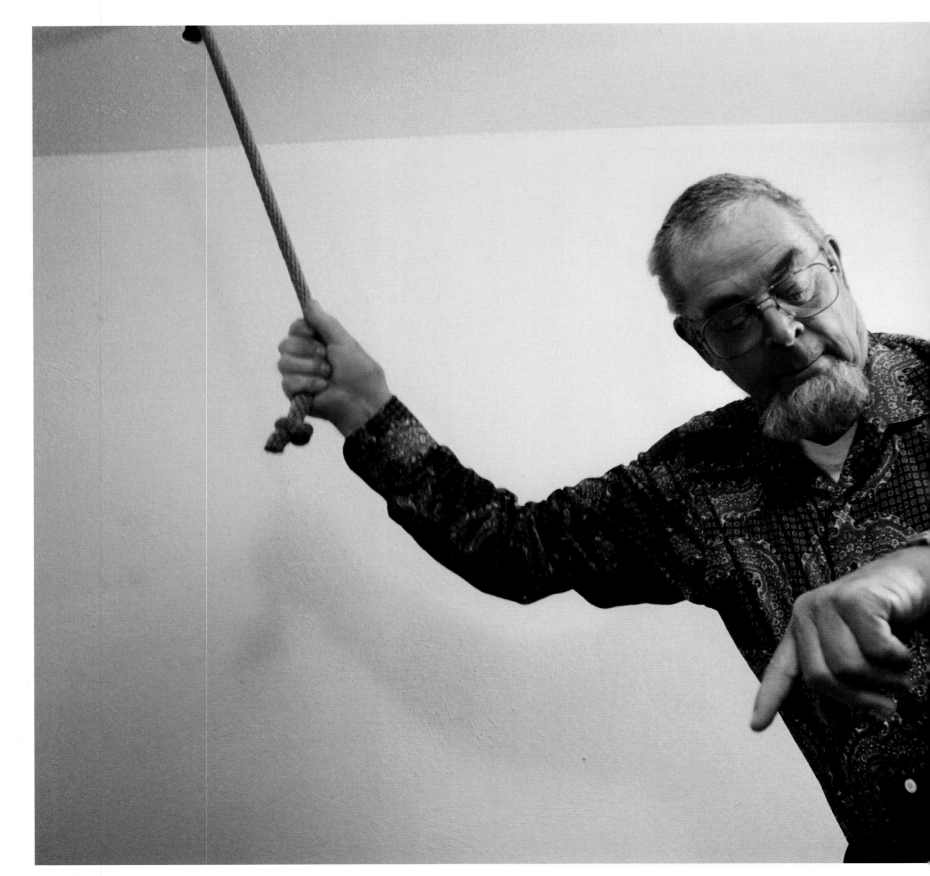

WENATCHEE
In the bell tower of The Sunnyslope Church, Ordo Stutzman checks his watch to make sure the ringing lasts exactly one minute. Today the bells mark a special occasion—the 100-year anniversary of the church, one of the oldest in the Wenatchee Valley.
Photos by Don Seabrook

WENATCHEE

The Sunnyslope membership poses for a photograph to mark the church's 100-year anniversary. Throughout its history, the church, whose mission is peace, has opposed all war including the two world wars, the Korean and Vietnam Wars, the Gulf War, and the war in Iraq.

WENATCHEE

Children's Time is a regular feature at the church. Youngsters are invited up to the altar where the pastor or a congregant reads them a bible story.

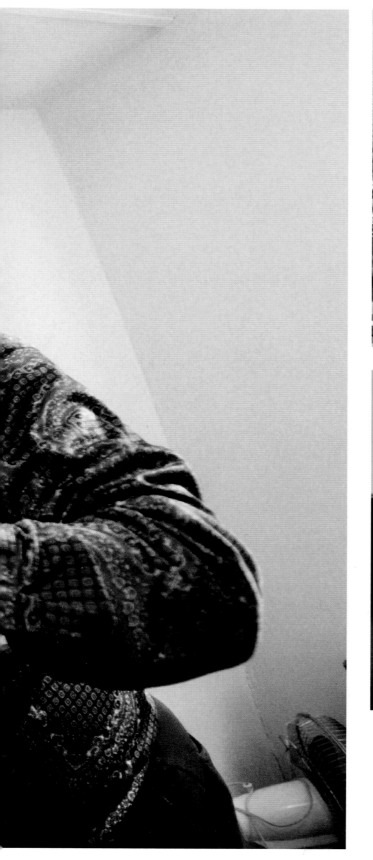

SEATTLE
Holding on to her son Brandon and daughter
Melissa, Nhanh Roeun is overcome by grief
during the cremation ceremony for her hus-
band, Sarith Yorm, who emigrated from
Cambodia in 1984.
Photo by Laurence Chen, LChenphoto.com

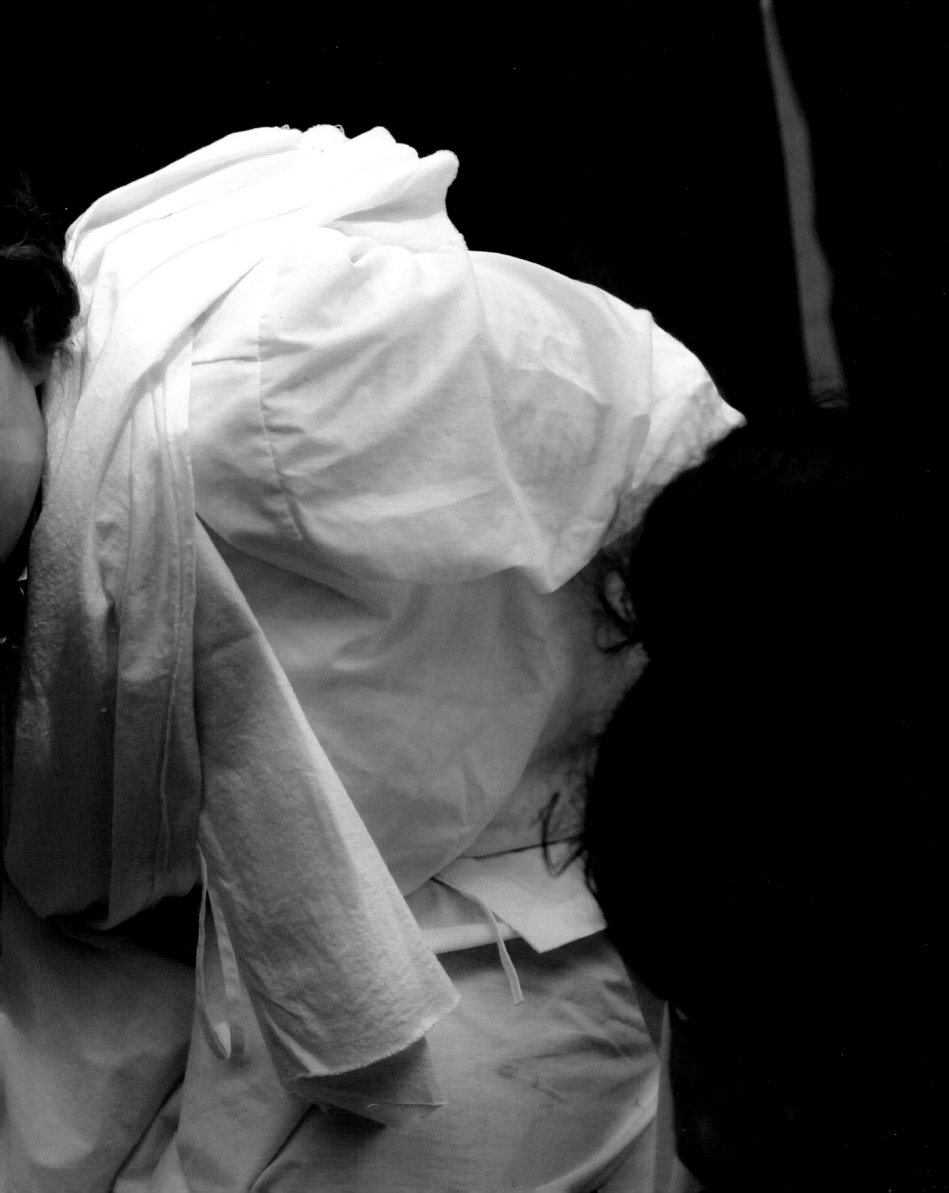

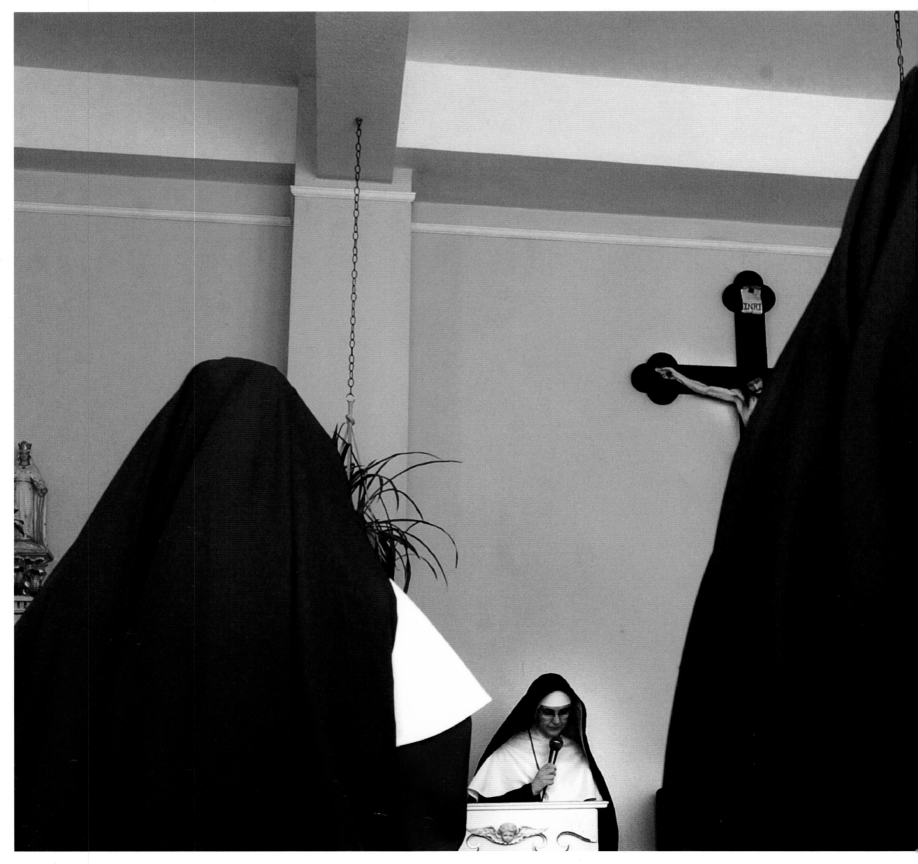

SPOKANE

In the dining hall at St. Michael's Convent of the Sisters of Mary Immaculate Queen, Reverend Mother Mary Katrina makes announcements. The motherhouse is part of Mount St. Michael, a Roman Catholic parish that remains faithful to traditional mass said in Latin and rejects the other liberalizations introduced by Vatican II.
Photos by Torsten Kjellstrand

SPOKANE

Sister Marie Francine ushers her fifth- and sixth-grade students to daily mass. The sisters staff St. Michael's Academy. In addition to teaching, they also run a print shop, religious bookstore, and mail-order center. As a way to raise funds, they formed the Singing Nuns in 1979 and have recorded nine albums.

SPOKANE

"I call this the gravy train," says Reverend Mother Mary Katrina as she carts Daisy down the hall. After each ride, Daisy gets a treat—and she knows it.

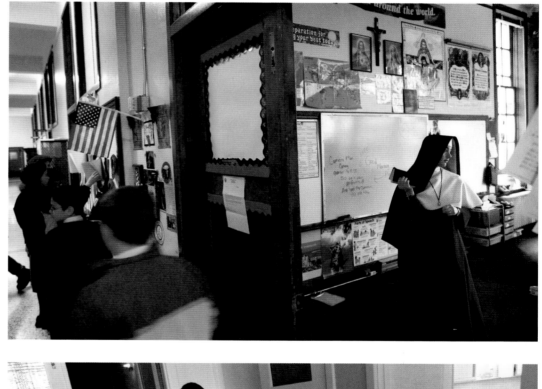

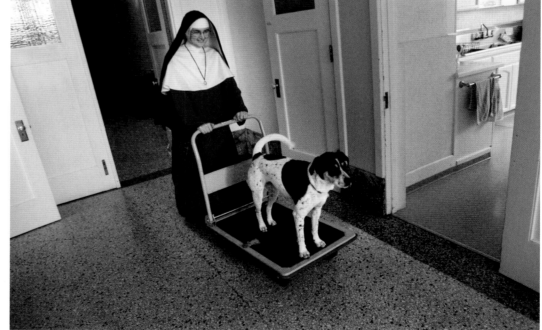

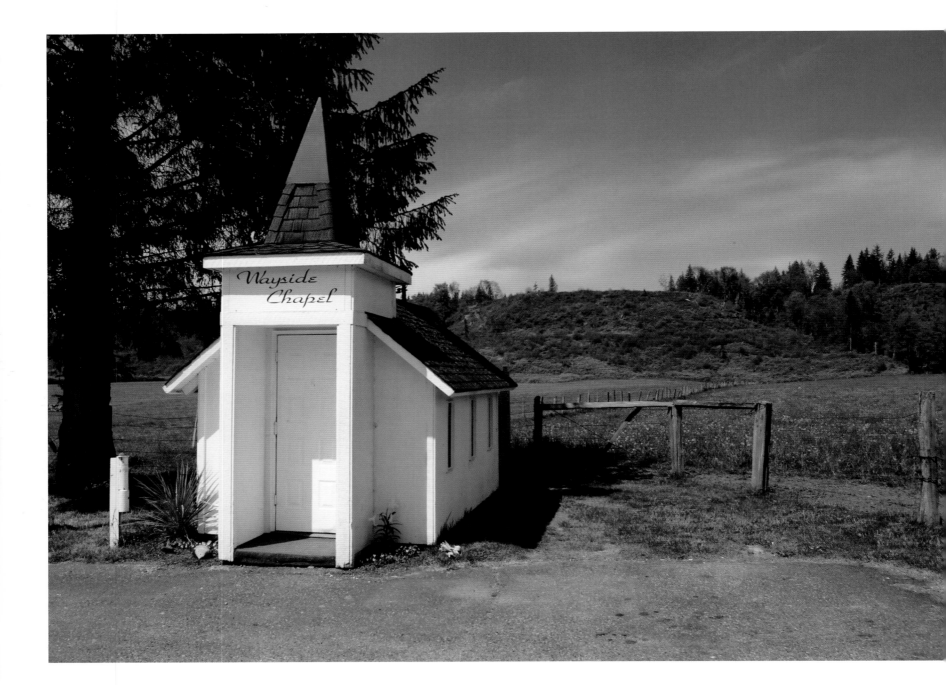

MONROE

Built as a sanctuary for travelers 43 years ago by the townspeople of Monroe, Wayside Chapel hasn't changed much. The tiny, 10-person chapel, a mile west of town on Highway 2, hosts several weddings a year.

Photo by Douglas P. Dobbins

OLYMPIA

Members of Ordo Templi Orientis, a century-old mystic order, gather in one of their apartments for the gnostic mass. Priest Josh Sharp (holding the lance) says his group's supreme injunction is to divine spiritual truth for oneself. Sharp says he learned about the order by reading a tract that British occultist Aleister Crowley wrote and which Sharp found in a pagan bookstore.
Photo by Mike Salsbury, The Olympian

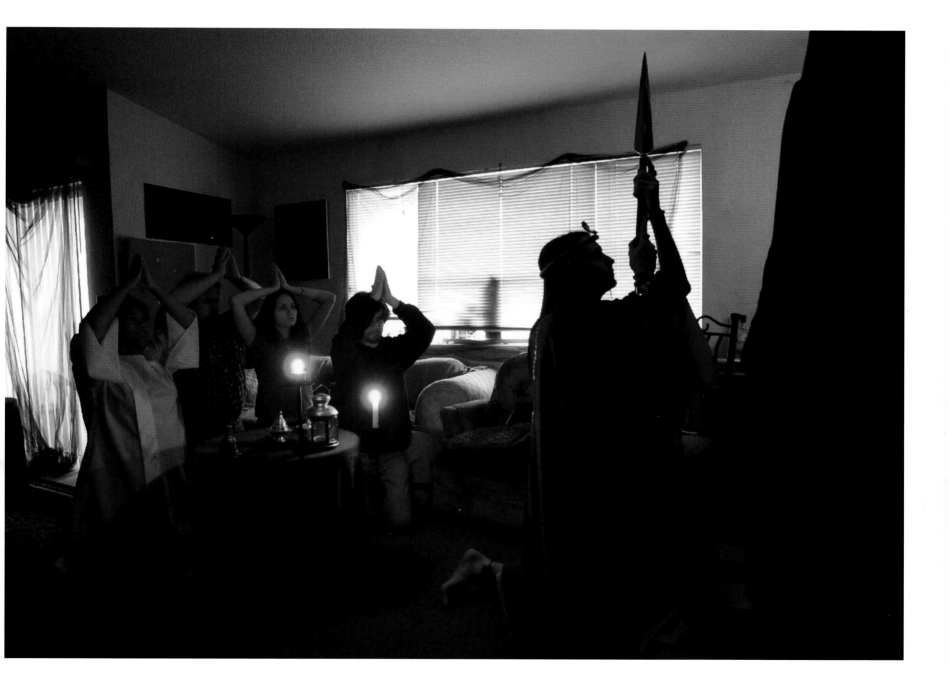

SEATTLE

Najwa Yosof, 16, anxiously watches the closing seconds of a San Antonio Spurs vs. Los Angeles Lakers game. Najwa, who plays hoops herself, came to King's Fried Chicken with her girlfriends, but she abandoned them to move closer to the television.
Photo by Laurence Chen, LChenphoto.com

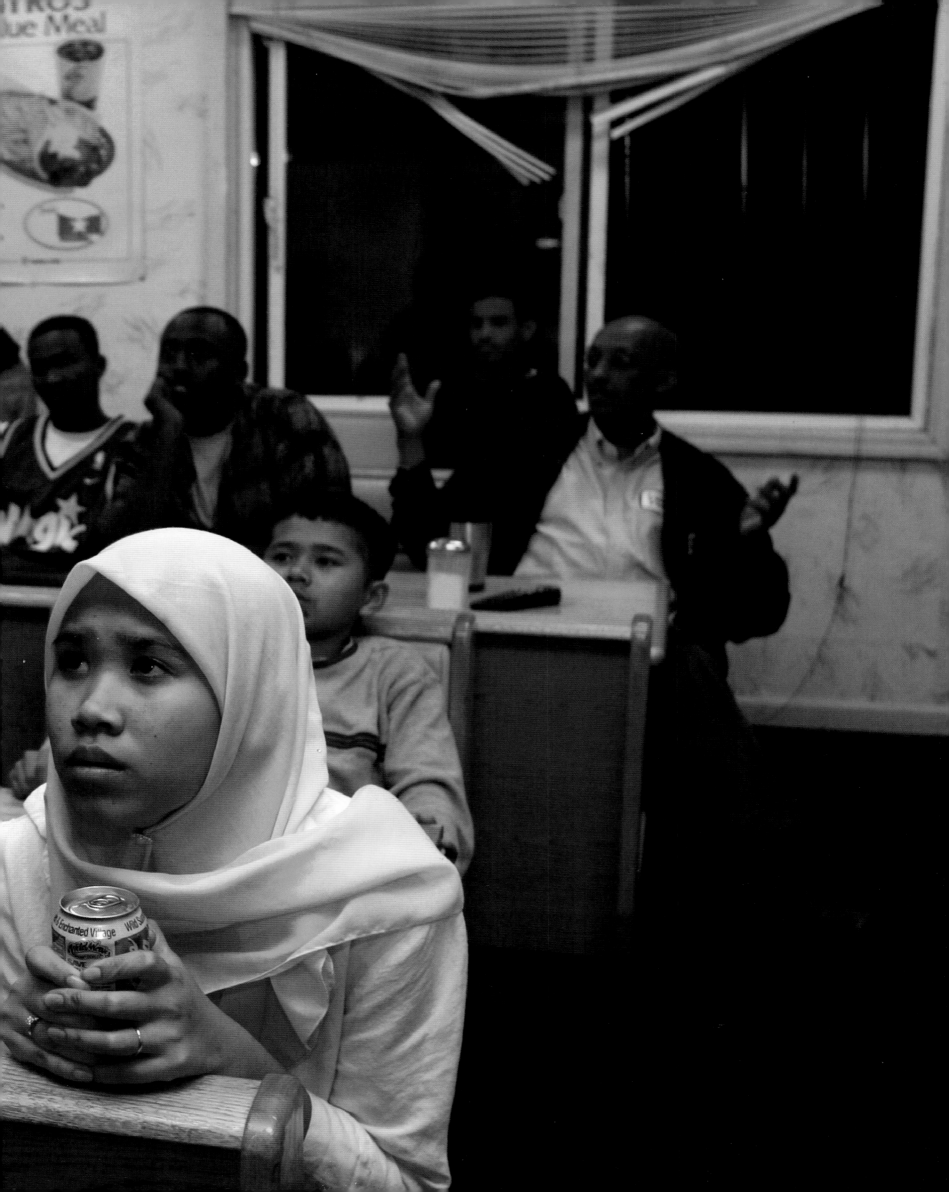

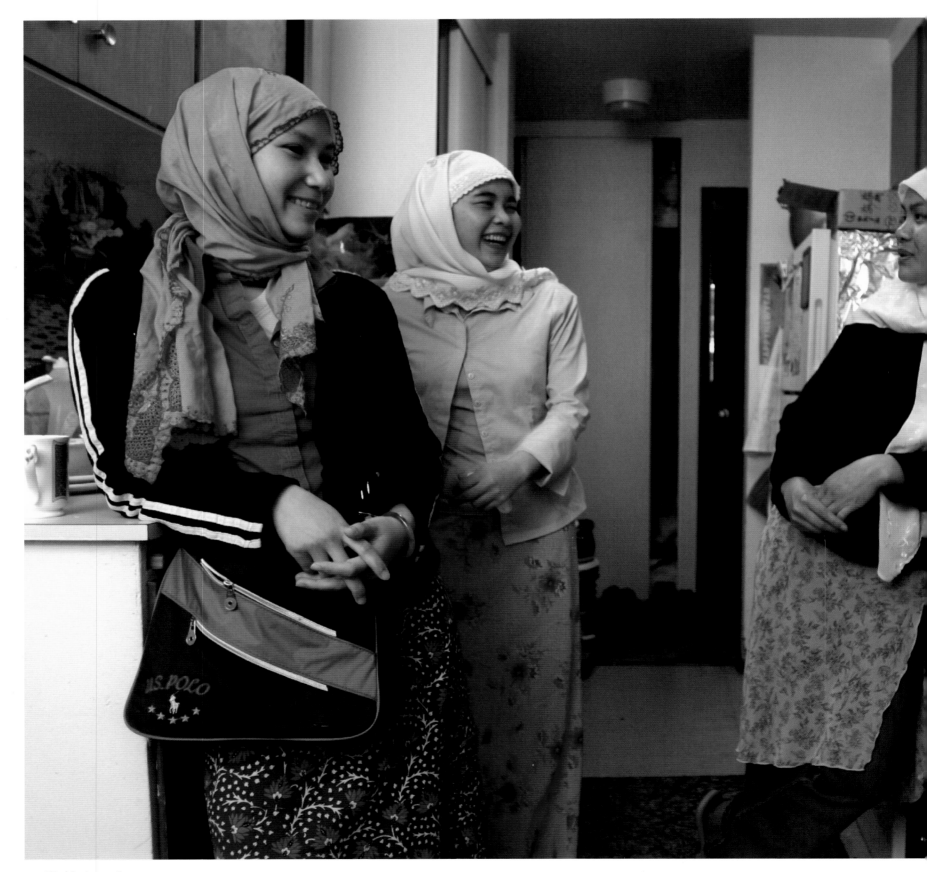

SEATTLE

As descendants of the Kingdom of Champa, an
ancient Muslim civilization that occupied what is
now central Vietnam, Salimah Man, Imana Chau,
Silamah Kieu, and Yuhanzie Chau perform a daily
balancing act between their culture's traditions
and modern-day life.

Photos by Laurence Chen, LChenphoto.com

SEATTLE

Imana Chau prays after class in a prayer room at South Seattle Community College. Chau, who is studying to be a nurse, prays five times a day. She is one of the 99,000 Cham people left worldwide. Before they were vanquished by the Vietnamese in the 1500s, the Cham numbered 2.5 million.

SEATTLE

Seeking religious freedom, the Chaus clan left Vietnam in 1998. Now they gather in their living room on Saturday and Sunday mornings to study *Fiqh*, or Islamic law; hadith, the statements of Muhammad; and *Cham*, their native language.

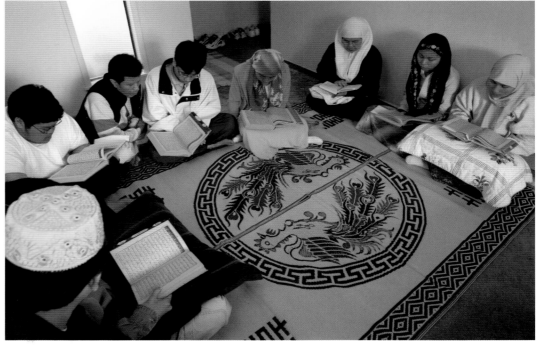

SEATTLE

We built this city. From gritty origins as a lumber depot and gold rush destination, Seattle, with its software titans and aviation workers, found itself on the cutting edge of the nation's economy at the close of the 20th century. Then the city suffered the dot-com crash, and 9/11 walloped Boeing. And they're still trying to figure out what to do about the traffic.

Photo by Paige Baker

Our Town

SEATTLE
At dusk, the Bainbridge Island–Seattle ferry approaches the city from the west. Since the early 1900s, ferries have navigated the waters of Puget Sound. What was meant as a temporary means of transport until bridges could be built has evolved into Seattle's quintessence.
Photo by Alan Berner

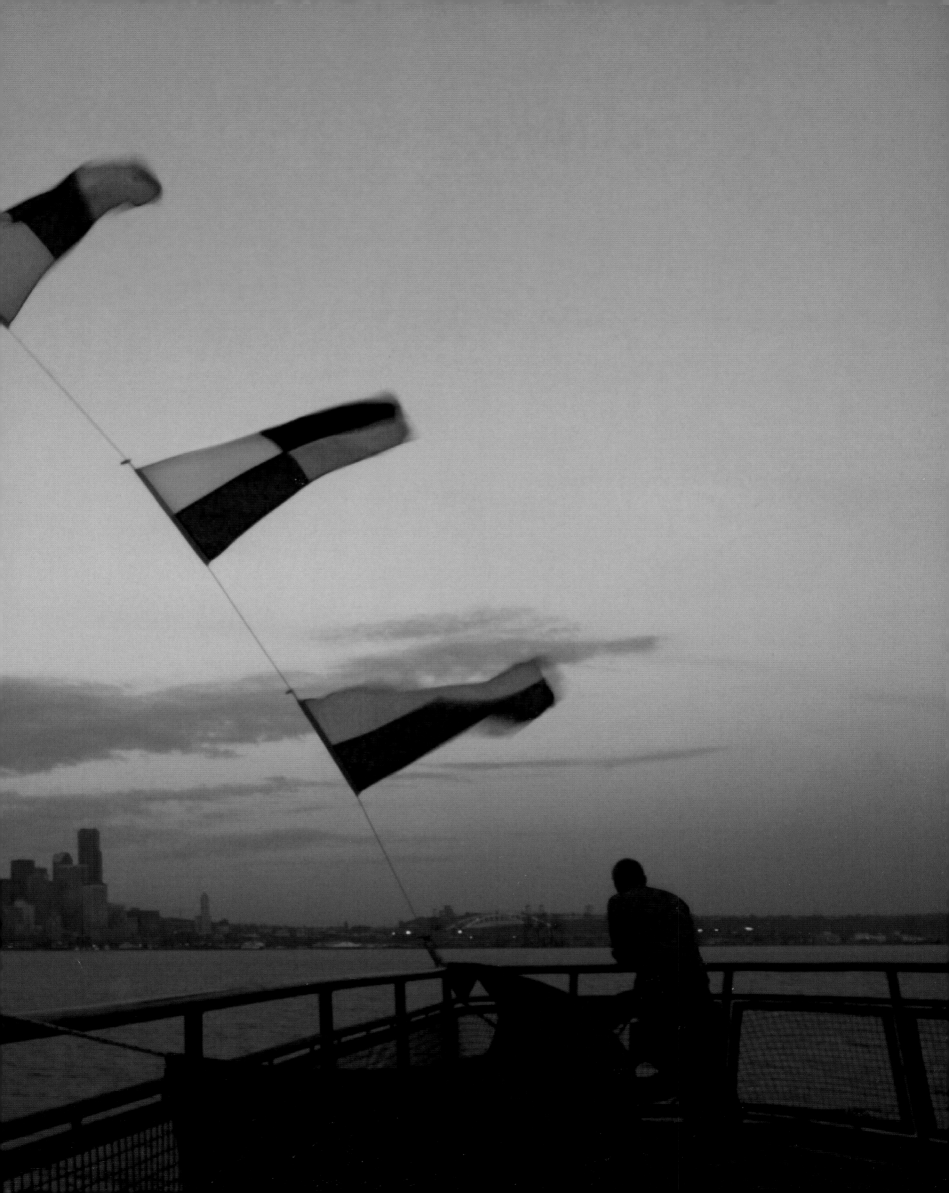

SAN JUAN CHANNEL

Window washing waits for no one: Craig Hansen, Washington State Ferries deckhand, keeps it ship-shape during a lunch-hour voyage from Friday Harbor to Orcas Island. America's largest ferry system, it has 10 routes, 20 terminals, and 29 vessels, carrying commuters and tourists through the inland waterways and British Columbia.

Photo by Tony Overman, The Olympian

HARNEY CHANNEL

Students from Lake City Junior Academy in Coeur d'Alene, Idaho, test the principles of physics while riding the ferry between Shaw and Orcas Islands. The kids are on a weeklong science and history trip to the San Juans.

Photo by Tony Overman, The Olympian

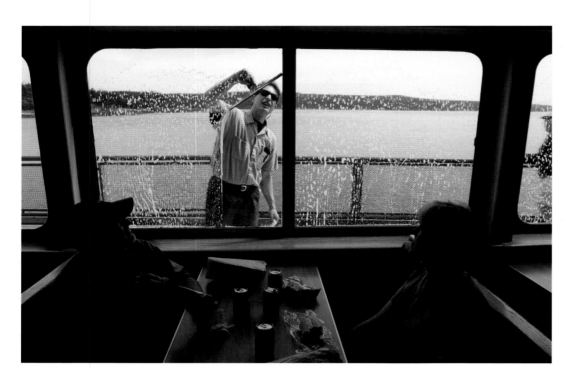

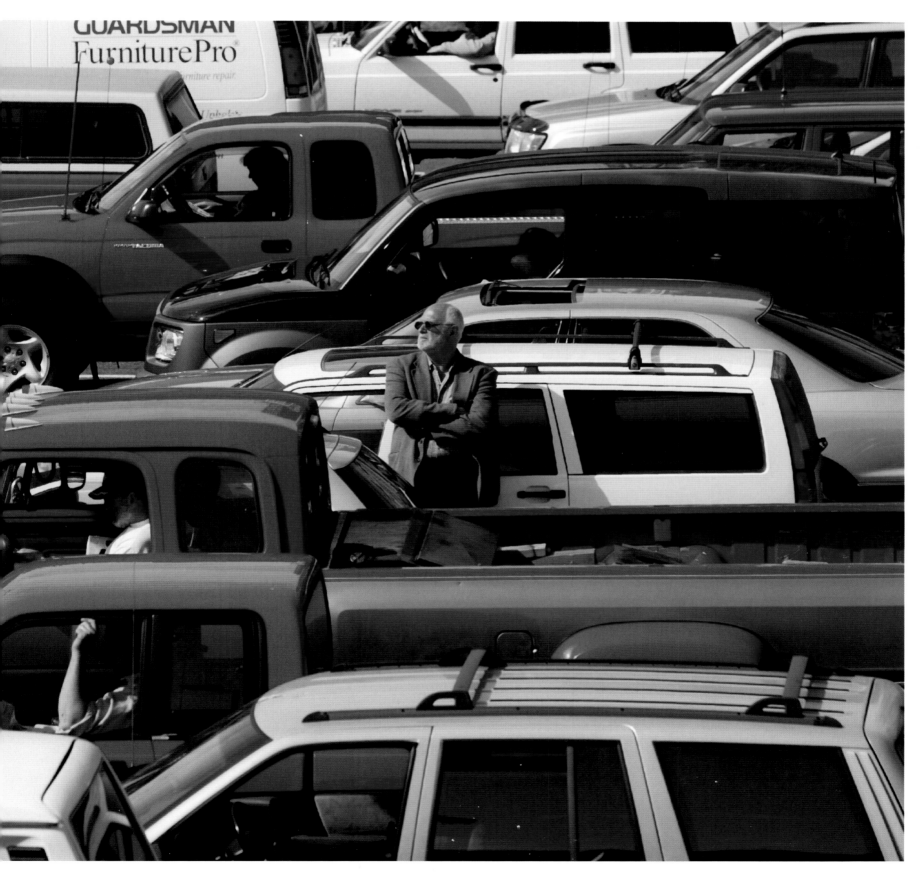

SEATTLE
Technically, it's not a parking lot. Travelers wait in the holding area of the Pier 52 terminal for the Bainbridge Island car ferry to arrive. Crossing to the Kitsap Peninsula takes about 35 minutes.
Photo by Alan Berner

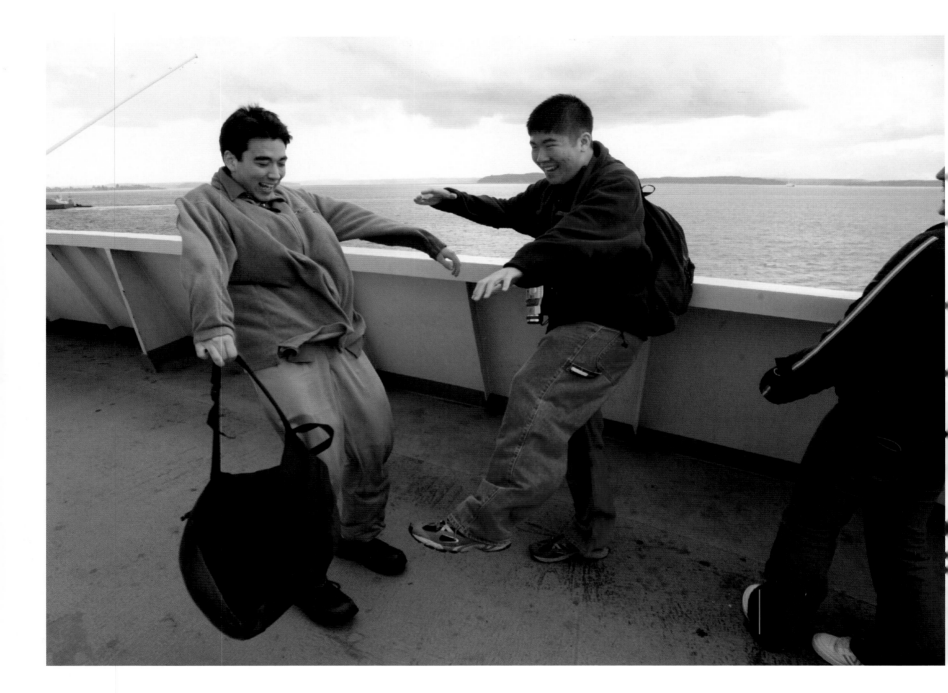

PUGET SOUND
On the bow of the ferry *Tacoma*, bound from
Seattle for Bainbridge Island, University of
Washington students Kenji Crosland and Andrew
Oh confront the brisk Puget Sound winds.
Photo by Alan Berner

ANACORTES

Catbird seat: Barnum and Bailey, platinum mink Tonkinese brothers, soak up the sun and sniff the sea breeze in the ferry's staging area. After a brief trip to the mainland, they're on their way back home to Friday Harbor.
Photo by Tony Overman, The Olympian

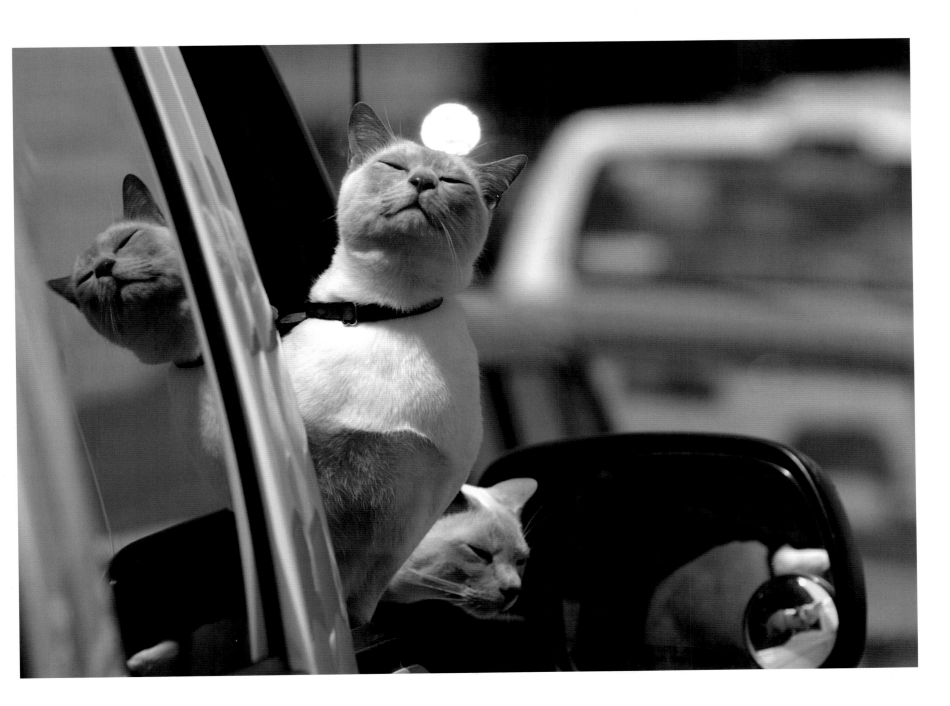

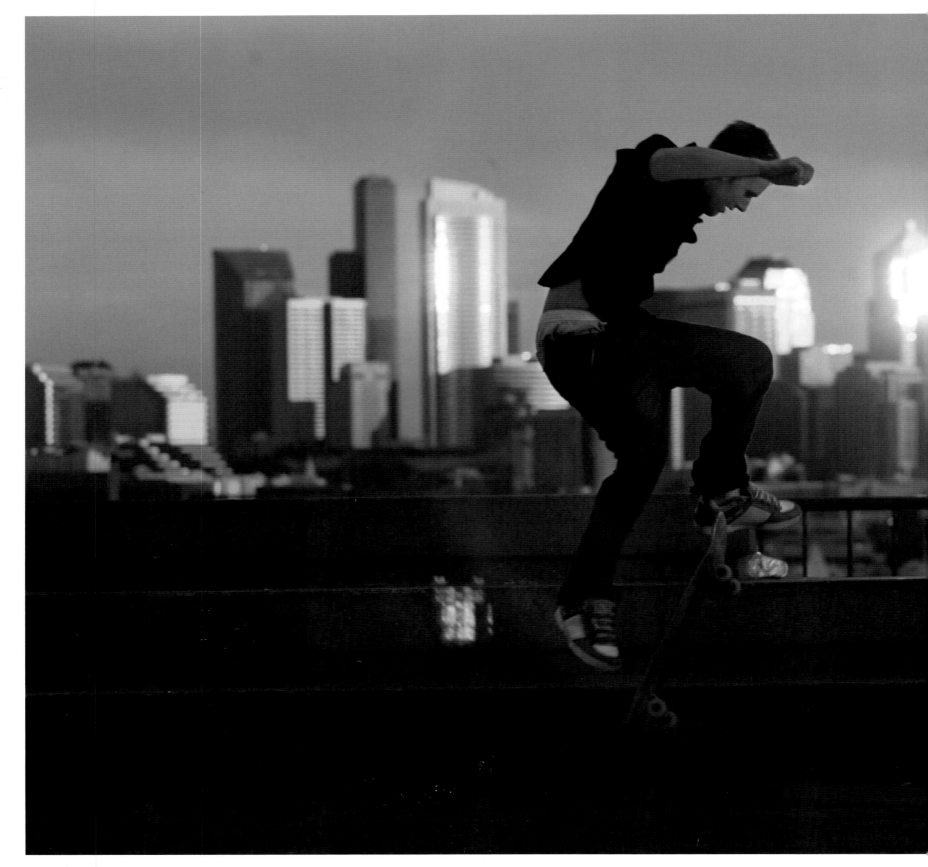

SEATTLE
Greg Smith of Bellingham shows off his moves—
as well as his boxers—in Gas Works Park. The
20-acre grassy plot on the north shore of Lake
Union was once a gas, coal, and crude oil manu-
facturing plant. Imported natural gas rendered it
obsolete in the 1950s. The derelict site became an
urban oasis 1975.
Photo by Alan Berner

When the outdoor recreation retailer REI wanted a focal point for its flagship store, "the Pinnacle" did just the trick. A guaranteed dry place to climb, the store's freestanding indoor wall is so popular that customers must make a paid reservation to climb it. Here, employee Corey Sampson belays down the 65-foot reinforced concrete structure. *Photo by Nathan P. Myhrvold*

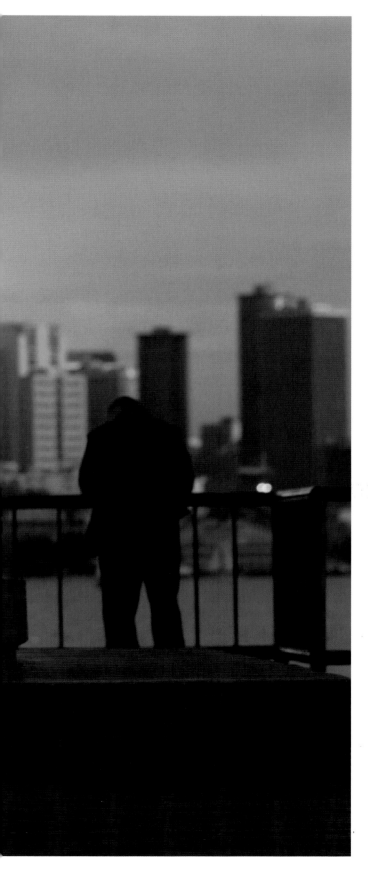

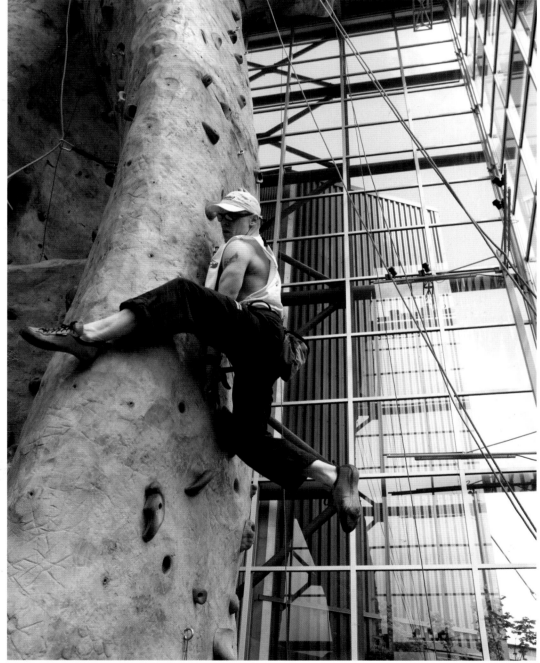

WALLA WALLA COUNTY

America's largest privately owned wind farm collects gusts on a ridge between Washington and Oregon. The 454 turbines, owned by FPL Energy, span 11 miles. Under blustery conditions, this farm can produce enough energy to run 70,000 homes. Startup costs are almost twice that for gas generators, but the raw material, say wind power proponents, is free and clean.
Photo by Kirk Hirota

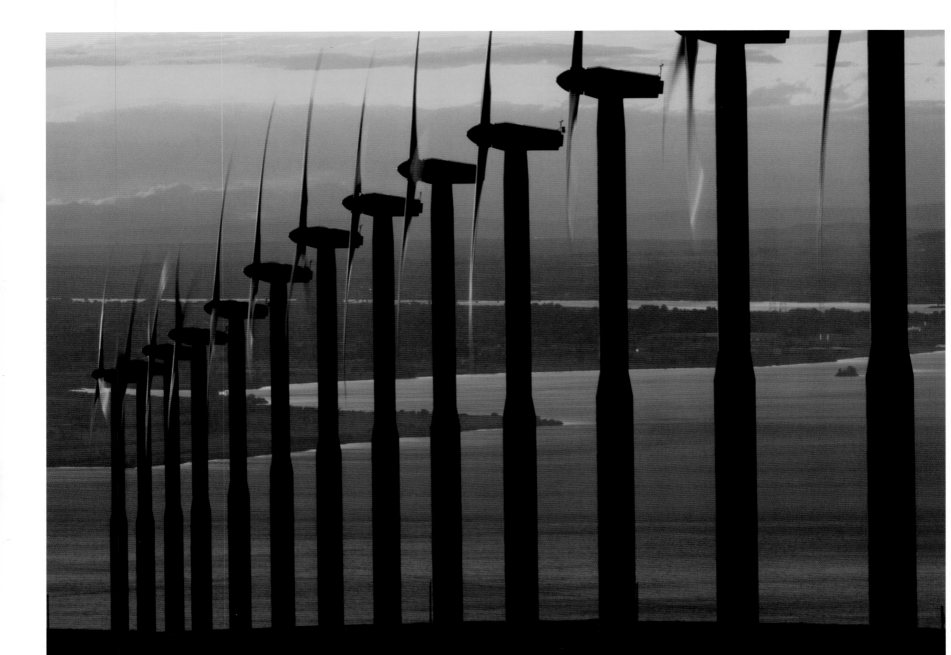

SEATTLE

The I-90 Floating Bridge connects Seattle and Mercer Island. Built in 1940, the bridge was listed with the National Register of Historic Places until a worker accidentally left a pontoon valve open and sank it in 1990. The new bridge was completed in 1993.

Photo by Wayne Hacker, WarrenImages.com

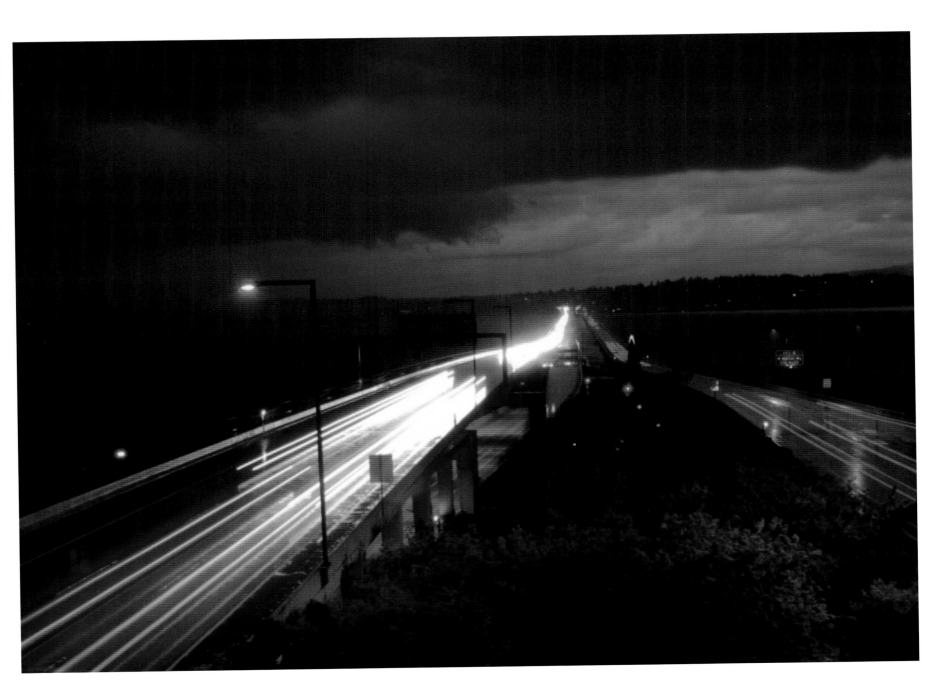

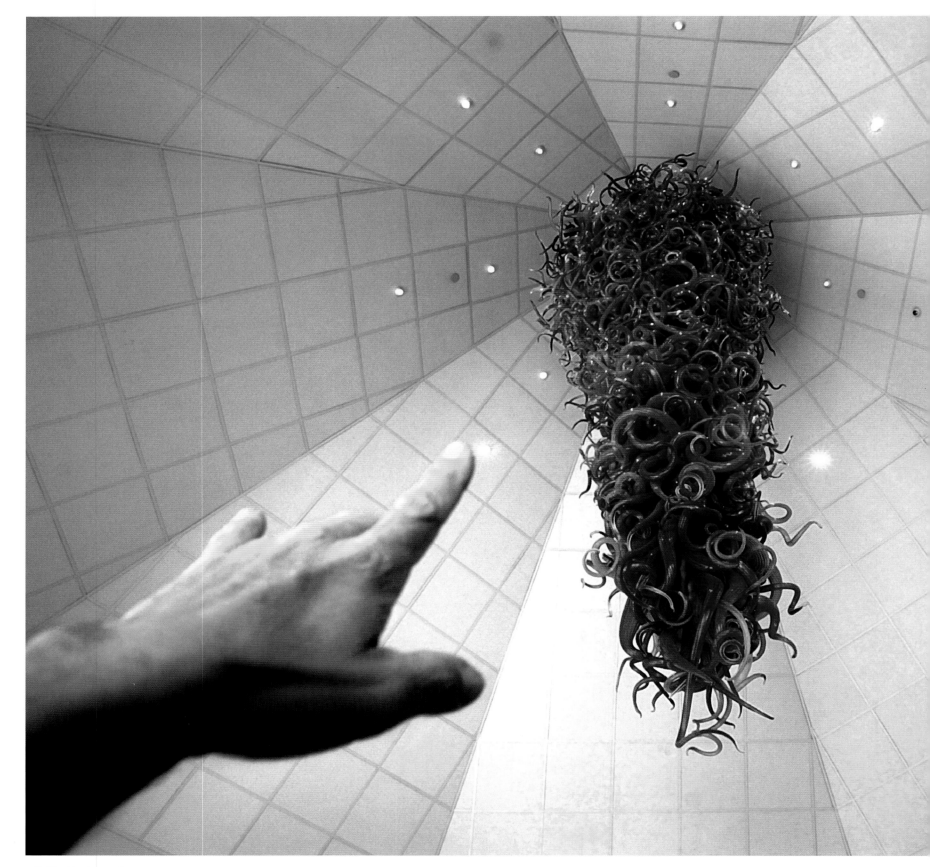

SPOKANE

In the Pacific Northwest, the name Dale Chihuly is synonymous with art. Chihuly and his studio created this 19-foot-tall chandelier, made of 800 separately handblown glass forms, for the Jundt Art Center and Museum at Gonzaga University.

Photo by Christopher Anderson,
The Spokesman-Review

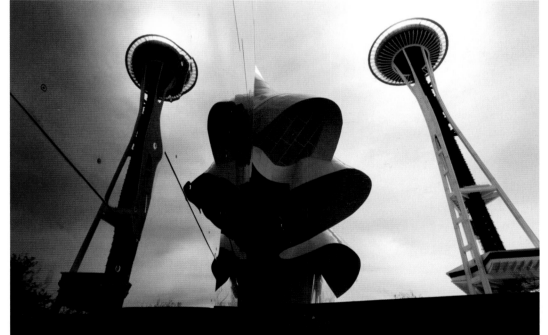

TACOMA

Seattle artist Buster Simpson's temporary installation, *Incidence*, adorns the Museum of Glass's rooftop reflecting pool. Constructed from 36 panes of 1/2-inch-thick, four-by-eight-foot glass. Reflected in the pools is the Hot Shop Amphitheater, where artists give glass blowing demonstrations.

Photo by Anthony M. Culanag, F/22 Studioworks

SEATTLE

Dedicated to Seattle son Jimi Hendrix, the indecipherable building on the left is named after his 1967 album, "Are You Experienced?" The Experience Music Project uses a mix of interactive exhibits and live performances to honor Hendrix and other rock 'n' roll legends including Bob Dylan, Hank Williams, and Kurt Cobain.

Photo by Blake Woken

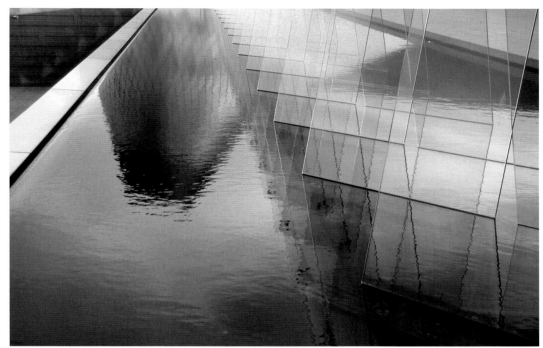

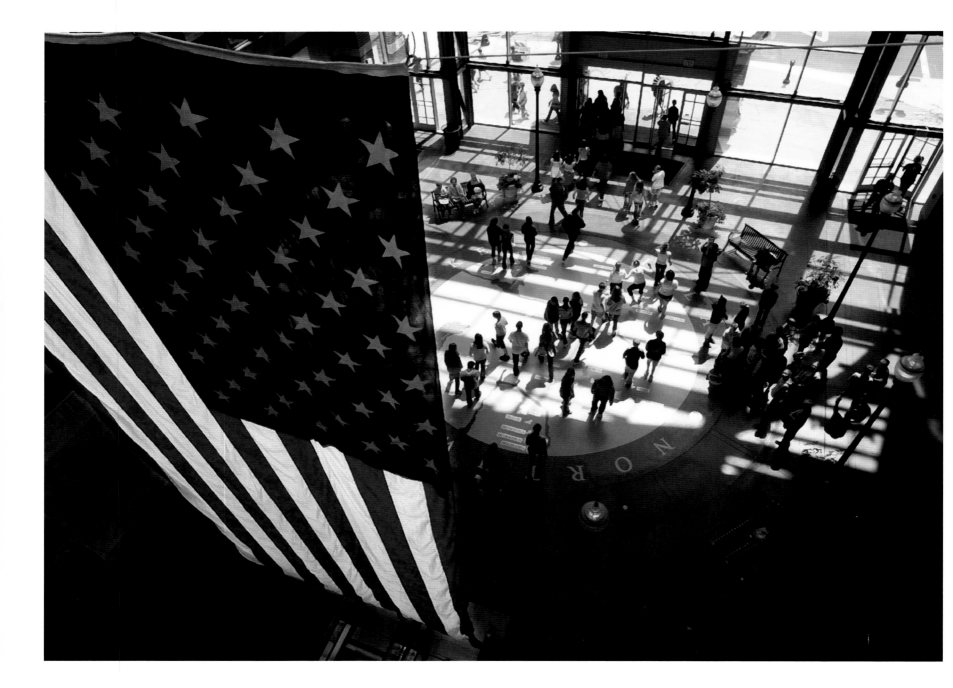

SPOKANE

After 9/11, the River Park Square Mall put up an enormous American flag. It comes down only to make room for Christmas decorations—or to celebrate a winning streak by Gonzaga's basketball team.

Photos by Christopher Anderson,
The Spokesman-Review

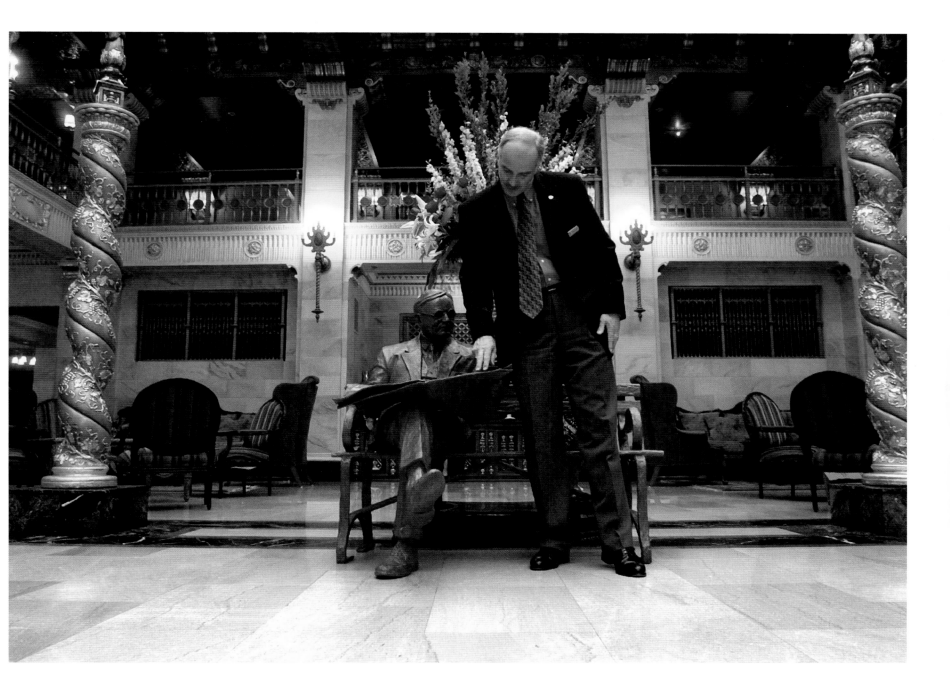

SPOKANE

The bronze Mr. Davenport abides the lobby of the renovated Davenport Hotel. The 90-year-old landmark hotel was crumbling and heading toward demolition when local entrepreneurs Walt and Karen Worthy decided to save it. Forty million dollars later, it's again a showplace and the pride of Spokane. Director of security Chris Powell investigates old news.

On May 20, voters in Sultan (pop. 3,344) got to decide whether to change their municipal government from a mayor-and-council arrangement to a council-and-manager one—or not. With 54-percent voter participation, the proposal was defeated, 595 to 481.

Photo by Casey Kelbaugh

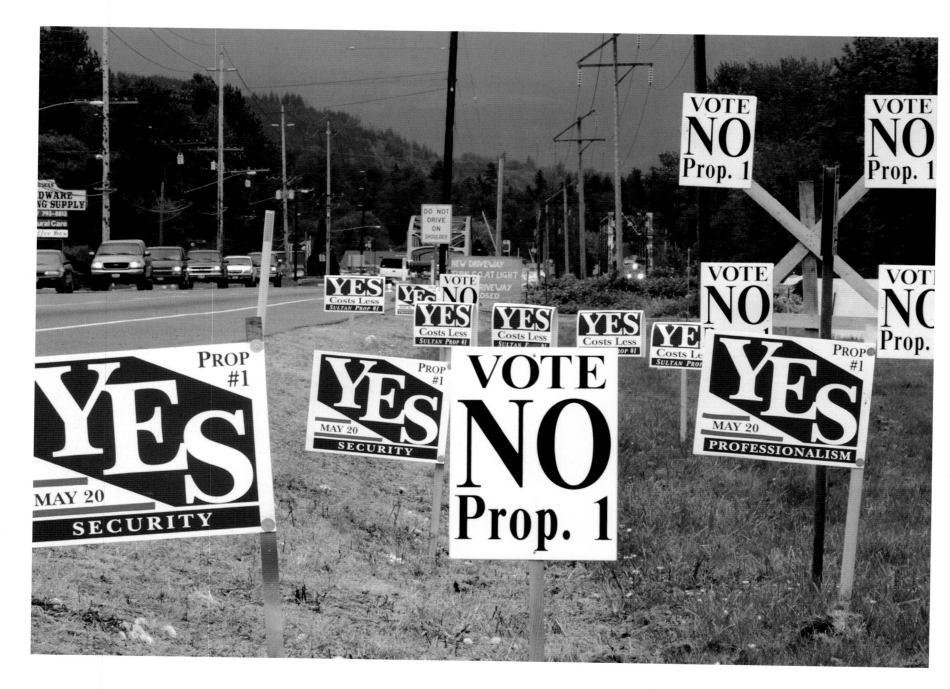

SEATTLE

At Pike Place Market, Nathan Nies informs people that although police are responding to a "dirty bomb" threat, it's just a $16 million drill. He hands out flyers depicting the president that read: "Bush has proved empty warheads are still dangerous."
Photo by Alan Berner

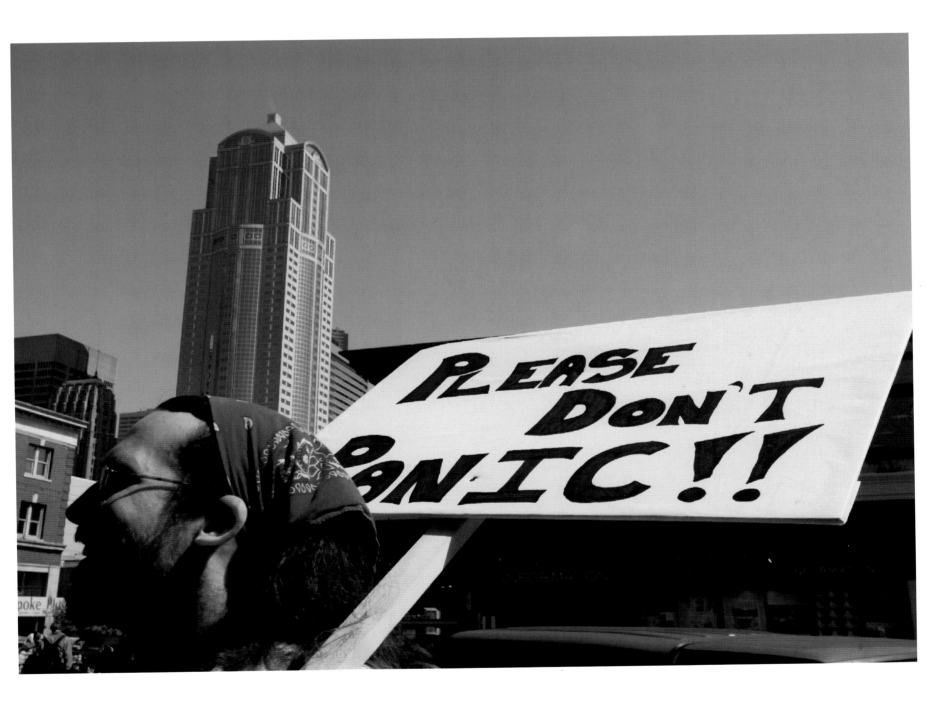

WINTHROP

Loan administrative clerk Dian Brown works at Washington's last remaining family-owned bank. The Farmers State Bank has graced Riverside Avenue in downtown Winthrop since 1915.
Photo by Blake Woken

SEATTLE

In 1901, John Nordstrom used his take from the gold rush in Alaska to open a shoe shop in Seattle. Today, the flagship Pine Street department store in downtown Seattle is one of 148 Nordstrom stores nationwide.
Photo by Rick Wong

SEATTLE

Seattle gets an average of 75 days of sunshine annually. A sloop eases along the Puget Sound waterfront, tempting office workers to rethink their schedules.
Photo by Nathan P. Myhrvold

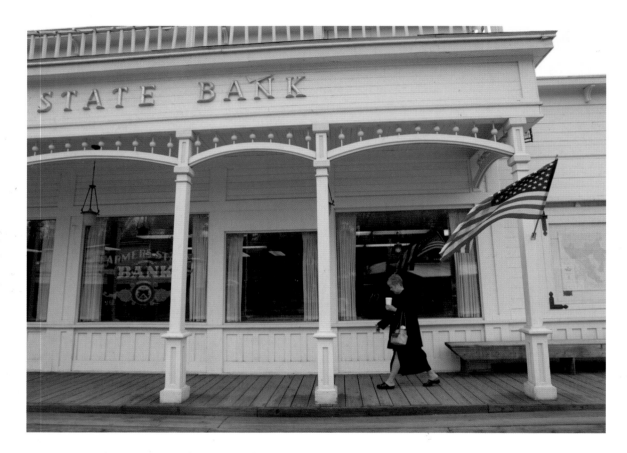

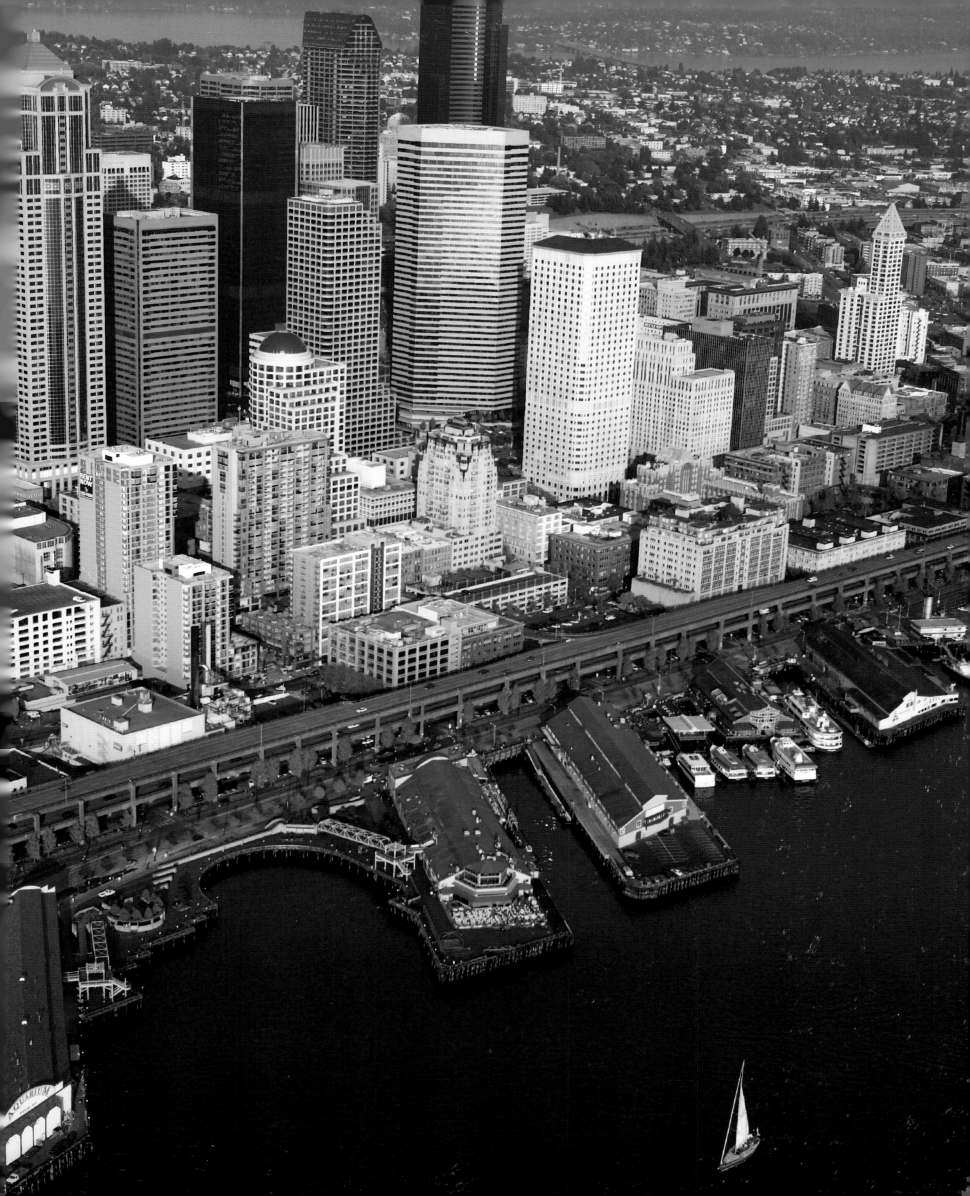

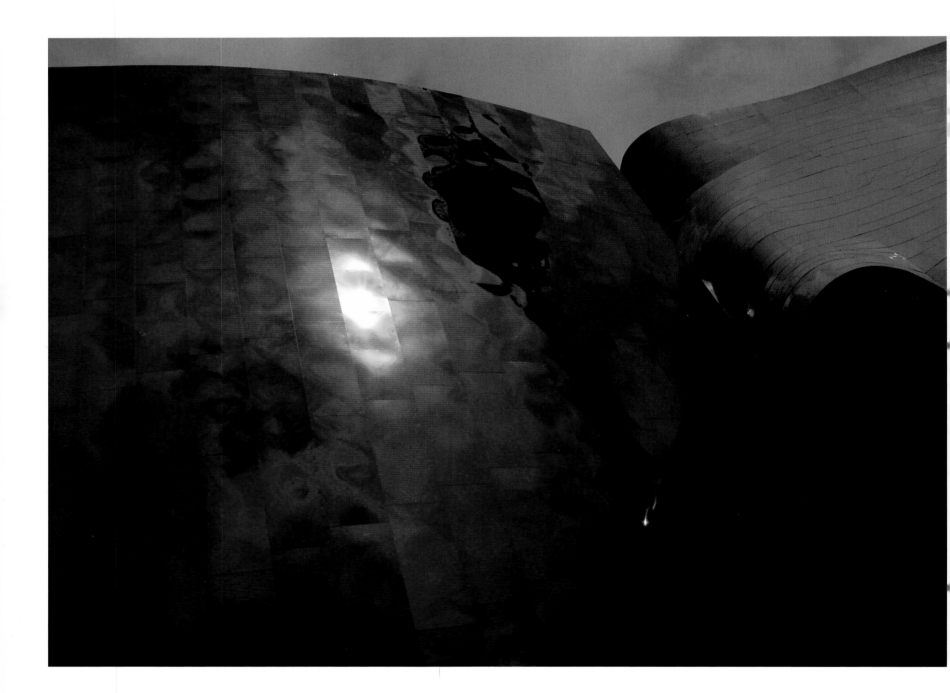

SEATTLE
The 140,000-square-foot, $100 million Experience Music Project building was designed by superstar architect Frank Gehry and paid for by Microsoft cofounder Paul Allen. Gehry describes his creation, modeled after the swooping shape of an electric guitar, as "huggable."
Photo by Rick Wong

CRESTON

Twenty-five grain farms span 16,000 acres and cover the Creston Valley in the Columbia River Plateau, west of Spokane. The area's wheat crop travels the world markets and feeds families as far away as Pakistan.

Photo by Torsten Kjellstrand

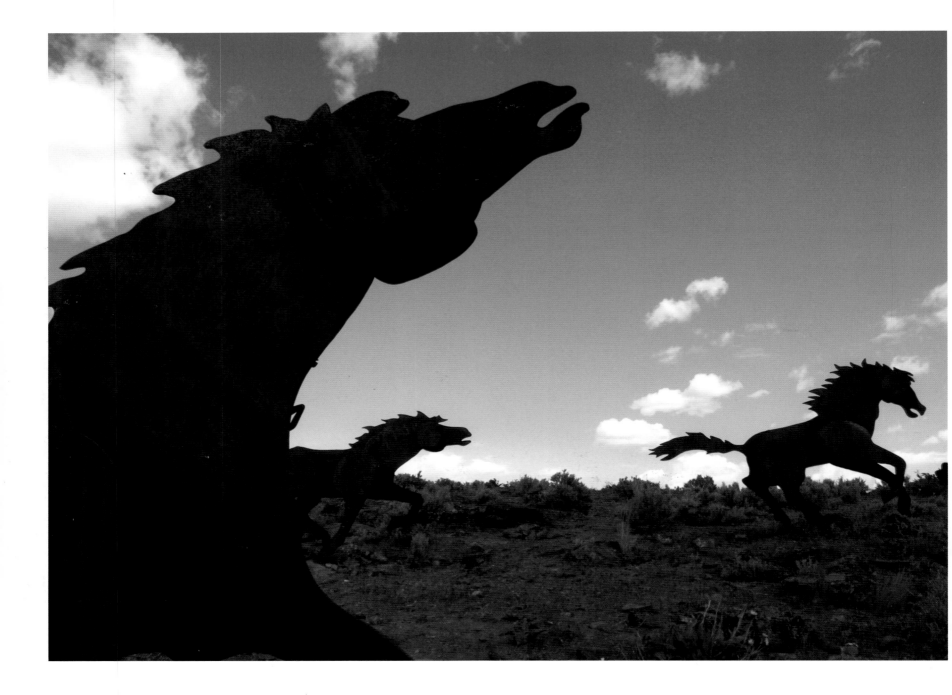

VANTAGE

The iron steeds of Wild Horse Monument gallop across a bluff in Central Washington where the Great Basin and Saddle Mountains converge— and where I-90 crosses the Columbia River. "This is wild-horse country," artist David Govedare once explained. "And my work is full of that imagery, the whole sense of freedom and balance among humans, animals, and the environment."
Photo by Douglas P. Dobbins

WASHTUCNA
Tumblin' tumbleweed. Washtucna winds are so fierce that, on a dusty day, they turn the afternoon sky dark enough for the chickens to roost. Along Highway 6, the fields are rich with young wheat, barley, canola, and alfalfa.
Photo by Kevin German

NEWHALEM

A dogwood tree blooms near Damnation Creek in the 684,000-acre North Cascades National Park. Moisture blowing in from the Puget Sound and the Strait of Juan de Fuca keeps this westernmost portion of the park emerald green year-round.
Photo by Blake Woken

MEDINA

1835 73rd Ave NE. Admittedly, the address doesn't sound extravagant. But the 65-thousand-square-foot home of Bill and Melinda Gates, located on Lake Washington and worth $97 million, is. The 2,100-square-foot library contains, among other items, a Leonardo da Vinci notebook that Gates bought for $31 million.
Photo by Nathan P. Myhrvold

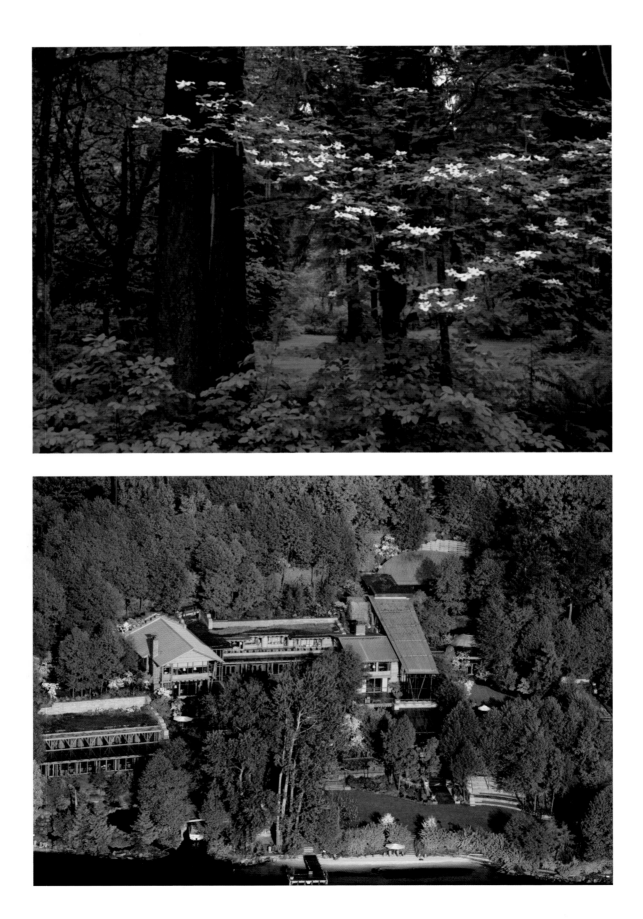

LEAVENWORTH

In the wake of a late spring snowstorm, a patch of sun opens up near the crest of 4,061-foot-high Stevens Pass. The pass gets an average of 30 feet of snow each winter.

Photo by Blake Woken

STEPTOE BUTTE STATE PARK

The verdant Palouse stretches across more than 2 million acres in eastern Washington and western Idaho. This region was originally inhabited by the Palouse people, famous for their Appaloosa horses.

Photo by Rick Wong

MT. RAINIER

Dangerous beauty: At sunset, Mt. Rainier may look chilly, quiet, and majestic, but it is actually an active volcano. Although its last spate of minor eruptions occurred back in the mid-19th century, volcanologists warn that the 14,411-foot-high rock and glacier mass is shifting and should be closely monitored. The peak in the distance is 12,276-foot-high Mt. Adams.

Photo by Nathan P. Myhrvold

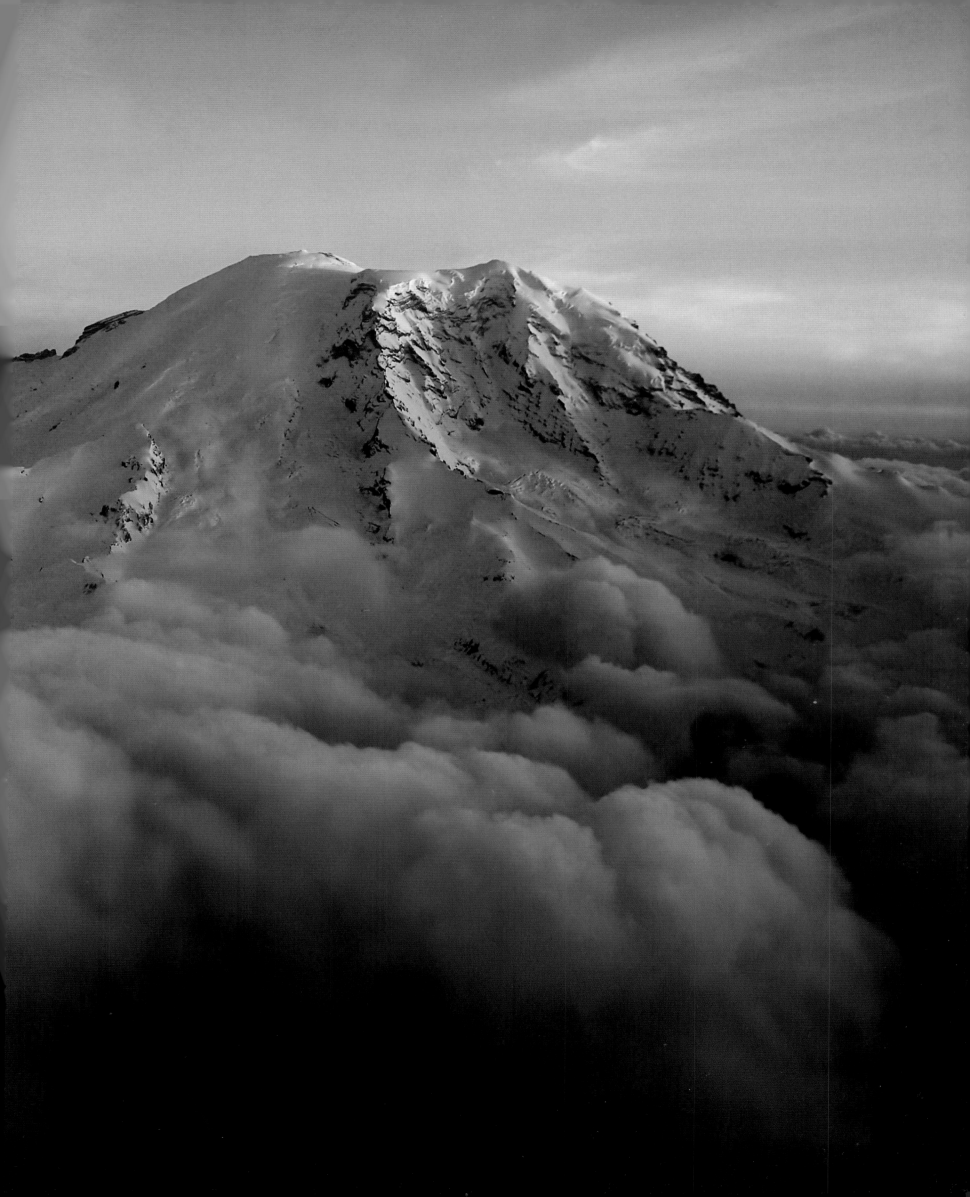

PORT ANGELES
The sun sets the clouds on fire above Hurricane Ridge, a popular lookout area in Olympic National Park.
Photo by Kevin German

How It Worked

The week of May 12-18, 2003, more than 25,000 professional and amateur photographers spread out across the nation to shoot over a million digital photographs with the goal of capturing the essence of daily life in America.

The professional photographers were equipped with Adobe Photoshop and Adobe Album software, Olympus C-5050 digital cameras, and Lexar Media's high-speed compact flash cards.

The 1,000 professional contract photographers plus another 5,000 stringers and students sent their images via FTP (file transfer protocol) directly to the *America 24/7* website. Meanwhile, thousands of amateur photographers uploaded their images to Snapfish's servers.

At *America 24/7*'s Mission Control headquarters, located at CNET in San Francisco, dozens of picture editors from the nation's most prestigious publications culled the images down to 25,000 of the very best, using Photo Mechanic by Camera Bits. These photos were transferred into Webware's ActiveMedia Digital Asset Management (DAM) system, which served as a central image library and enabled the designers to track, search, distribute, and reformat the images for the creation of the 51 books, foreign language editions, web and magazine syndication, posters, and exhibitions.

Once in the DAM, images were optimized (and in some cases resampled to increase image resolution) using Adobe Photoshop. Adobe InDesign and Adobe InCopy were used to design and produce the 51 books, which were edited and reviewed in multiple locations around the world in the form of Adobe Acrobat PDFs. Epson Stylus printers were used for photo proofing and to produce large-format images for exhibitions. The companies providing support for the *America 24/7* project offer many of the essential components for anyone building a digital darkroom. We encourage you to read more on the following pages about their respective roles in making *America 24/7* possible.

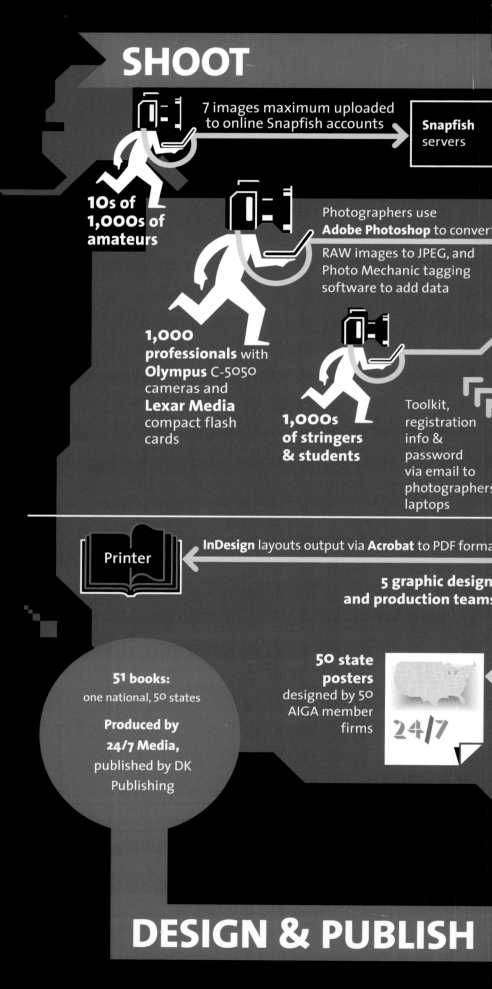

SHOOT

7 images maximum uploaded to online Snapfish accounts → **Snapfish** servers

10s of 1,000s of amateurs

Photographers use **Adobe Photoshop** to convert RAW images to JPEG, and Photo Mechanic tagging software to add data

1,000 professionals with **Olympus** C-5050 cameras and **Lexar Media** compact flash cards

1,000s of stringers & students

Toolkit, registration info & password via email to photographers laptops

InDesign layouts output via **Acrobat** to PDF forma

Printer

5 graphic design and production teams

51 books: one national, 50 states

Produced by 24/7 Media, published by DK Publishing

50 state posters designed by 50 AIGA member firms

24/7

DESIGN & PUBLISH

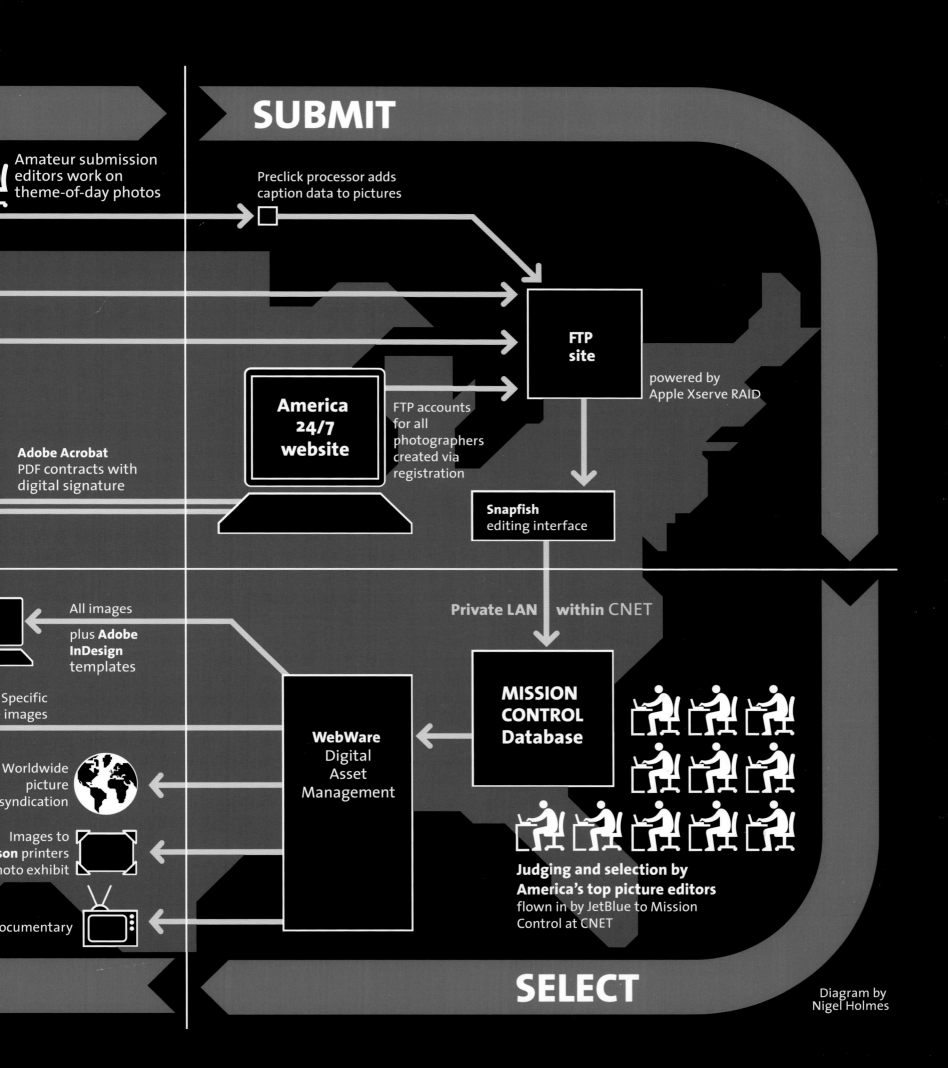

SUBMIT

Amateur submission editors work on theme-of-day photos

Preclick processor adds caption data to pictures

FTP site

powered by Apple Xserve RAID

America 24/7 website

FTP accounts for all photographers created via registration

Adobe Acrobat
PDF contracts with digital signature

Snapfish
editing interface

All images

plus **Adobe InDesign** templates

Specific images

Private LAN within CNET

WebWare
Digital Asset Management

MISSION CONTROL Database

Worldwide picture syndication

Images to ...son printers ...hoto exhibit

...ocumentary

Judging and selection by America's top picture editors
flown in by JetBlue to Mission Control at CNET

SELECT

Diagram by Nigel Holmes

About Our Sponsors

America 24/7 gave digital photographers of all levels the opportunity to share their visions of what it means to live in the United States. This project was made possible by a digital photography revolution that is dramatically changing and improving picture-taking for professionals and amateurs alike. And an Adobe product, Photoshop®, has been at the center of this sea change.

Adobe's products reflect our customers' passion for the creative process, be it the photographer, graphic designer, layout artist, or printer. Adobe is the Publishing and Imaging Software Partner for *America 24/7* and products such as Adobe InDesign®, Photoshop, Acrobat®, and Illustrator® were used to produce this stunning book in a matter of weeks. We hope that our software has helped do justice to the mythic images, contributed by well-known photographers and the inspired hobbyist.

Adobe is proud to be a lead sponsor of *America 24/7*, a project that celebrates the vibrancy of the American spirit: the same spirit that helped found Adobe and inspires our employees and customers to deliver the very best.

Bruce Chizen
President and CEO
Adobe Systems Incorporated

Olympus, a global technology leader in designing precision healthcare solutions and innovative consumer electronics, is proud to be the official digital camera sponsor of *America 24/7*. The opportunity to introduce Americans from coast to coast to the thrill, excitement, and possibility of digital photography makes the vision behind this book a perfect fit for Olympus, a leader in digital cameras since 1996.

For most people, the essence of digital photography is best grasped through firsthand experience with the technology, which is precisely what *America 24/7* is about. We understand that direct experience is the pathway to inspiration, and welcome opportunities like this sponsorship to bring the power of the digital experience into the lives of people everywhere. To Olympus, *America 24/7* offers a platform to help realize a core mission: to deliver and make accessible the power of the digital experience to millions of American photographers, amateurs, and professionals alike.

The 1,000 professional photographers contracted to shoot on the America 24/7 project were all equipped with Olympus C-5050 digital cameras. Like all Olympus products, the C-5050 is offered by a company well known for designing, manufacturing, and servicing products used by professionals to perform their work, every day. Olympus is a customer-centric company committed to working one-to-one with a diverse group of professionals. From biomedical researchers who use our clinical microscopes, to doctors who perform life-saving procedures with our endoscopes, to professional photographers who use cameras in their daily work, Olympus is a trusted brand.

The digital imaging technology involved with *America 24/7* has enabled the soul of America to be visually conveyed, not just by professional observers, but by the American public who participated in this project—the very people who collectively breath life into this country's existence each day.

We are proud to be enabling so many photographers to capture the pictures on these pages that tell the story of who we are as a nation. From sea to shining sea, digital imagery allows us to connect to one another in ways we never dreamed possible.

At Olympus, our ideas have proliferated as rapidly as technology has evolved. We have channeled these visions into breakthrough products and solutions to meet the demands of our changing world-products like microscopes, endoscopes, and digital voice recorders, supported by the highly regarded training, educational, and consulting services we offer our customers.

Today, 83 years after we introduced our first microscope, we remain as young, as curious, and as committed as ever.

Lexar Media has grown from the digital photography revolution, which is why we are proud to have supplied the digital memory cards used in the America 24/7 project. Lexar Media's high-performance memory cards utilize our unique and patented controller coupled with high-speed flash memory from Samsung, the world's largest flash memory supplier. This powerful combination brings out the ultimate performance of any digital camera.

Photographers who demand the most from their equipment choose our products for their advanced features like write speeds up to 40X, Write Acceleration technology for enabled cameras, and Image Rescue, which recovers previously deleted or lost images. Leading camera manufacturers bundle Lexar Media digital memory cards with their cameras because they value its performance and reliability.

Lexar Media is at the forefront of digital photography as it transforms picture-taking worldwide, and we will continue to be a leader with new and innovative solutions for professionals and amateurs alike.

Snapfish, which developed the technology behind the *America 24/7* amateur photo event, is a leading online photo service, with more than 5 million members and 100 million photos posted online. Snapfish enables both film and digital camera owners to share, print, and store their most important photo memories, at prices that cannot be equaled. Digital camera users upload photos into a password-protected online album for free. Users can also order film-quality prints on professional photographic paper for as low as 25¢. Film camera users get a full set of prints, plus online sharing and storage, for just $2.99 per roll.

Founded in 1995, eBay created a powerful platform for the sale of goods and services by a passionate community of individuals and businesses. On any given day, there are millions of items across thousands of categories for sale on eBay. eBay enables trade on a local, national and international basis with customized sites in markets around the world.

Through an array of services, such as its payment solution provider PayPal, eBay is enabling global e-commerce for an ever-growing online community.

JetBlue Airways is proud to be *America 24/7's* preferred carrier, flying photographers, photo editors, and organizers across the United States.

Winner of Condé Nast Traveler's Readers' Choice Awards for Best Domestic Airline 2002, JetBlue provides friendly service and low fares for travelers in 22 cities in nine states across America.

On behalf of JetBlue's 5,000 crew members, we're excited to be involved in this remarkable project, and for the opportunity to serve American travelers each and every day, coast to coast, 24/7.

DIGITAL POND

Digital Pond has been a leading creator of large graphic displays for museums, corporations, trade shows, retail environments and fine art since 1992.

We were proud to bring together our creative, print and display capabilities to produce signage and displays for mission control, critical retouching for numerous key images for the book, and art galleries for the New York Public Library and Bryant Park.

The Pond's team and SplashPic® Online service enabled us to nimbly design, produce and install over 200 large graphic panels in two NYC locations within the truly "24/7" production schedule of less than ten days.

WEBWARE

WebWare Corporation is pleased to be a major sponsor of the America 24/7 project. We take pride in being part of a groundbreaking adventure that is stretching the boundaries—and the imagination—in digital photography, digital asset management, publishing, news, and global events.

Our ActiveMedia Enterprise™ digital asset management software is the "nerve center" of *America 24/7*, the central repository for managing, sharing, and collaborating on the project's photographs. From photo editors and book publishers to 24/7's media relations and marketing personnel, ActiveMedia provides the application support that links all facets of the project team to the content worldwide.

WebWare helps Global 2000 firms securely manage, reuse, and distribute media assets locally or globally. Its suite of ActiveMedia software products provide powerful media services platforms for integrating rich media into content management systems marketing and communication portals; web publishing systems; and e-commerce portals.

Google

Google's mission is to organize the world's information and make it universally accessible and useful.

With our focus on plucking just the right answer from an ocean of data, we were naturally drawn to the America 24/7 project. The book you hold is a compendium of images of American life distilled from thousands of photographs and infinite possibilities. Are you looking for emotion? Narrative? Shadows? Light? It's all here, thanks to a multitude of photographers and writers creating links between you, the reader, and a sea of wonderful stories. We celebrate the connections that constitute the human experience and are pleased to help engender them. And we're pleased to have been a small part of this project, which captures the results of that interaction so vividly, so dynamically, and so dramatically.

Special thanks to additional contributors: FileMaker, Apple, Camera Bits, LaCie, Now Software, Preclick, Outpost Digital, Xerox, Microsoft, WoodWing Software, net-linx Publishing Solutions, and Radical Media. The Savoy Hotel, San Francisco; The Pan Pacific, San Francisco; Four Seasons Hotel, San Francisco; and The Queen Anne Hotel. Photography editing facilities were generously hosted by CNET Networks, Inc.

Participating Photographers

Coordinator: John Sale, Director of Photography, *The Spokesman-Review*

Christopher Anderson, *The Spokesman-Review*
Paige Baker
Alan Berner
Al Camp, *The Omak Chronicle*
Jon Canfield
Laurence Chen, LChenphoto.com
Stuart W. Conway
Randy S. Corbin
Anthony M. Culanag, F/22 Studioworks
Douglas P. Dobbins
Greg Ebersole, *Longview Daily News*
Natalie Fobes
Monte H. Gerlach
Kevin German
Teri Harris, Ladybug Photography
Wayne Hacker, WarrenImages.com
Mike Hanson
Kirk Hirota
Amy Hsieh
Casey Kelbaugh
Paul Kitagaki, Jr.*
Torsten Kjellstrand

Brian Lanker*
Rika Manabe
Warren Mell
Colin Mulvany
Nathan P. Myhrvold
Pat Newsome
Rachel Olsson Photography
Tony Overman, *The Olympian*
Joanna B. Pinneo, Aurora
Roger Ressmeyer, Visions of Tomorrow
Kathryn Riebe
Rocky Ross
Doug Rowan
Mike Salsbury, *The Olympian*
Phil Schofield
Don Seabrook
Larry Steagall, *The Sun*
eLisa Teague
Anya M. Traisman
Betty Udesen
Joan Wildman

*Pulitzer Prize winner

Thumbnail Picture Credits

Credits for thumbnail photographs are listed by the page number and are in order from left to right.

20 Natalie Fobes
Rachel Olsson Photography
Don Seabrook
Casey Kelbaugh
Natalie Fobes
Don Seabrook
Natalie Fobes

21 Natalie Fobes
Rachel Olsson Photography
Warren Mell
Natalie Fobes
Colin Mulvany
Nicholas Stevens
Rika Manabe

22 Chandler McKaig Photography
Anne Drobish-Shahat
Christopher Anderson, *The Spokesman-Review*
Don Seabrook
Paul Kitagaki, Jr.
Rika Manabe
Rika Manabe

23 Betty Udesen
Rika Manabe
Betty Udesen
Rika Manabe
Warren Mell
Betty Udesen
Warren Mell

26 Douglas P. Dobbins
Carolyn J. Yaschur, *The Sun*
Anya M. Traisman
Douglas P. Dobbins
Paul Kitagaki, Jr.
Douglas P. Dobbins
Paul Kitagaki, Jr.

27 Greg Ebersole, *Longview Daily News*
Rachel Olsson Photography
Kevin German
Mike Salsbury, *The Olympian*
Anya M. Traisman
Greg Ebersole, *Longview Daily News*
Michael Durham, www.DurmPhoto.com

29 Al Camp, *The Omak Chronicle*
Brian Lanker

Anya M. Traisman
Joanna B. Pinneo, Aurora
Kirk Hirota
Kirk Hirota
Joanna B. Pinneo, Aurora

31 Chandler McKaig Photography
Larry Steagall, *The Sun*
Chandler McKaig Photography
Larry Steagall, *The Sun*
Chandler McKaig Photography
Carolyn J. Yaschur, *The Sun*
Carolyn J. Yaschur, *The Sun*

32 Don Seabrook
Natalie Fobes
Natalie Fobes
Natalie Fobes
Rachel Olsson Photography
Natalie Fobes
Natalie Fobes

33 Roger Ressmeyer, Visions of Tomorrow
Roger Ressmeyer, Visions of Tomorrow
Roger Ressmeyer, Visions of Tomorrow
Roger Ressmeyer, Visions of Tomorrow
Roger Ressmeyer, Visions of Tomorrow
Rachel Olsson Photography
Natalie Fobes

36 Paige Baker
Paul Kitagaki, Jr.
Paige Baker
Natalie Fobes
Paul Kitagaki, Jr.
Paul Kitagaki, Jr.
Casey Kelbaugh

37 Natalie Fobes
Colin Mulvany
Natalie Fobes
Paige Baker
Natalie Fobes
Paul Kitagaki, Jr.
Betty Udesen

38 Joanna B. Pinneo, Aurora
Joanna B. Pinneo, Aurora
Joanna B. Pinneo, Aurora
Joanna B. Pinneo, Aurora

Joanna B. Pinneo, Aurora
Joanna B. Pinneo, Aurora
Joanna B. Pinneo, Aurora

39 Joanna B. Pinneo, Aurora
Joanna B. Pinneo, Aurora
Joanna B. Pinneo, Aurora
Joanna B. Pinneo, Aurora
Joanna B. Pinneo, Aurora
Joanna B. Pinneo, Aurora
Joanna B. Pinneo, Aurora

40 Nathan P. Myhrvold
Nathan P. Myhrvold
Nathan P. Myhrvold
Nathan P. Myhrvold
Nathan P. Myhrvold
Nathan P. Myhrvold

41 Nathan P. Myhrvold
Nathan P. Myhrvold
Nathan P. Myhrvold
Rachel Olsson Photography
Nathan P. Myhrvold
Rachel Olsson Photography
Jason Moodie

48 Alan Berner
Alan Berner
Rick Wong
Alan Berner
Alan Berner
Alan Berner
Paige Baker

49 Rick Wong
Alan Berner
Laurence Chen, LChenphoto.com
Alan Berner
Paige Baker
Dixon Hamby, www.idixon.com
Alan Berner

50 Randy S. Corbin
Randy S. Corbin
Magdalena Biernat-Webster
Holli Hage
Roger Ressmeyer, Visions of Tomorrow
Rick Wong
Joanna B. Pinneo, Aurora

51 Roger Ressmeyer, Visions of Tomorrow
Nathan P. Myhrvold
Sylvia Hoffard-Blaauw, H-B Design
Nathan P. Myhrvold
Nathan P. Myhrvold
Susi Prescott
Wayne Hacker, WarrenImages.com

54 Alan Berner
Colin Mulvany
Alan Berner
Colin Mulvany
Alan Berner
Colin Mulvany
Chandler McKaig Photography

55 Cara J. Jennings, CJ Jennings Photography
Colin Mulvany
Torsten Kjellstrand
Torsten Kjellstrand
Tony Overman, *The Olympian*
Tony Overman, *The Olympian*
Tony Overman, *The Olympian*

58 Don Seabrook
Al Camp, *The Omak Chronicle*
Kirk Hirota
Don Seabrook
Kevin German
Kevin German
Kevin German

59 Kirk Hirota
Kevin German
Kirk Hirota
Don Seabrook
Don Seabrook
Rachel Olsson Photography
Kirk Hirota

60 Anthony M. Culanag, F/22 Studioworks
Blake Woken
Anne Drobish-Shahat
Joanna B. Pinneo, Aurora

Christopher Anderson, *The Spokesman-Review*
Nathan P. Myhrvold
Nathan P. Myhrvold

61 Nathan P. Myhrvold
Warren Mell
Nathan P. Myhrvold
Nathan P. Myhrvold
Nathan P. Myhrvold
Warren Mell
Nathan P. Myhrvold

63 Colin Mulvany
Don Seabrook
Don Seabrook
Don Seabrook
Don Seabrook
Don Seabrook
Nicholas Stevens

64 Amanda Smith
Laurence Chen, LChenphoto.com
Carolyn J. Yaschur, *The Sun*
Carolyn J. Yaschur, *The Sun*
Jon Canfield
Laurence Chen, LChenphoto.com
Kevin German

65 Laurence Chen, LChenphoto.com
Laurence Chen, LChenphoto.com
Laurence Chen, LChenphoto.com
Laurence Chen, LChenphoto.com
Phil Schofield
Phil Schofield
Phil Schofield

68 Stuart W. Conway
Stuart W. Conway
Nathan P. Myhrvold
Nathan P. Myhrvold
Nathan P. Myhrvold
Nathan P. Myhrvold
Nathan P. Myhrvold

69 Rick Wong
Stuart W. Conway
Anne Drobish-Shahat
Christopher Anderson, *The Spokesman-Review*
Christopher Anderson, *The Spokesman-Review*
Blake Woken
Stuart W. Conway

70 Douglas P. Dobbins
Douglas P. Dobbins
Douglas P. Dobbins
Nathan P. Myhrvold
Mike Salsbury, *The Olympian*
Mike Salsbury, *The Olympian*
Nathan P. Myhrvold

71 Mike Salsbury, *The Olympian*
Mike Salsbury, *The Olympian*
Mike Salsbury, *The Olympian*
Nathan P. Myhrvold
Mike Salsbury, *The Olympian*
Nathan P. Myhrvold
Nathan P. Myhrvold

76 Rick Wong
Warren Mell
Don Seabrook
Don Seabrook
Don Seabrook
Warren Mell
Douglas P. Dobbins

77 Casey Kelbaugh
Rick Wong
Don Seabrook
Don Seabrook
Don Seabrook
Warren Mell
Douglas P. Dobbins

78 Stuart W. Conway
Kevin German
Don Seabrook
Paige Baker
Don Seabrook
Sylvia Hoffard-Blaauw, H-B Design
Stuart W. Conway

79 Phil Schofield
Greg Harris, Ladybug Photography
Stuart W. Conway
Greg Harris, Ladybug Photography

Phil Schofield
Tony Overman, *The Olympian*
Wayne Hacker, WarrenImages.com

80 Alan Berner
Phil Schofield
Anya M. Traisman
Anya M. Traisman
Tony Overman, *The Olympian*
Joanna B. Pinneo, Aurora
Sylvia Hoffard-Blaauw, H-B Design

81 Wayne Hacker, WarrenImages.com
Don Seabrook
Tony Overman, *The Olympian*
Don Seabrook
Greg Ebersole, *Longview Daily News*
Wayne Hacker, WarrenImages.com
Blake Woken

86 Al Camp, *The Omak Chronicle*
Mike Salsbury, *The Olympian*
Greg Ebersole, *Longview Daily News*
Larry Steagall, *The Sun*
Mike Salsbury, *The Olympian*
Greg Ebersole, *Longview Daily News*
Larry Steagall, *The Sun*

87 Laurence Chen, LChenphoto.com
Laurence Chen, LChenphoto.com
Laurence Chen, LChenphoto.com
Laurence Chen, LChenphoto.com
Laurence Chen, LChenphoto.com
Mike Salsbury, *The Olympian*
Greg Ebersole, *Longview Daily News*

88 Amanda Smith
Betty Udesen
Amanda Smith
Betty Udesen
Kevin German
Don Seabrook
Colin Mulvany

89 Kevin German
Kevin German
Laurence Chen, LChenphoto.com
Warren Mell
Laurence Chen, LChenphoto.com
Warren Mell
Warren Mell

90 Joanna B. Pinneo, Aurora
Joanna B. Pinneo, Aurora
Joanna B. Pinneo, Aurora
Joanna B. Pinneo, Aurora
Nathan P. Myhrvold
Nathan P. Myhrvold
Nathan P. Myhrvold

92 Kirk Hirota
Jennifer Hoerth, Henry Cogswell College
Tony Overman, *The Olympian*
Kevin German
Anya M. Traisman
Laurence Chen, LChenphoto.com
Laurence Chen, LChenphoto.com

93 Magdalena Biernat-Webster
Monte H. Gerlach
Mike Salsbury, *The Olympian*
Steve Zugschwerdt, *The Sun*
Tony Overman, *The Olympian*
Nicholas Stevens
Teri Harris, Ladybug Photography

97 Douglas P. Dobbins
Casey Kelbaugh
Steve Zugschwerdt, *The Sun*
Laurence Chen, LChenphoto.com
Tony Overman, *The Olympian*
Greg Ebersole, *Longview Daily News*
Casey Kelbaugh

98 Anthony M. Culanag, F/22 Studioworks
Don Seabrook
Don Seabrook
Don Seabrook
Don Seabrook
Don Seabrook
Don Seabrook

99 Douglas P. Dobbins
Don Seabrook
Greg Harris, Ladybug Photography
Don Seabrook

Jason Moodie
Tony Overman, *The Olympian*
Tony Overman, *The Olympian*

101 Don Seabrook
Don Seabrook
Rachel Olsson Photography
Don Seabrook
Rachel Olsson Photography
Kevin German
Rachel Olsson Photography

102 Don Seabrook
Tony Overman, *The Olympian*
Greg Ebersole, *Longview Daily News*
Casey Kelbaugh
Greg Harris, Ladybug Photography
Nicholas Stevens
Joanna B. Pinneo, Aurora

103 Steve Zugschwerdt, *The Sun*
Don Seabrook
Rick Wong
Phil Schofield
Steve Zugschwerdt, *The Sun*
Steve Zugschwerdt, *The Sun*
Tony Overman, *The Olympian*

108 Laurence Chen, LChenphoto.com
Laurence Chen, LChenphoto.com
Kevin German
Laurence Chen, LChenphoto.com
Laurence Chen, LChenphoto.com
Stuart W. Conway
Laurence Chen, LChenphoto.com

109 Tony Overman, *The Olympian*
Laurence Chen, LChenphoto.com
Laurence Chen, LChenphoto.com
Nathan P. Myhrvold
Laurence Chen, LChenphoto.com
Nathan P. Myhrvold
Laurence Chen, LChenphoto.com

110 Kevin German
Casey Kelbaugh
Kevin German
Casey Kelbaugh
Casey Kelbaugh
Jon Canfield
Casey Kelbaugh

111 Casey Kelbaugh
J. Carlos Klapp
Casey Kelbaugh
Kevin German
Casey Kelbaugh
Tony Overman, *The Olympian*
Rick Wong

112 Don Seabrook
Don Seabrook
Cassidy Lena Brock
Don Seabrook
Jon Canfield
Al Camp, *The Omak Chronicle*
Anthony M. Culanag, F/22 Studioworks

113 Greg Ebersole, *Longview Daily News*
Don Seabrook
Michael Good
Don Seabrook
Wayne Hacker, WarrenImages.com
Kevin German
Sylvia Hoffard-Blaauw, H-B Design

116 Kevin German
Torsten Kjellstrand
Kevin German
Torsten Kjellstrand
Torsten Kjellstrand
Sylvia Hoffard-Blaauw, H-B Design
Torsten Kjellstrand

117 Torsten Kjellstrand
Torsten Kjellstrand
Stuart W. Conway
Torsten Kjellstrand
Torsten Kjellstrand
Tony Overman, *The Olympian*
Torsten Kjellstrand

118 Casey Kelbaugh
Casey Kelbaugh
Laurence Chen, LChenphoto.com
Douglas P. Dobbins

Jon Canfield
Laurence Chen, LChenphoto.com
Laurence Chen, LChenphoto.com

119 Laurence Chen, LChenphoto.com
Laurence Chen, LChenphoto.com
Laurence Chen, LChenphoto.com
Mike Salsbury, *The Olympian*
Mike Salsbury, *The Olympian*
Mike Salsbury, *The Olympian*

122 Laurence Chen, LChenphoto.com
Laurence Chen, LChenphoto.com
Laurence Chen, LChenphoto.com
Laurence Chen, LChenphoto.com
Laurence Chen, LChenphoto.com
Laurence Chen, LChenphoto.com
Laurence Chen, LChenphoto.com

123 Laurence Chen, LChenphoto.com
Laurence Chen, LChenphoto.com
Laurence Chen, LChenphoto.com
Laurence Chen, LChenphoto.com
Laurence Chen, LChenphoto.com
Laurence Chen, LChenphoto.com
Laurence Chen, LChenphoto.com

128 Alan Berner
Alan Berner
Tony Overman, *The Olympian*
Alan Berner
Tony Overman, *The Olympian*
Alan Berner
Alan Berner

129 Alan Berner
Alan Berner
Alan Berner
Warren Mell
Christopher Davenport, Galloping Pictures Inc.
Warren Mell
Warren Mell

130 Jennifer Hoerth, Henry Cogswell College
Alan Berner
Laurence Chen, LChenphoto.com
Alan Berner
Alan Berner
Alan Berner
Larry Steagall, *The Sun*

131 Larry Steagall, *The Sun*
Larry Steagall, *The Sun*
Tony Overman, *The Olympian*
Rika Manabe
Rika Manabe
Tony Overman, *The Olympian*
Tony Overman, *The Olympian*

132 Alan Berner
Alan Berner
Alan Berner
Alan Berner
Anthony M. Culanag, F/22 Studioworks
Anthony M. Culanag, F/22 Studioworks
Anthony M. Culanag, F/22 Studioworks

133 Douglas P. Dobbins
Jeff Horner Photo
Magdalena Biernat-Webster
Nathan P. Myhrvold
Nathan P. Myhrvold
Nathan P. Myhrvold
Nathan P. Myhrvold

134 Jennifer Hoerth, Henry Cogswell College
Christopher Anderson, *The Spokesman-Review*
Douglas P. Dobbins
Kirk Hirota
Kirk Hirota
Larry Steagall, *The Sun*
Larry Steagall, *The Sun*

135 Magdalena Biernat-Webster
Sylvia Hoffard-Blaauw, H-B Design
Sylvia Hoffard-Blaauw, H-B Design
Wayne Hacker, WarrenImages.com
Sylvia Hoffard-Blaauw, H-B Design
Jon Canfield
Wayne Hacker, WarrenImages.com

136 Anthony M. Culanag, F/22 Studioworks
Christopher Anderson, *The Spokesman-Review*
Anthony M. Culanag, F/22 Studioworks
Rick Wong
Anthony M. Culanag, F/22 Studioworks
Larry Steagall, *The Sun*
Nathan P. Myhrvold

137 Colin Mulvany
Anthony M. Culanag, F/22 Studioworks
David Griffith
Blake Woken
Nathan P. Myhrvold
Christopher Anderson, *The Spokesman-Review*
Christopher Anderson, *The Spokesman-Review*

138 Christopher Davenport,
Galloping Pictures Inc.
Douglas P. Dobbins
Christopher Anderson, *The Spokesman-Review*
Larry Steagall, *The Sun*
Christopher Anderson, *The Spokesman-Review*
Sylvia Hoffard-Blaauw, H-B Design
Blake Woken

139 Christopher Anderson,
The Spokesman-Review
Douglas P. Dobbins
Christopher Anderson, *The Spokesman-Review*
Christopher Anderson, *The Spokesman-Review*
Christopher Davenport, Galloping Pictures Inc.
Christopher Anderson, *The Spokesman-Review*
Christopher Davenport, Galloping Pictures Inc.

140 Paul Kitagaki, Jr.
Paige Baker
Casey Kelbaugh
Casey Kelbaugh
Anne Drobish-Shahat
Colin Mulvany
Warren Mell

141 Greg Harris, Ladybug Photography
Alan Berner
Kevin German
Alan Berner
Dixon Hamby, www.idixon.com
Kevin German
Tony Overman, *The Olympian*

142 Paige Baker
Blake Woken
Nathan P. Myhrvold
Rick Wong
Paige Baker
Nathan P. Myhrvold
Nathan P. Myhrvold

144 Anthony M. Culanag, F/22 Studioworks
Blake Woken
Blake Woken
Rick Wong
Blake Woken
Anthony M. Culanag, F/22 Studioworks
Blake Woken

145 Colin Mulvany
Torsten Kjellstrand
Casey Kelbaugh
Kevin German
Kevin German
Kevin German
Casey Kelbaugh

146 Anne Drobish-Shahat
Douglas P. Dobbins
Douglas P. Dobbins
Blake Woken
Anne Drobish-Shahat
Douglas P. Dobbins
Al Camp, *The Omak Chronicle*

147 Kevin German
Rick Wong
Kevin German
Rachel Olsson Photography
Kevin German
Sylvia Hoffard-Blaauw, H-B Design
Tony Overman, *The Olympian*

148 Anne Drobish-Shahat
Blake Woken
Anne Drobish-Shahat
Nathan P. Myhrvold
Nathan P. Myhrvold
Kevin German
Holli Hage

149 Blake Woken
Blake Woken
Holli Hage
Wayne Hacker, WarrenImages.com
Rick Wong
Wayne Hacker, WarrenImages.com
Wayne Hacker, WarrenImages.comz

Staff

The *America 24/7* series was imagined years ago by our friend Oscar Dystel, a publishing legend whose vision and enthusiasm have been a source of great inspiration.

We also wish to express our gratitude to our truly visionary publisher, DK.

Rick Smolan, Project Director
David Elliot Cohen, Project Director

Administrative
Katya Able, Operations Director
Gina Privitere, Communications Director
Chuck Gathard, Technology Director
Kim Shannon, Photographer Relations Director
Erin O'Connor, Photographer Relations Intern
Leslie Hunter, Partnership Director
Annie Polk, Publicity Manager
John McAlester, Website Manager
Alex Notides, Office Manager
C. Thomas Hardin, State Photography Coordinator

Design
Brad Zucroff, Creative Director
Karen Mullarkey, Photography Director
Judy Zimola, Production Manager
David Simoni, Production Designer
Mary Dias, Production Designer
Heidi Madison, Associate Picture Editor
Don McCartney, Production Designer
Diane Dempsey Murray, Production Designer
Jan Rogers, Associate Picture Editor
Bill Shore, Production Designer and Image Artist
Larry Nighswander, Senior Picture Editor
Bill Marr, Sarah Leen, Senior Picture Editors
Peter Truskier, Workflow Consultant
Jim Birkenseer, Workflow Consultant

Editorial
Maggie Canon, Managing Editor
Curt Sanburn, Senior Editor
Teresa L. Trego, Production Editor
Lea Aschkenas, Writer
Olivia Boler, Writer
Korey Capozza, Writer
Beverly Hanly, Writer
Bridgett Novak, Writer
Alison Owings, Writer
Fred Raker, Writer
Joe Wolff, Writer
Elise O'Keefe, Copy Chief
Daisy Hernández, Copy Editor
Jennifer Wolfe, Copy Editor

Infographic Design
Nigel Holmes

Literary Agent
Carol Mann, The Carol Mann Agency

Legal Counsel
Barry Reder, Coblentz, Patch, Duffy & Bass, LLP
Phil Feldman, Coblentz, Patch, Duffy & Bass, LLP
Gabe Perle, Ohlandt, Greeley, Ruggiero & Perle, LLP
Jon Hart, Dow, Lohnes & Albertson, PLLC
Mike Hays, Dow, Lohnes & Albertson, PLLC
Stephen Pollen, Warshaw Burstein, Cohen, Schlesinger & Kuh, LLP
Rick Pappas

Accounting and Finance
Rita Dulebohn, Accountant
Robert Powers, Calegari, Morris & Co. Accountants
Eugene Blumberg, Blumberg & Associates
Arthur Langhaus, KLS Professional Advisors Group, Inc.

Picture Editors
J. David Ake, Associated Press
Caren Alpert, formerly *Health* magazine
Simon Barnett, *Newsweek*
Caroline Couig, *San Jose Mercury News*
Mike Davis, formerly *National Geographic*
Michel duCille, *Washington Post*
Deborah Dragon, *Rolling Stone*
Victor Fisher, formerly Associated Press
Frank Folwell, *USA Today*
MaryAnne Golon, *Time*
Liz Grady, formerly *National Geographic*
Randall Greenwell, *San Francisco Chronicle*
C. Thomas Hardin, formerly *Louisville Courier-Journal*
Kathleen Hennessy, *San Francisco Chronicle*
Scot Jahn, *U.S. News & World Report*
Steve Jessmore, *Flint Journal*
John Kaplan, University of Florida
Kim Komenich, *San Francisco Chronicle*
Eliane Laffont, *Hachette Filipacchi Media*
Jean-Pierre Laffont, *Hachette Filipacchi Media*
Andrew Locke, MSNBC
Jose Lopez, *The New York Times*
Maria Mann, formerly AFP
Bill Marr, formerly *National Geographic*
Michele McNally, *Fortune*
James Merithew, *San Francisco Chronicle*
Eric Meskauskas, *New York Daily News*
Maddy Miller, *People* magazine
Michelle Molloy, *Newsweek*
Dolores Morrison, *New York Daily News*
Karen Mullarkey, formerly *Newsweek, Rolling Stone, Sports Illustrated*
Larry Nighswander, Ohio University School of Visual Communication
Jim Preston, *Baltimore Sun*
Sarah Rozen, formerly *Entertainment Weekly*
Mike Smith, *The New York Times*
Neal Ulevich, formerly Associated Press

Website and Digital Systems
Jeff Burchell, Applications Engineer

Television Documentary
Sandy Smolan, Producer/Director
Rick King, Producer/Director
Bill Medsker, Producer

Video News Release
Mike Cerre, Producer/Director

Digital Pond
Peter Hogg
Kris Knight
Roger Graham
Philip Bond
Frank De Pace
Lisa Li

Senior Advisors
Jennifer Erwitt, Strategic Advisor
Tom Walker, Creative Advisor
Megan Smith, Technology Advisor
Jon Kamen, Media and Partnership Advisor
Mark Greenberg, Partnership Advisor
Patti Richards, Publicity Advisor
Cotton Coulson, Mission Control Advisor

Executive Advisors
Sonia Land
George Craig
Carole Bidnick

Advisors
Chris Anderson
Samir Arora
Russell Brown
Craig Cline
Gayle Cline
Harlan Felt
George Fisher
Phillip Moffitt
Clement Mok
Laureen Seeger
Richard Saul Wurman

DK Publishing
Bill Barry
Joanna Bull
Therese Burke
Sarah Coltman
Christopher Davis
Todd Fries
Dick Heffernan
Jay Henry
Stuart Jackman
Stephanie Jackson
Chuck Lang
Sharon Lucas
Cathy Melnicki
Nicola Munro
Eunice Paterson
Andrew Welham

Colourscan
Jimmy Tsao
Eddie Chia
Richard Law
Josephine Yam
Paul Koh
Chee Cheng Yeong
Dan Kang

Chief Morale Officer
Goose, the dog